THE AGILE RABBIT BOOK OF HISTORICAL AND CURIOUS
MAPS

HISTORISCHE UND KURIOSE LANDKARTEN
MAPAS HISTÓRICOS E CURIOSOS
CARTES HISTORIQUES ET ATYPIQUES
MAPAS HISTÓRICOS Y CURIOSOS
CARTE GEOGRAFICHE STORICHE E SINGOLARI
古地図と美術地図　　歴史地圖及奇趣地圖

THE PEPIN PRESS 🐇 AGILE RABBIT EDITIONS

Graphic Themes & Pictures

90 5768 001 7	1000 Decorated Initials
90 5768 003 3	Graphic Frames
90 5768 007 6	Images of the Human Body
90 5768 012 2	Geometric Patterns
90 5768 014 9	Menu Designs
90 5768 017 3	Classical Border Designs
90 5768 055 6	Signs & Symbols
90 5768 024 6	Bacteria And Other Micro Organisms
90 5768 023 8	Occult Images
90 5768 046 7	Erotic Images & Alphabets
90 5768 062 9	Fancy Alphabets
90 5768 056 4	Mini Icons
90 5768 016 5	Graphic Ornaments (2 CDs)
90 5768 025 4	Compendium of Illustrations (2 CDs)
90 5768 021 1	5000 Animals (4 CDs)
90 5768 065 3	Teknological

Textile Patterns

90 5768 004 1	Batik Patterns
90 5768 030 0	Weaving Patterns
90 5768 037 8	Lace
90 5768 038 6	Embroidery
90 5768 058 0	Ikat Patterns
90 5768 075 0	Indian Textiles

Miscellaneous

90 5768 005 x	Floral Patterns
90 5768 052 1	Astrology
90 5768 051 3	Historical & Curious Maps
90 5768 061 0	Wallpaper Designs
90 5768 066 1	Atlas of World Mythology
90 5768 076 9	Watercolour Patterns

Styles (Historical)

90 5768 089 0	Early Christian Patterns
90 5768 090 4	Byzanthine
90 5768 091 2	Romanesque
90 5768 092 0	Gothic
90 5768 027 0	Mediæval Patterns
90 5768 034 3	Renaissance
90 5768 033 5	Baroque
90 5768 043 2	Rococo
90 5768 032 7	Patterns of the 19th Century
90 5768 013 0	Art Nouveau Designs
90 5768 060 2	Fancy Designs 1920
90 5768 059 9	Patterns of the 1930s
90 5768 072 6	Art Deco Designs

Styles (Cultural)

90 5768 006 8	Chinese Patterns
90 5768 009 2	Indian Textile Prints
90 5768 011 4	Ancient Mexican Designs
90 5768 020 3	Japanese Patterns
90 5768 022 x	Traditional Dutch Tile Designs
90 5768 028 9	Islamic Designs
90 5768 029 7	Persian Designs
90 5768 036 X	Turkish Designs
90 5768 042 4	Elements of Chinese & Japanese Design
90 5768 071 8	Arabian Geometric Patterns

Photographs

90 5768 047 5	Fruit
90 5768 048 3	Vegetables
90 5768 064 5	Body Parts (USA/Asia Ed)
90 5768 079 3	Male Body Parts
90 5768 080 7	Body Parts in Black & White
90 5768 067 x	Images of the Universe
90 5768 074 2	Rejected Photographs
90 5768 070 x	Flowers

Web Design

90 5768 018 1	Web Design Index 1
90 5768 026 2	Web Design Index 2
90 5768 045 9	Web Design Index 3
90 5768 063 7	Web Design Index 4
90 5768 068 8	Web Design Index 5
90 5768 093 9	Web Design Index 6
90 5768 069 6	Web Design Index by Content

Folding & Packaging

90 5768 039 4	How To Fold
90 5768 040 8	Folding Patterns for Display & Publicity
90 5768 044 0	Structural Package Designs
90 5768 053 x	Mail It!
90 5768 054 8	Special Packaging

More titles in preparation

In addition to the Agile Rabbit series of book+CD-ROM sets, The Pepin Press publishes a wide range of books on art, design, architecture, applied art, and popular culture.

Please visit www.pepinpress.com for more information.

The Pepin Press BV
P.O. Box 10349
1001 EH Amsterdam
The Netherlands

tel +31 20 4202021
fax +31 20 4201152
mail@pepinpress.com
www.pepinpress.com

Text and concept: Pepin van Roojen
Design: Kitty Molenaar
Scanning: Sang Choy, Inkahootz

Cover image: South Pole and expeditions (p.28)

All images are from the Pepin Press archives, except:
p. 35, 72, 73, 76, 77, 80, 81: Antiquariat Gebr. Haas
(www.atiquariat-haas.de)
p. 42, 43: The Puzzle Museum - Dalgety & Hordern Collections
p. 34, 108, 109, 110, 111: Shinichi Inagaki

The publisher gratefully acknowledge the assistance of
Jacques Koops and Joe Krisher

ISBN 90 5768 051 3

10 9 8 7 6 5 4 3 2
2012 11 10 09 08 07 06 05

Manufactured in Singapore

contents

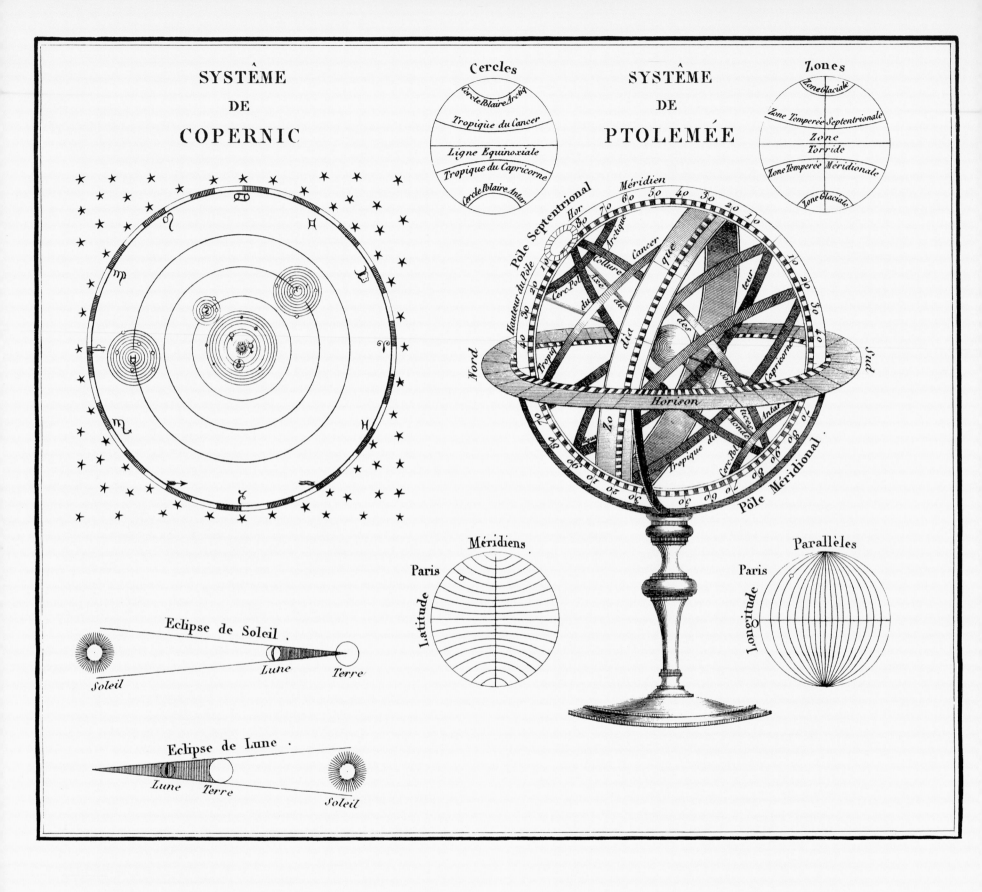

SYSTÊME
DE
COPERNIC

SYSTÊME
DE
PTOLEMÉE

Cercles

Zones

Eclipse de Soleil.

Eclipse de Lune.

Méridiens

Parallèles

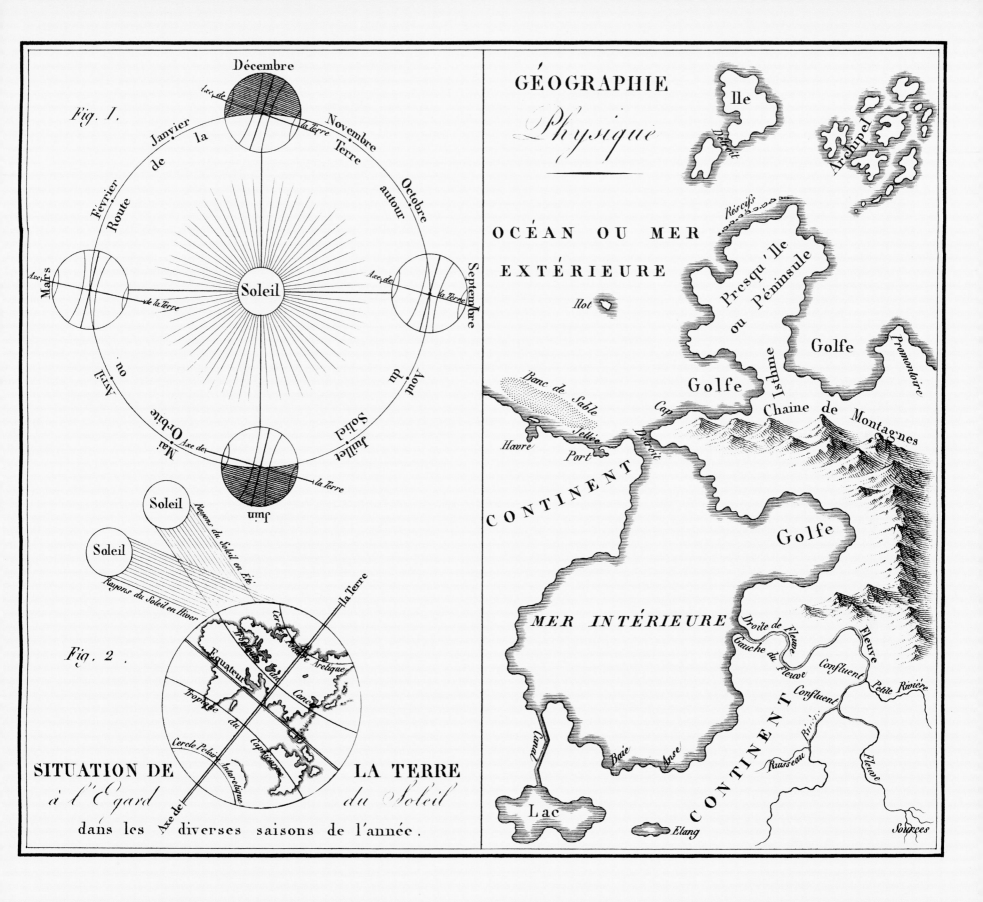

GÉOGRAPHIE
Physique

Fig. I.

Décembre

Janvier · Novembre · Octobre

de · la · Terre · autour

Février · Route · Septembre

Soleil

Mars · Axe de la Terre

Avril · Août

Mai · Orbite · Juillet

Juin

la Terre

Fig. 2.

Soleil

Soleil

Rayons du Soleil en Été

Rayons du Soleil en Hiver

la Terre

Équateur · Cercle Arctique · Cancer · Tropique du Capricorne · Cercle Polaire Antarctique · Axe de

SITUATION DE LA TERRE
à l'Égard du Soleil
dans les diverses saisons de l'année.

OCÉAN OU MER EXTÉRIEURE

Île · Détroit · Archipel

Récifs

Îlot

Presqu'Île ou Péninsule

Golfe · Isthme · Golfe · Promontoire

Banc de Sable · Cap · Chaîne de Montagnes

Jettée · Détroit

Havre · Port

CONTINENT

Golfe

MER INTÉRIEURE

Droite de Fleuve · Fleuve

Gauche du Fleuve · Confluent

Confluent · Petite Rivière

Canal · Baie · Anse · Ruisseau · Rivière · Fleuve

CONTINENT

Lac · Étang · Sources

5

English

The Agile Rabbit Book of Historical & Curious Maps contains a collection of amazing and beautifully made maps that have been chosen due to their visual impact and uniqueness. The book features a vast array of appearances and meanings; there are comparative overviews of the length of rivers and the height of mountains, nautical charts, medieval city plans and maps from pre-historical times.

Also included are images of Europeans' perceptions of how the world looked many centuries ago; highly detailed bird's-eye maps from Japan; and archaic, fascinating charts made by Native Americans and Australian Aborigines. Furthermore, there are a number of extraordinary maps with dual meanings. Details of some of the maps are shown in the book. The CD-ROM, however, contains full reproductions of all the maps.

français

Le livre Agile Rabbit des Cartes historiques et atypiques renferme toute une collection de cartes extraordinaires et superbement réalisées, choisies pour leur impact visuel et leur caractère unique. L'ouvrage présente de multiples aspects et points de vue : des panoramas comparatifs de la longueur des fleuves et de la hauteur des montagnes aux cartes marines, plans de cités médiévales et cartes des époques pré-historiques.

On y trouve également des illustrations des perceptions du monde par les Européens il y a plusieurs siècles, des cartes aériennes extrêmement détaillées du Japon, des cartes archaïques et fascinantes dessinées par les Indiens d'Amérique et les aborigènes d'Australie, sans oublier d'extraordinaires cartes à double sens. Le livre contient les détails de certaines cartes en particulier, tandis que le CD-ROM contient les reproductions complètes de toutes les cartes.

deutsch

Das Agile Rabbit-Buch „Historische und kuriose Landkarten" enthält eine Sammlung beeindruckender und wunderschön gestalteter Landkarten, die aufgrund ihrer visuellen Wirkung und ihrer Einzigartigkeit ausgewählt wurden. Das Buch umfasst eine Vielzahl von Darstellungsformen und Inhalten. Es bietet Vergleichsübersichten über die Länge von Flüssen und die Höhe von Bergen und enthält Seekarten, mittelalterliche Stadtpläne sowie prähistorische Landkarten. Ebenfalls enthalten sind Abbildungen, die erkennen lassen, wie das Weltbild der Europäer vor vielen hundert Jahren ausgesehen hat, sowie detaillierte Japankarten aus der Vogelperspektive und faszinierende, altertümliche Karten, die einst von den amerikanischen Ureinwohnern und den australischen Aborigenes gezeichnet wurden. Darüber hinaus befinden sich in dem Buch zahlreiche außergewöhnliche doppeldeutige Landkarten. Details einiger Landkarten sind im Buch abgebildet. Auf der CD-ROM sind jedoch vollständige Reproduktionen aller Landkarten enthalten.

Español

Mapas históricos y curiosos, de Agile Rabbit, presenta una serie de mapas tan sorprendentes como hermosos, seleccionados por su vistosidad y originalidad. En este libro encontrará un amplio catálogo de imágenes con distintos significados: comparativas de la longitud de ríos y la altura de montañas, cartas de navegación, planos de ciudades medievales y mapas trazados en la era prehistórica. También se incluyen ejemplos de la percepción del mundo que tenían los europeos hace muchos siglos, mapas a vista de pájaro extremadamente detallados procedentes de Japón y fascinantes planos arcaicos realizados por los indios norteamericanos y los aborígenes australianos. Asimismo, podrá consultar mapas extraordinarios con doble significado. Aunque en el libro únicamente aparecen detalles de algunos de los mapas, en el CD-ROM encontrará las reproducciones íntegras de todos ellos.

Português

O Livro de Mapas Históricos e Curiosos The Agile Rabbit contém uma belíssima e surpreendente colecção de mapas, seleccionada com base no seu impacto visual e carácter singular. Neste livro, é possível encontrar uma grande diversidade de apresentações gráficas e significados, entre os quais se contam perspectivas comparativas do comprimento dos rios e da altura das montanhas, cartas náuticas, plantas de cidades medievais e mapas de tempos pré-históricos.

Também foram incluídas imagens reveladoras da concepção que os europeus tinham do mundo há muitos séculos, pormenorizados mapas aéreos do Japão e fascinantes mapas arcaicos desenhados pela mão dos índios nativos americanos e pelos aborígenes australianos. Além disso, há diversos mapas extraordinários com duplos significados. O livro apresenta pormenores de alguns dos mapas, mas o CD-ROM contém reproduções integrais de todos os mapas.

Direitos de autor e autorizações: Este livro contém imagens que podem ser utilizadas como recurso gráfico ou simplesmente como fonte de inspiração. As ilustrações estão armazenadas no CD-ROM anexo e podem ser utilizadas em muitos tipos de aplicações. O CD-ROM é fornecido gratuitamente com o livro, sendo proibido vendê-lo em separado.

Todos os direitos reservados. Porém, os ficheiros contidos no CD-ROM poderão ser utilizados para fins pessoais, desde que não sejam disseminados, publicados ou vendidos. O uso comercial ou profissional dos ficheiros contidos neste CD, incluindo todos os tipos de publicações impressas ou digitais, carece da prévia permissão dos editores (consulte a página 5 para obter informações detalhadas). A política de autorizações de The Pepin Press/Agile Rabbit Editions é muito razoável e as taxas cobradas tendem a ser muito reduzidas.

日本語

アジャイル・ラビット監修『古地図と美術地図』は見事に作製されたすばらしい地図のコレクションを収録しており、いずれも選択基準である鮮やかな印象を与える稀少な地図です。収録品は外観と意義において多様性に富んだもので、川の長さや山の高さを相対的に描いたものや、海図、中世の都市計画図、先史時代の地図が含まれています。

そのほか、何世紀も昔にヨーロッパ人が世界をどのようにとらえていたかを窺い知ることのできるイメージ、精緻な日本の鳥瞰図、アメリカ原住民やオーストラリア先住民が作った魅了される古代図も含まれています。さらに、二様の意味を持つ非常に変わった地図も多数収録されています。そのうちの幾つかの部分図が本書に掲載されていますが、CD-ROM にはすべての地図が完全版で収録されています。

版権と使用許可：本書にはグラフィックリソースやインスピレーションの源として利用できるイメージが掲載されています。添付の CD-ROM にはイラストレーションが収録されていて、様々なタイプのアプリケーションで使用できます。CD-ROM は付録として本書に無料で添付されているもので、別売りはされていません。

収録品はすべて版権で保護されています。ただし、方法もしくは形態を問わず配布や出版または販売されるのでない限り、CD-ROM に収録されているファイルを個人目的でご使用いただくことができます。商業目的または営利目的で画像を使用する場合は、あらゆる種類の印刷またはデジタル出版を含めて、発行者の許可が必要です（詳細は 5 ページを参照）。使用許可に関するペピン・プレス／アジャイル・ラビット・エディションズのポリシーは妥当なもので、料金が発生する場合は非常にお得な料金となるはずです。

Italiano

L'atlante delle Carte Geografiche Storiche e Singolari pubblicato dalla Agile Rabbit è una raccolta di mappe molto particolari, di ottima fattura, che sono state selezionate per l'impatto visivo che hanno sul lettore e per la loro rarità. Si tratta di carte diverse per aspetto e significato, che vanno dall'analisi comparata della lunghezza dei fiumi e dell'altezza delle montagne alle carte nautiche, dalle piante medievali delle città alle carte dei tempi preistorici.

L'opera presenta anche immagini che illustrano la visione che gli Europei avevano del mondo molti secoli fa; carte a volo d'uccello molto dettagliate del Giappone, e carte antiche, e molto affascinanti, disegnate dai nativi americani e dagli aborigeni australiani. A queste si aggiungono carte di straordinaria bellezza dal doppio significato. Alcune carte sono riprodotte parzialmente sul libro, mentre tutte sono riportate integralmente sul CD-ROM.

Copyright e permesso di utilizzo: Il libro contiene immagini che possono essere utilizzate come risorsa grafica o come fonte d'ispirazione. Le illustrazioni sono contenute nel CD-ROM allegato e possono essere utilizzate per scopi diversi. Il CD-ROM è gratuito e non può essere venduto separatamente.

Tutti i diritti sono riservati. È consentito l'uso privato dei file contenuti nel CD-ROM a condizione che non siano distribuiti, pubblicati o venduti in qualunque modo o forma; al contrario, l'uso a scopo commerciale e/o professionale, incluso qualunque tipo di pubblicazione su supporto cartaceo o digitale, è consentito solo previo consenso dell'editore (v. pag. 5). La casa editrice Pepin Press/Agile Rabbit Editions ha adottato una politica ragionevole per la concessione del permesso all'utilizzo del copyright che riduce al minimo il pagamento dei diritti.

中文

Agile Rabbit 出版的《歷史地圖及奇趣地圖》一書收集了大量精心挑選、製作精美的地圖，為您帶來獨特而深刻的體驗。這些地圖無論是從外形還是內涵均各有特色；您可以觀察到河流的長度及山峰的高度，也可以深入研究航海圖、中世紀的城市規劃以及史前時期的地圖。

該書還附帶許多圖片，您可以瞭解若干世紀前歐洲的風貌、欣賞製作詳細的日本鳥瞰圖，以及由印地安人和澳洲土著人繪製的古老而迷人的圖表。其中許多地圖具有雙重意義、非常特別。該書對某些地圖進行了詳細介紹。光碟片中則包含了所有地圖的完整資訊。

版權及使用許可: 本書所帶圖片既可用作圖片資料，也可幫助您激發靈感。插圖存儲在附帶的光碟片中，並可在許多種應用程式中使用。光碟片隨本書免費贈送，不單獨出售。

保留所有權利。但是，我們允許您將光碟片中所含檔案作為自用，但不能以任何方式或通過任何途徑進行傳播、出版或出售。對於商業和/或專業用途（包括任何類型的印刷或數位出版），必須從出版商（詳情請參考第 5 頁）獲得使用許可權。Pepin Press/Agile Rabbit Editions 使用許可政策是合理的，對於那些需要收費的資料，費用也相當低廉。

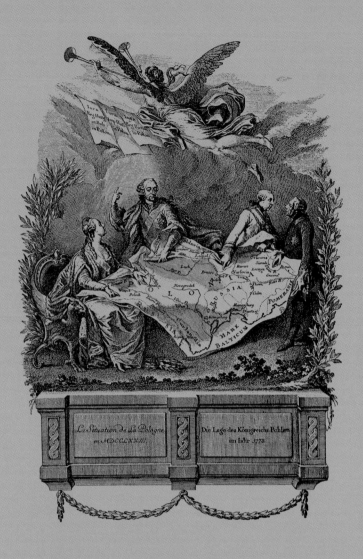

La Situation de la Pologne en MDCCLXXII.

Die Lage des Königreichs Pohlen im Jahr 1773.

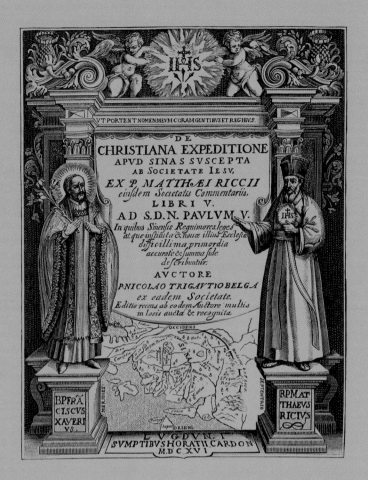

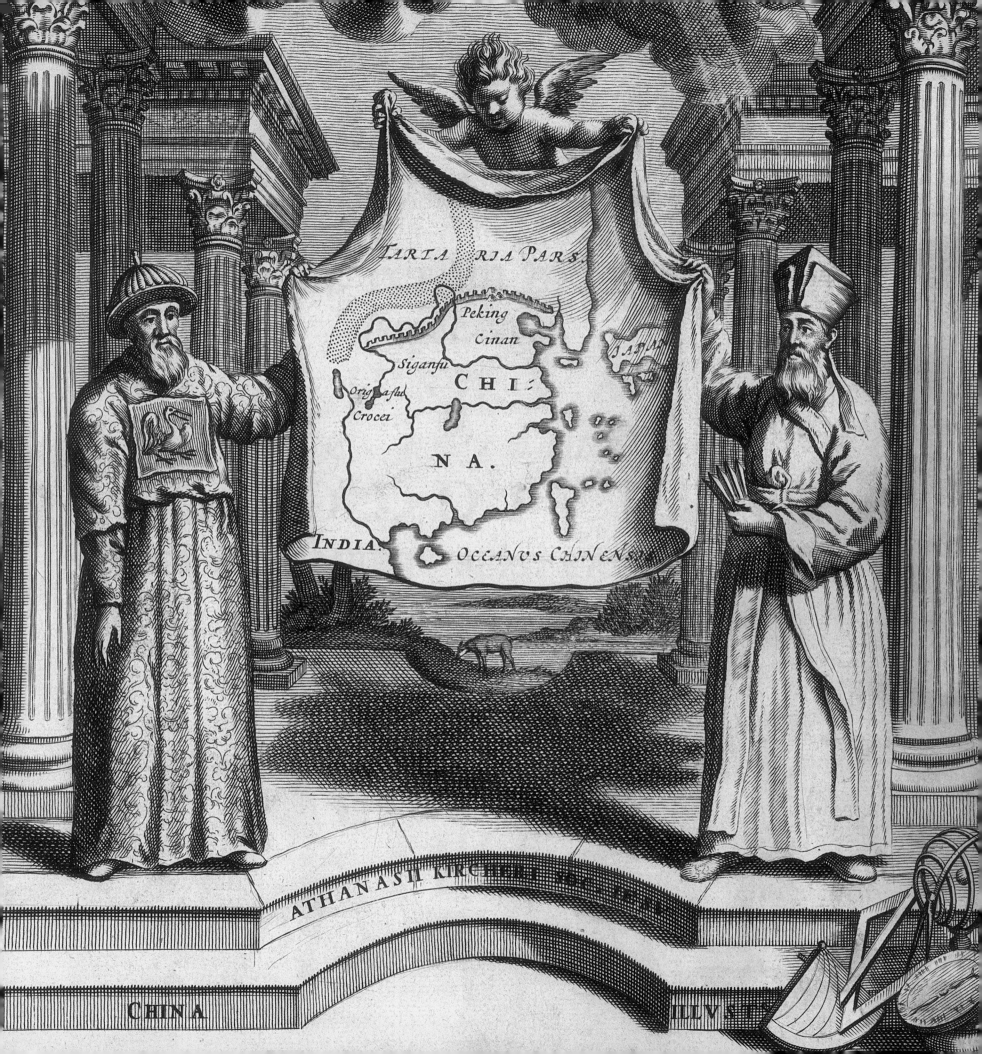

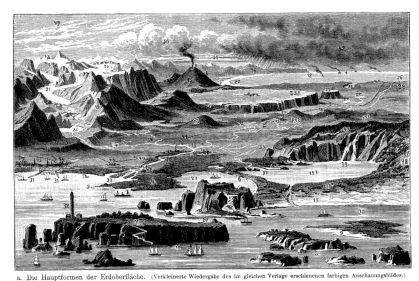

a. Die Hauptformen der Erdoberfläche. (Verkleinerte Wiedergabe des im gleichen Verlage erschienenen farbigen Anschauungsbildes.)

1. Gesichtskreis (Horizont). — 2. Insel. — 3. Inselmeer (Archipelagus). — 4. Halbinsel. — 5. Landzunge. — 6. Landenge. — 7. Klippen. — 8. Flachinsel. — Flachküste. — 10. Steilküste. — 11. Dünen. — 11a. Nehrung. — 11b. Haff. — 12. Kap. — 13. Hügel. — 13b. Hügelland und Wasserscheide. — 14. Berg. — 15. Vulkan. — 15a. Gipfel u. Krater des Vulkans, b. Abhang, c. Fuß des Berges. — 16. Bergkette (Seealpen). — 17. Einsattelung und Paß. — 18. Vorberge. — 19. Voralpen. — 20. Hochalpen mit Schneefeld. — 21. Gletscher. — 22. Ebene und Tiefland. — 23a. Tafelland. — 23 b. Tafelberg. — 24. Binnensee (Flußsee). — 25. Gebirgssee. — 26. Meer. — 27. Meerbusen. — 28. Bucht. — 29. Meerenge. — 30. Sund. — 31. Hafendamm. — 32. Leuchtturm. — 33. Quelle und Quellgebiet. — 34. Nebenfluß. — 35. Wiesenland. — 35a. Rechtes Flußufer. — 35b. Linkes Flußufer. — 36. Unterlauf. — 37. Mündung. — 38. Delta. — 39. Wasserfall. — 40. Landstraße. — 41. Eisenbahn. — 42. Eisenbahnbrücke. — 43. Tunnel. — 44. Hafen. — 45. Stadt. — 46. Dorf. — 47. Nadelwald. — 48. Laubwald. — 49. Federwolken. — 50. Haufenwolken. — 51. Schichtwolken. — 52. Regenwolken.

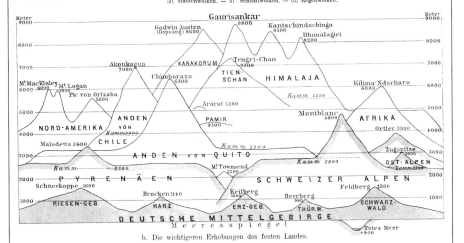

b. Die wichtigeren Erhebungen des festen Landes.

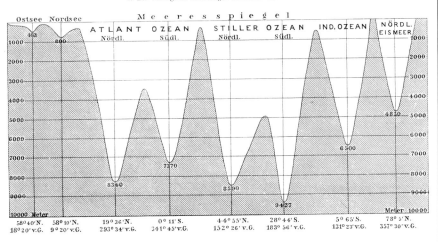

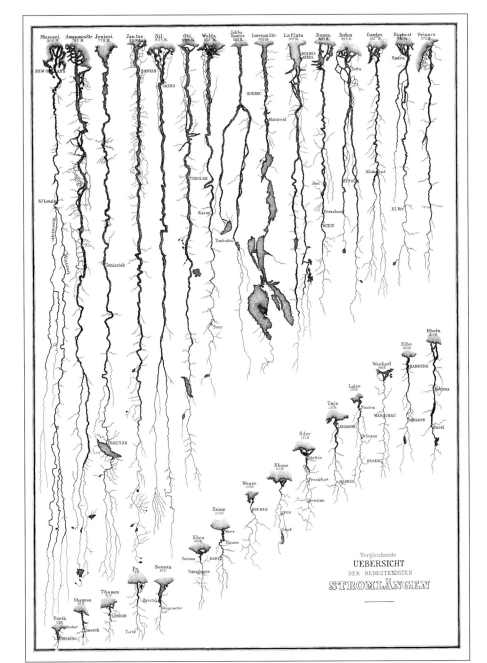

Vergleichende
UEBERSICHT
DER BEDEUTENDSTEN
STROMLÄNGEN

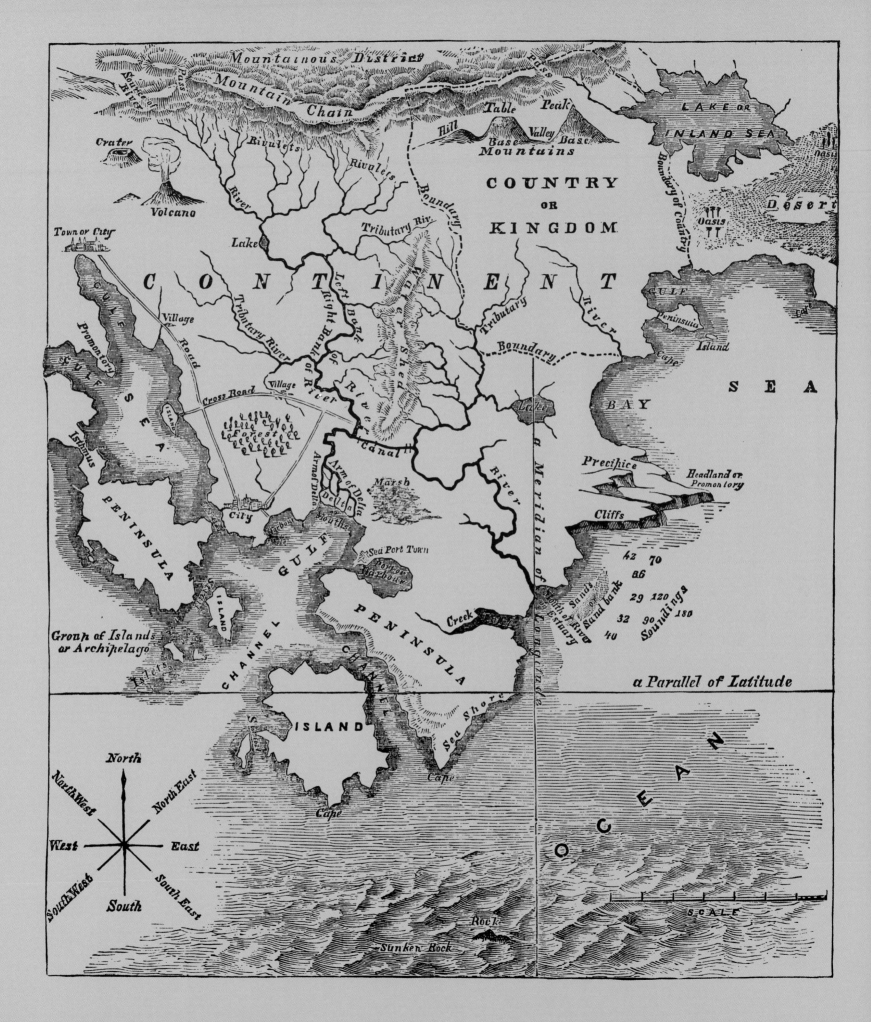

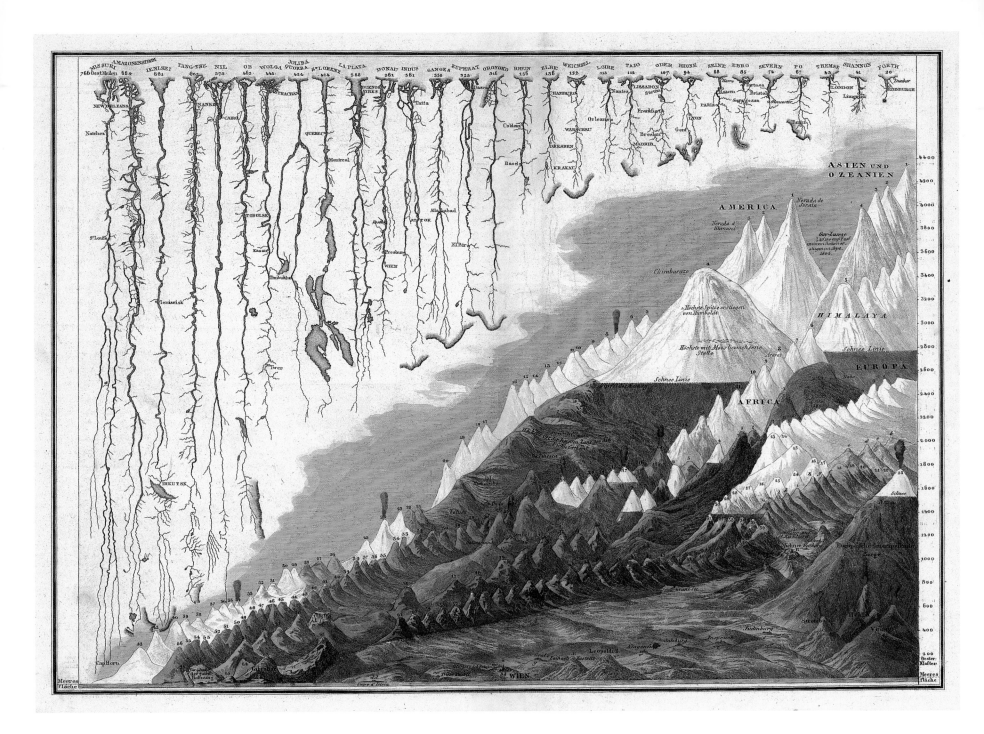

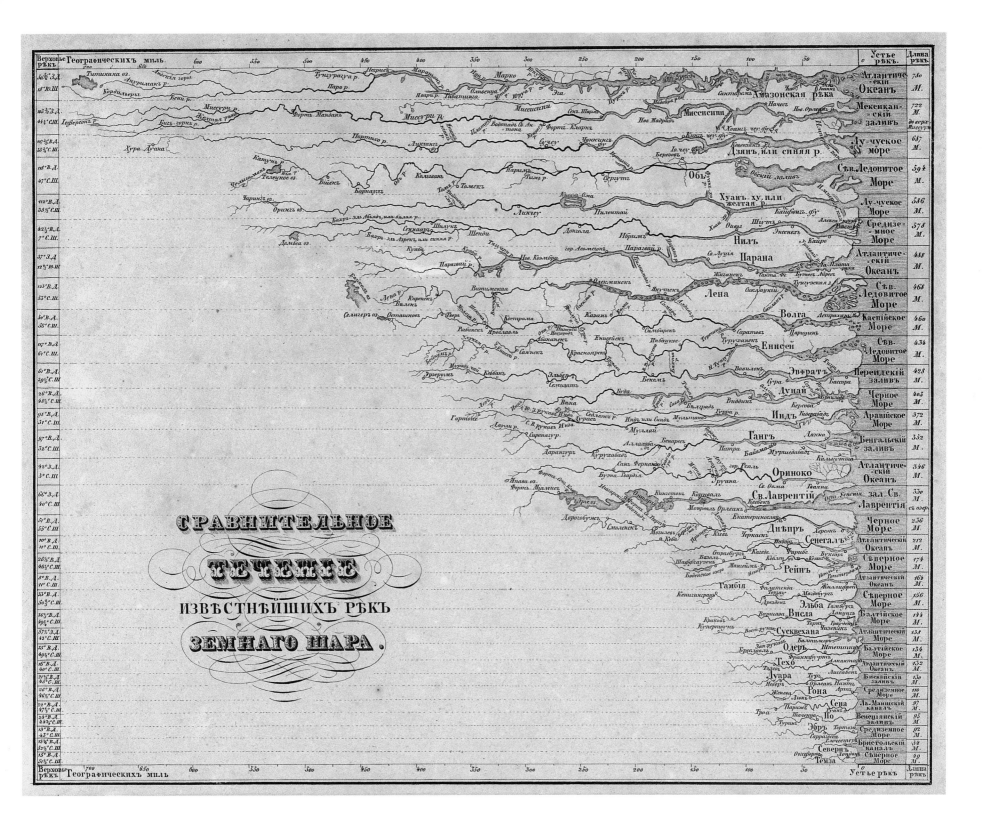

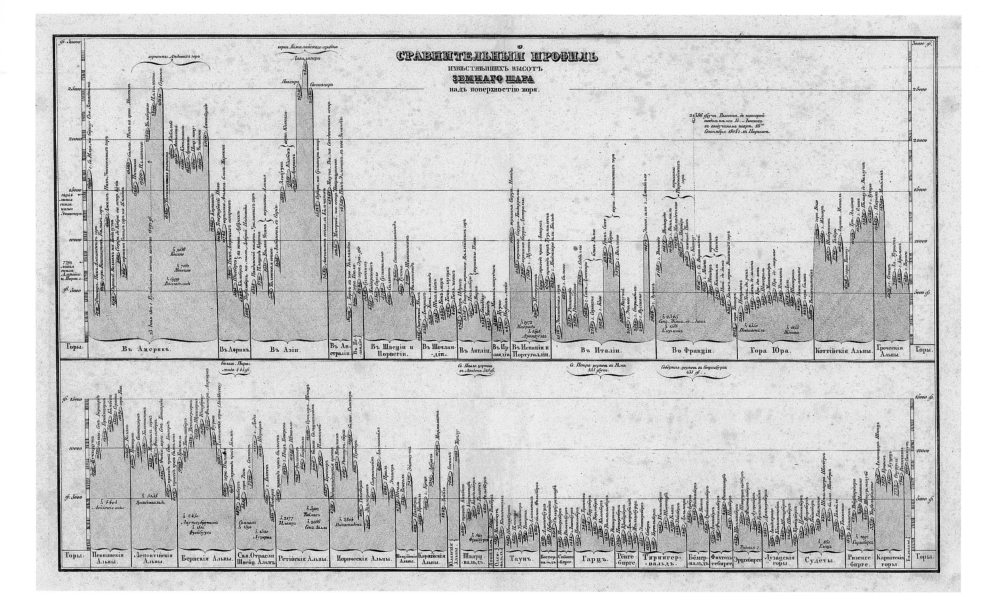

СРАВНИТЕЛЬНЫЙ ПРОФИЛЬ
ИЗВѢСТНѢЙШИХЪ ВЫСОТЪ
ЗЕМНАГО ШАРА
надъ поверхностію моря.

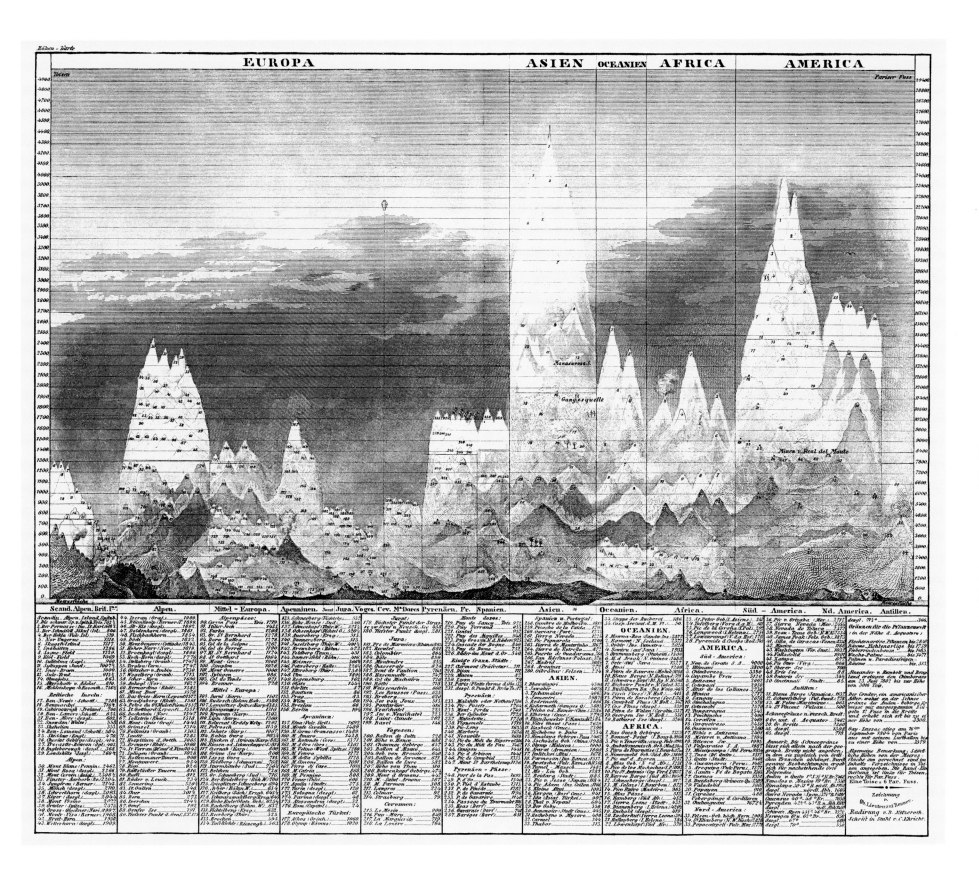

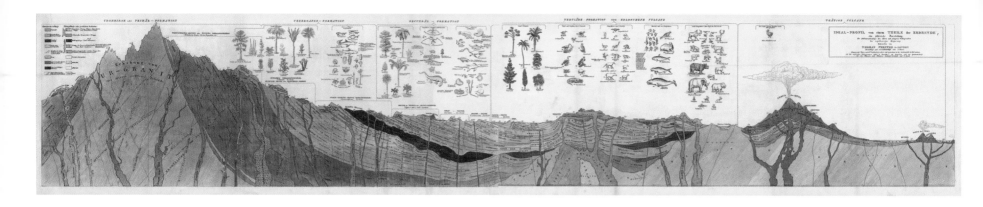

See-Thiere u.Pflanzen

14 Acanthodes. F.
15 Catopterus. F.
16 Amblypterus. F.
17 Orodus. storbener Hai. F.

19. Zähne von Psammodus, aus Kalkstein in Derbyshire
19' Zähne von Orodus, aus Bergkalk bei Bristol
20 Calymene.F.
21 Paradoxus.F. } Trilobiten.
22 Asaphus.F.

18 ...on Phillippi, ...son Hai. L.
18' Gaumen-Zähne v.Cest.Phill.L.
19 19'
20
21
23 ...halus. F.
Spirifer. F.
22
24
25 Actinocrinites.F.
...acta. F.
Platycrinites. F. 27
28 29
Turbinolia. L.u.F. 26
30 27a
Astrea. L.u.F.
...altem Sandst: in Schweden.
Fucoides circinatus. F.

Land-Pflanzen

Baumartiges Farrnkraut.
Pteris aquilina.L. Pecopteris.F.
31 Pinus.L.u.F.
37
38
39
Scolopendrium.L. Taeniopteris im Oolith bei Scarborough.F.
32 Thuia.L.u.F.
Cycas circinalis.L. Cycadites.F.
33
36 Dracaena.L. verwandt mit Bucklandia u.Clathraria.F.
35 Zamia horrida.L. Zamia.F.
34 Cycas revoluta.L. Cycadites.F.

Säugethiere, Reptilen und Insecten

Pterodactylus brevirostris.F. 42
Buprestis.I. Stonesfield.F. 48
Libellula.L. Solenhofen.F. 49
Pterodactylus crassirostris.F. 43
Didelphys.L. b.Stonesfield in Schiefer zwei kleine Species.F.
40
46 Testudo Land Schildkröte.L. Schildkrösten Schalen b.Stonesfield Oxon.F. Fussstapfen v.Schildkröt.bei Dumfries.F.
41 Didelphys.L. Cheirotherium? F.
44 Gavial.L. verwandt mit Teleosaurus.F.
47 Emys.L. Solothurn.F.
Jguana.L. Jguanodon.F. 45
Ammonites Bucklandi.F. Der Lias eigenthümlich

See-Thiere u.Pflanzen

56 Loligo.L. Lyme Regis.F.
57 Nautilus Pom... manche Spec...
53 Pygopterus im Zech...
54 Dapedium im Lias.F.
55 Hybodu... (Ideale Ergänz.)
50 Plesiosaurus.F.
52 Meer Schildkröte.L. bei Luneville im Muschelkalk.F.
51 Jchthyosaurus.F.
62 Ophiura. L.u.F.
63 Asterias.L.u.F.
64 Echinus.L.u.F.
61 Trigonia.F. New-Holland.L.
58
65a 65
59 Astacus L.u.F.
60 Limulus Königskrebs. Solenhofen.F.
Fucoides recurvus.F.
Apiocrinites.F.

LIN-KOHLEN-GRUPPE (KOHLENGEBIRGE) (Carboniferous System)

GRUPPE des NEUERN- oder BUNTEN-SANDSTEINS (Upper-new-red-System)

OOLIT-GRUPPE (Oolitic System)

KREIDE-GRUPPE (Cretaceous Syste...)

13 Steinkohlen Ablagerung
Millstone Grit
14 TRACHYT
f 3
c 1
15 KALKBÜHLE
16
17 BASALT-KUPPE f 4
Braunkohlen
19
20
21 f 5
22 23 f 5' 24
Kalkschloten

BERG- MÜHLSTEIN-SAND
KOHLEN-ÜBER... KOHLENSANDSTEIN
(Magnesian Limestone)
DOLOMITISCHER KALK
(Shell Limestone)
(Variegated Sandstone) BUNTER SANDSTEIN
(Lias) LIAS
OOLITHEN- (Oolite)
Green Sand
KREIDE
JURA...
MUSCHELKALK
KEUPER
Gyps u.Salzstöcke
Gyps u.Salzstock

ALTER ROTHER SANDSTEIN
Old red Sandstone
(auch Grauwackensandstein)
Mountain Limestone
(Ludlow Shale)
(Transition Limestone)
(Quartzite)
ROTHES TODTLIEGENDES (Conglomerate)
ROTHES CONGLOMERAT oder Sandstone
GRAUWACKEN- oder ÜBERGANGS-KALK

THON-SCHIEFER (Clay Slate)
ÜBERGANGSCONGL...
(Grauwacke Slate and Sandstone)
(Transition Conglomerates)
Calcaire Metal...

TRAP
Grauwacke
THON-SCHIEFER

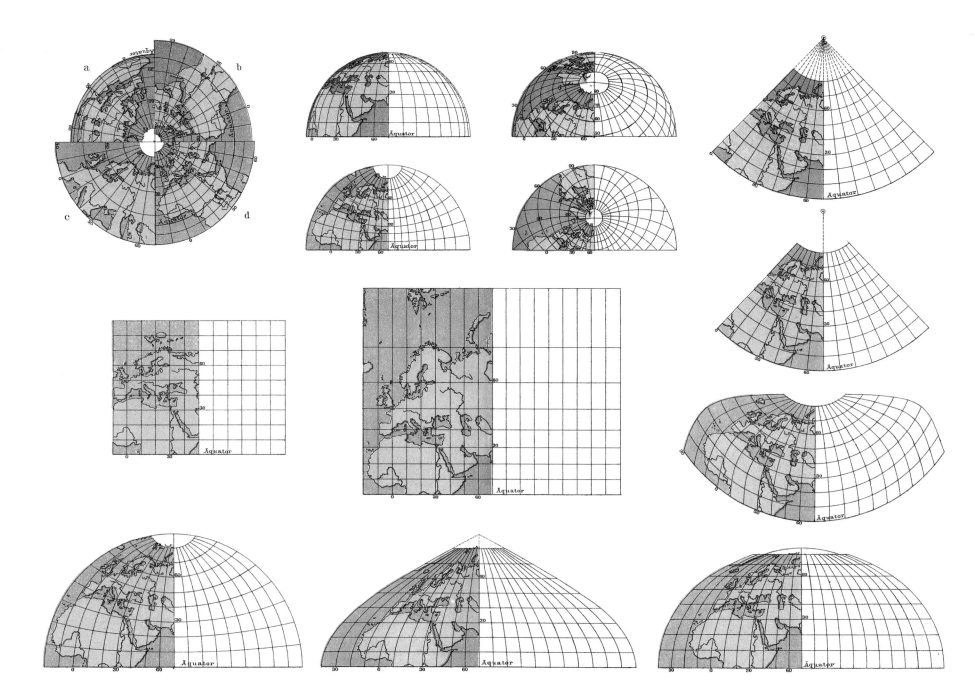

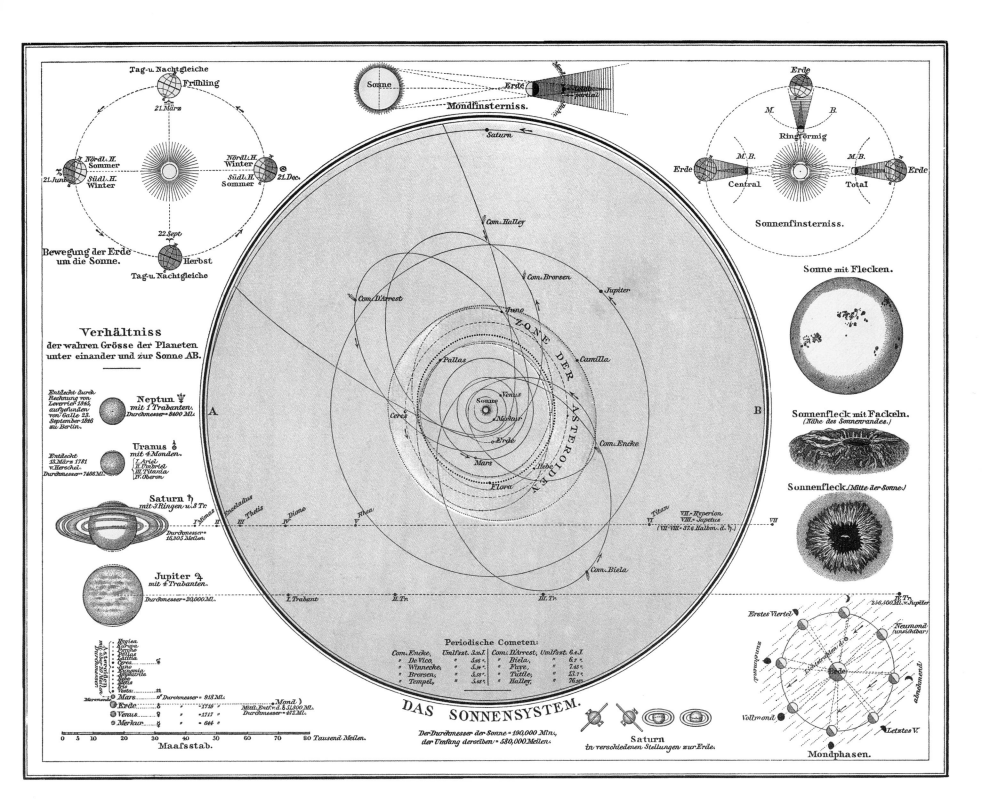

Tag-u. Nachtgleiche
Frühling
21.März

Nördl. H. Sommer
21.Juni
Südl. H. Winter

Nördl. H. Winter
21.Dec.
Südl. H. Sommer

22.Sept.
Herbst

Bewegung der Erde um die Sonne.

Tag-u. Nachtgleiche

Sonne

Erde

Mondfinsterniss.

Erde
M. B.
Ringförmig
Erde Central Erde Total

M. B. M. B.

Sonnenfinsterniss.

Sonne mit Flecken.

Sonnenfleck mit Fackeln.
(Nähe des Sonnenrandes.)

Sonnenfleck (Mitte der Sonne.)

Verhältniss
der wahren Grösse der Planeten unter einander und zur Sonne AB.

Entdeckt durch Rechnung von Leverrier 1845, aufgefunden von Galle 23. September 1846 zu Berlin.
Neptun ♆ mit 1 Trabanten.
Durchmesser = 8400 Ml.

Entdeckt 13.März 1781 v.Herschel. Durchmesser = 7406 Ml.
Uranus ♅ mit 4 Monden.
I. Ariel
II. Umbriel
III. Titania
IV. Oberon

Saturn ♄ mit 3 Ringen u. 8 Tr.
Durchmesser 16,305 Meilen.

Jupiter ♃ mit 4 Trabanten.
Durchmesser = 20,000 Ml.

Hygiea
Iris
Psyche
Pallas
Ceres
Juno
Eugenia
Amphitrite
Hebe
Iris
Flora
Vesta
Asteroiden mit über 20 Millen Durchmesser

Marsmonds
Mars ♂ Durchmesser = 918 Ml.
Erde ♁ " = 1719 "
Venus ♀ " = 1717 "
Merkur ☿ " = 644 "

Mond ☽
Mittl. Entf. v. d. E. 51,800 Ml.
Durchmesser = 472 Ml.

0 5 10 20 30 40 50 60 70 80 Tausend Meilen.
Maassstab.

Com. Halley
Com. Brorsen
Jupiter
Com. D'Arrest
Juno
ZONE DER ASTEROIDEN
Camilla
Pallas
Venus
Sonne
Ceres
Merkur
Erde
Com. Encke
Mars
Hebe
Flora
Com. Biela
Saturn

Enceladus
Thetis
I Mimas II III IV Dione V Rhea Titan VI VII=Hyperion VIII=Japetus VII
(VII-VIII= 37.6 Halbm. d. ♄.)

I. Trabant II. Tr. III. Tr. IV Tr. 230,500 Ml. v. Jupiter

Periodische Cometen:

Com. Encke,	Umlfszt. 3.3 J.	Com. D'Arrest,	Umlfszt. 6.4 J.
De Vico,	" 5.46 "	Biela,	6.7 "
Winnecke,	" 5.3 "	Faye,	7.45 "
Brorsen,	" 5.5 "	Tuttle,	13.7 "
Tempel,	" 5.68 "	Halley,	76.16 "

DAS SONNENSYSTEM.

Der Durchmesser der Sonne = 190,000 Mln, der Umfang derselben = 580,000 Meilen.

Saturn
in verschiedenen Stellungen zur Erde.

Erstes Viertel
Neumond (unsichtbar)
zunehmend
Erde
Lichtstrahlen die
abnehmend
Vollmond
Letztes V.

Mondphasen.

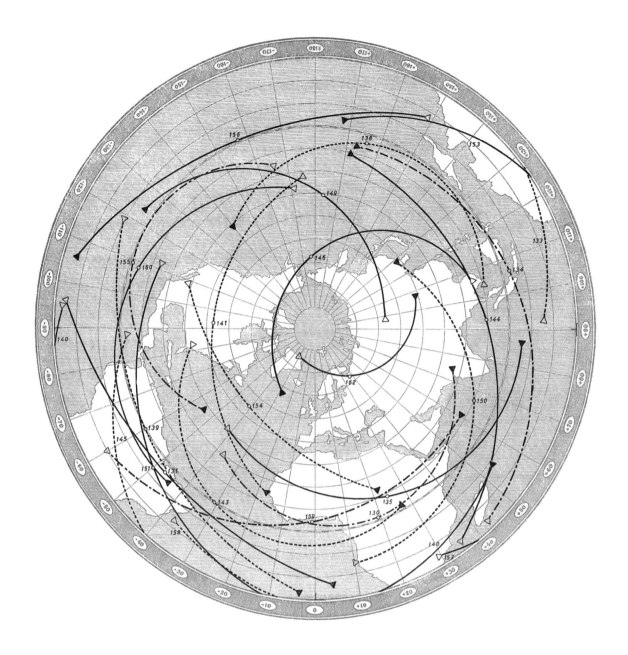

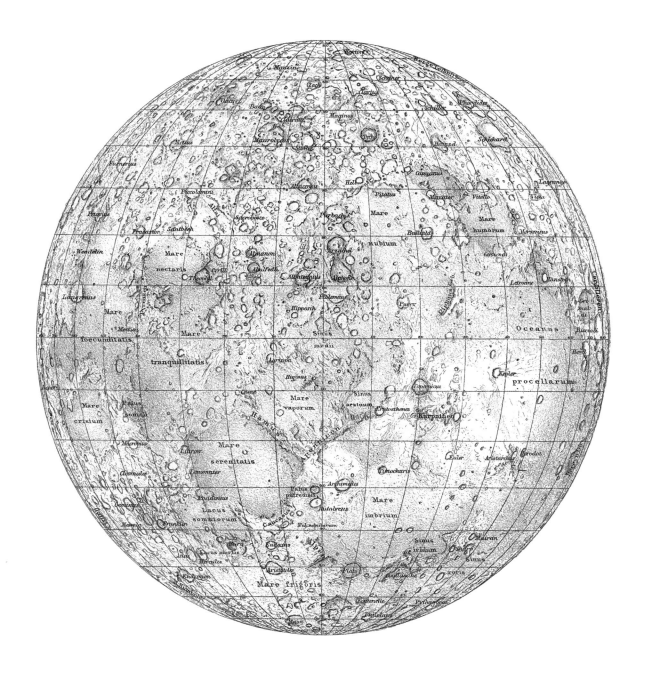

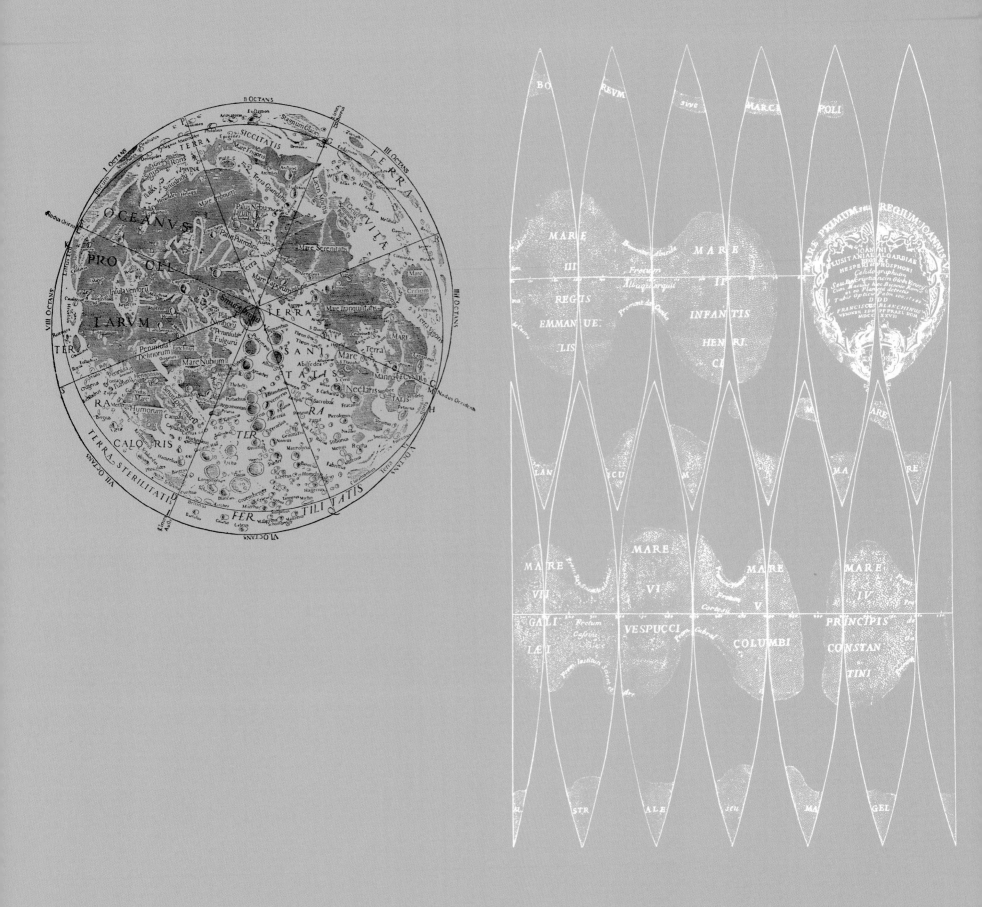

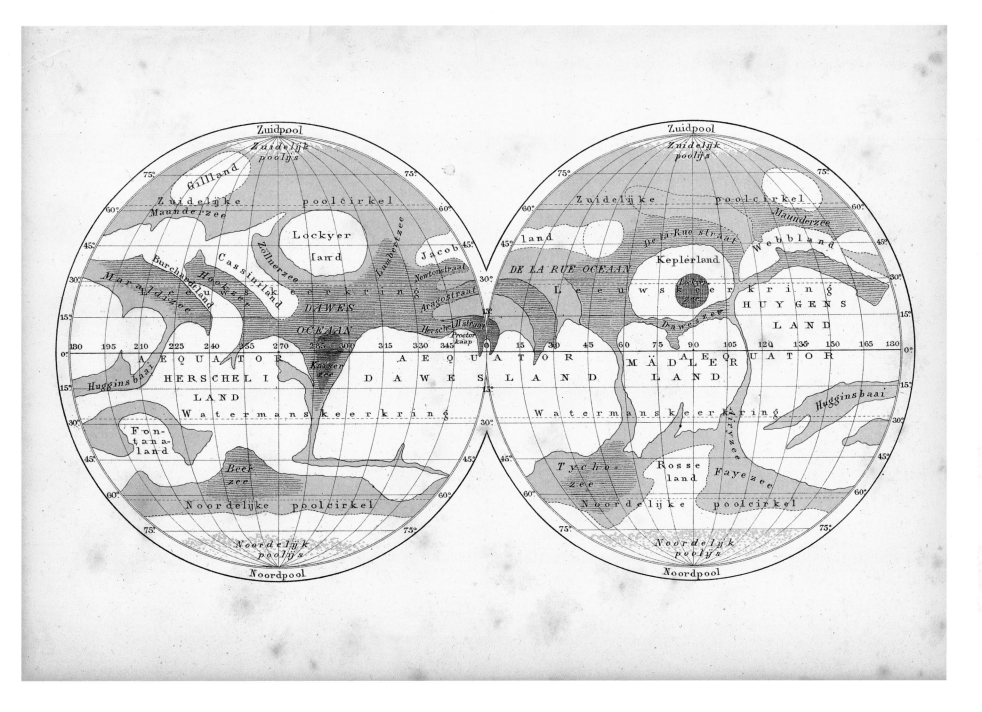

23

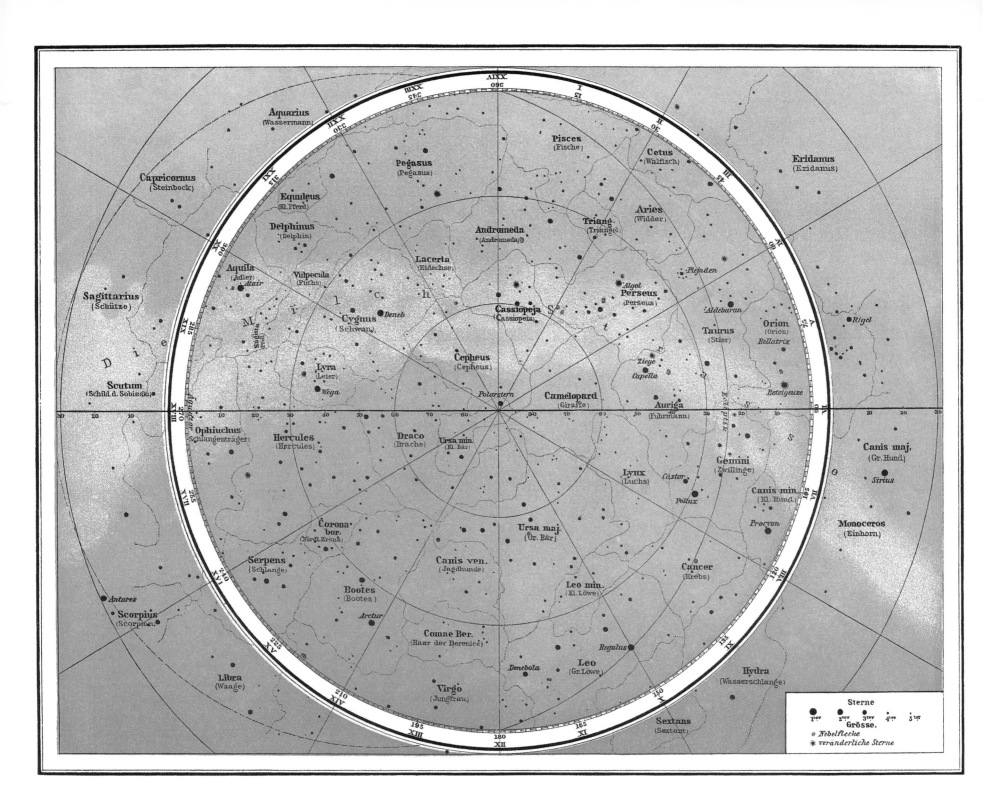

24

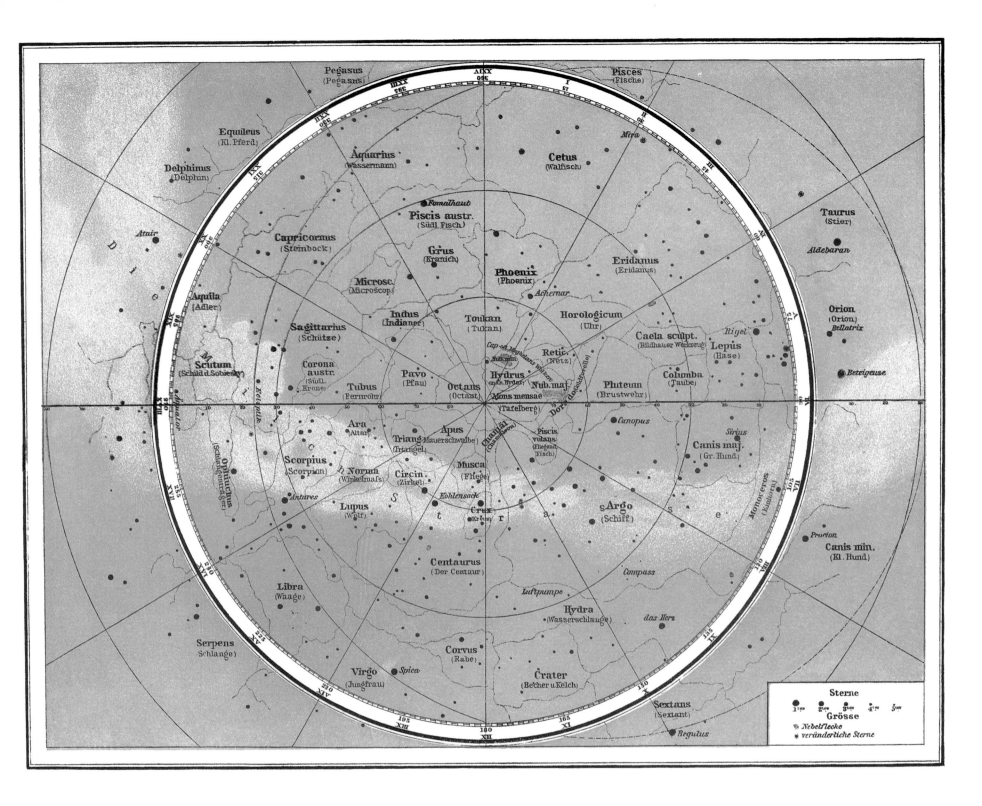

25

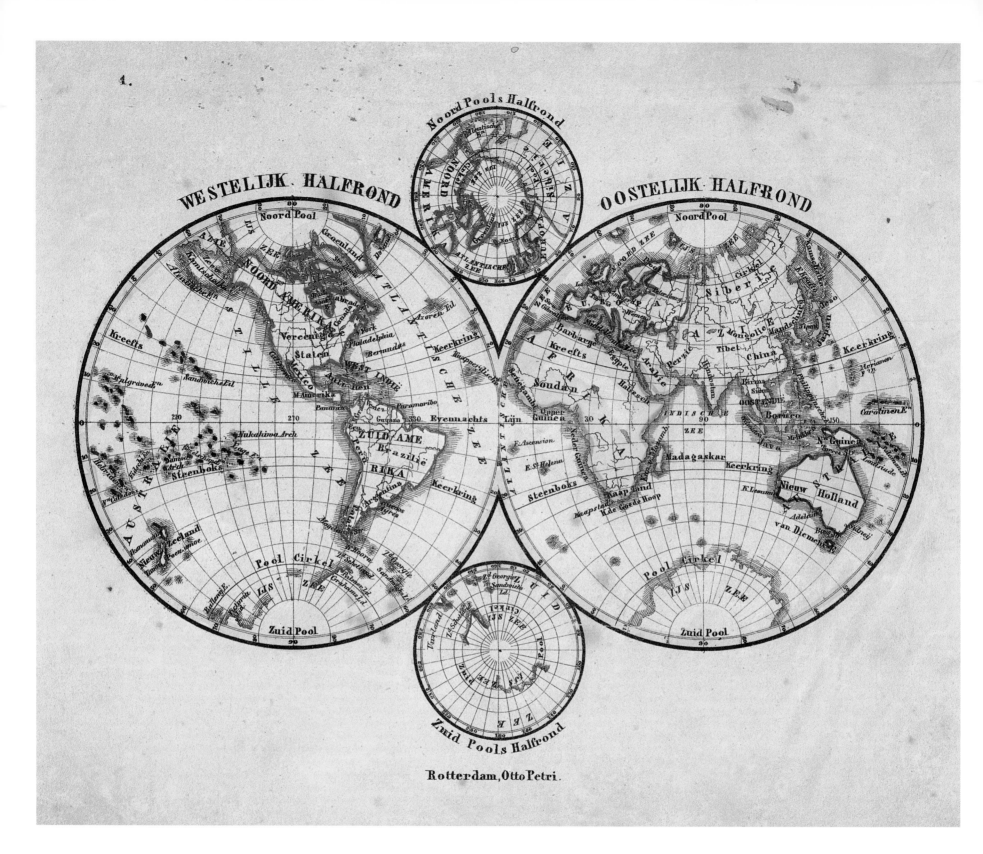

WESTELIJK · HALFROND

OOSTELIJK · HALFROND

Noord Pools Halfrond

Zuid Pools Halfrond

Rotterdam, Otto Petri.

26

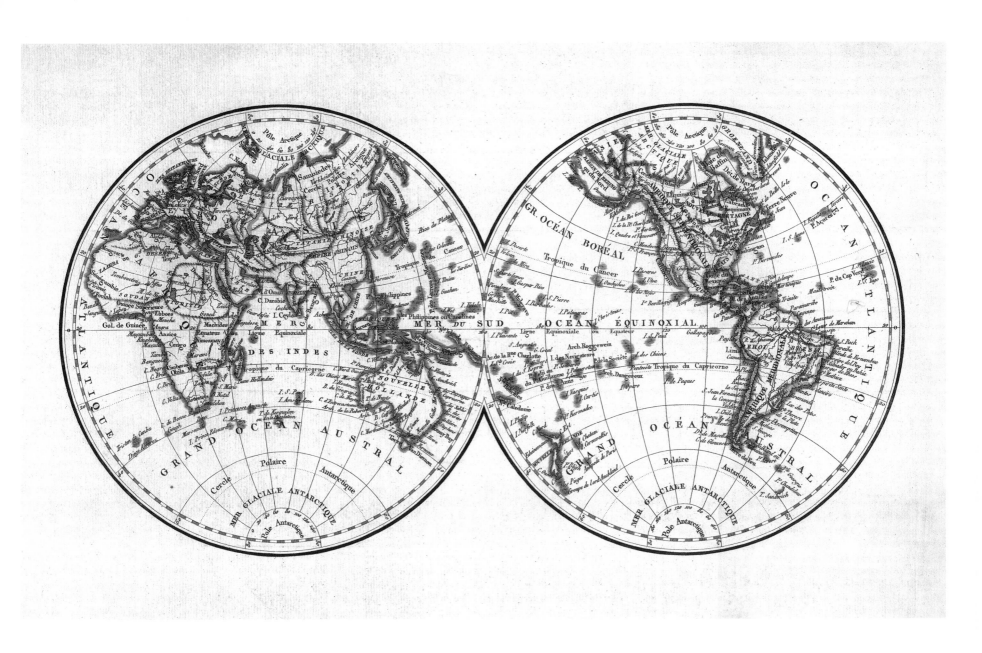

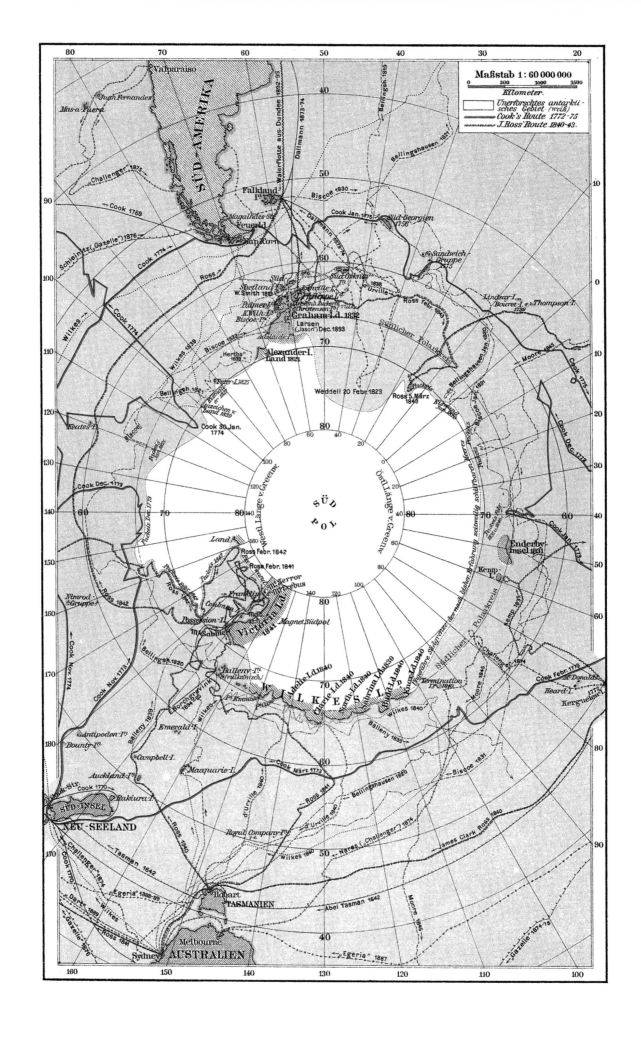

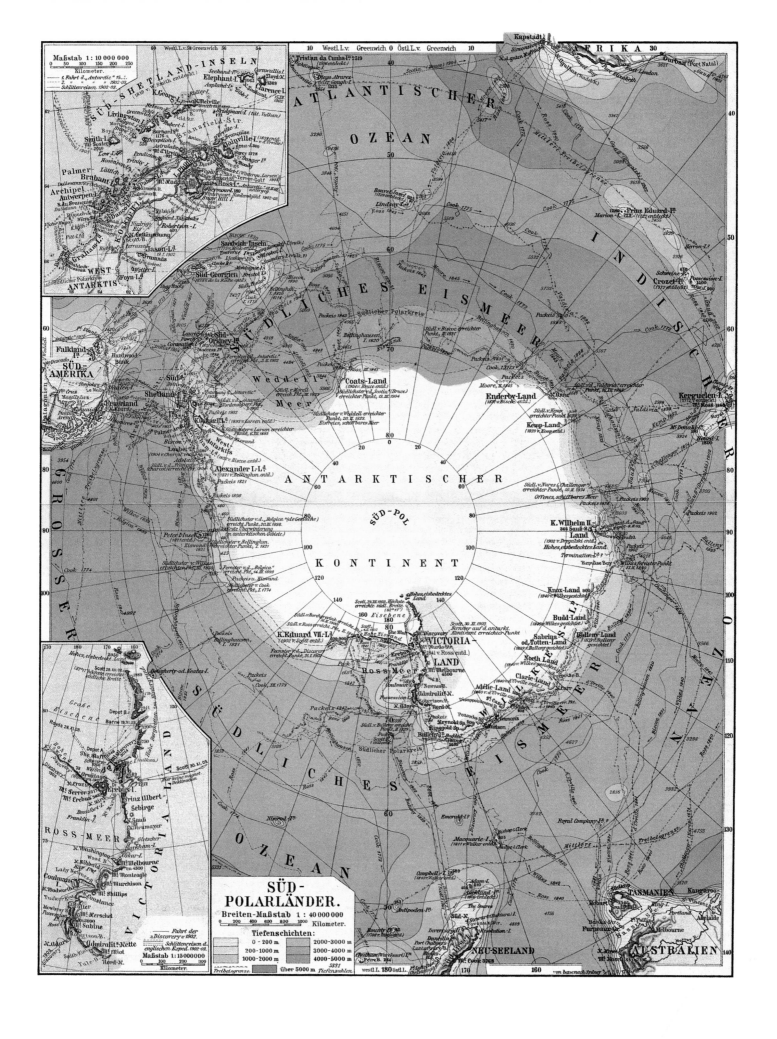

SÜD-POLARLÄNDER.

Breiten-Maßstab 1 : 40 000 000

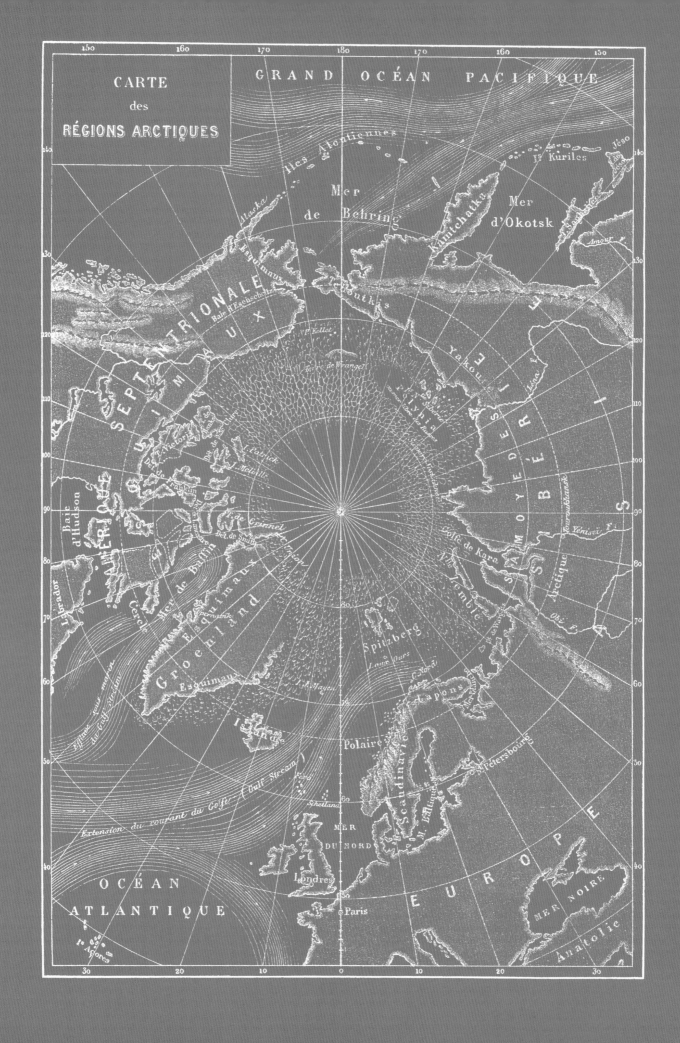

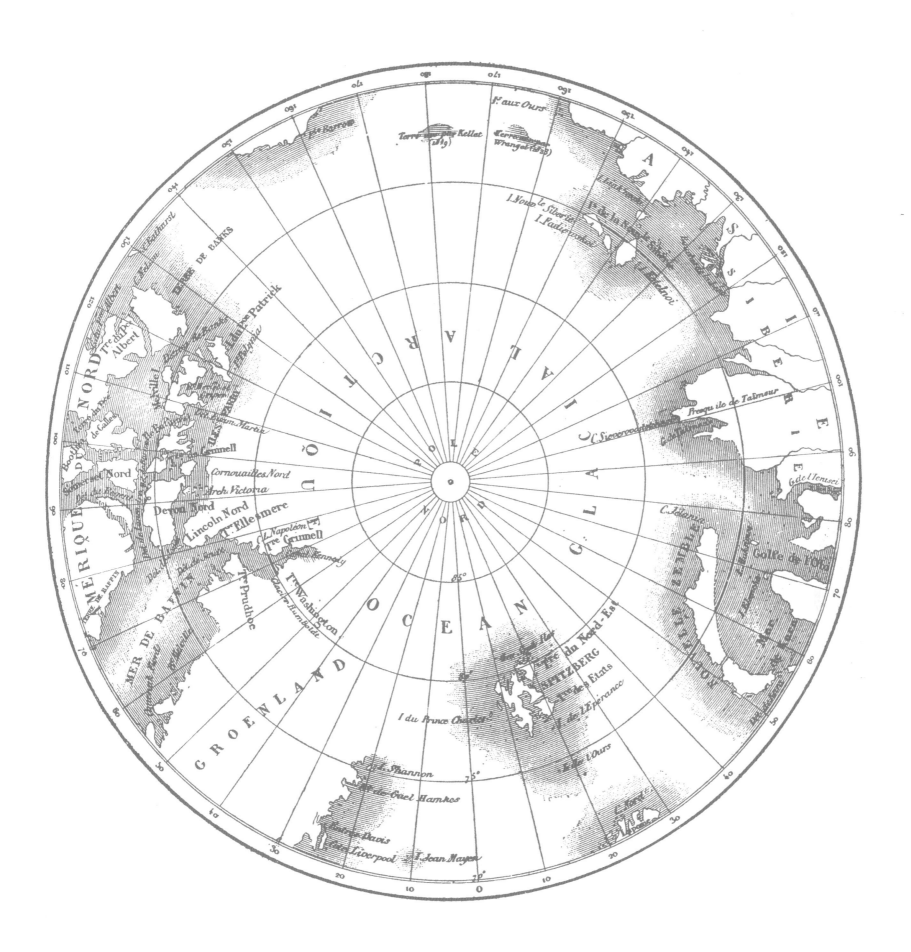

31

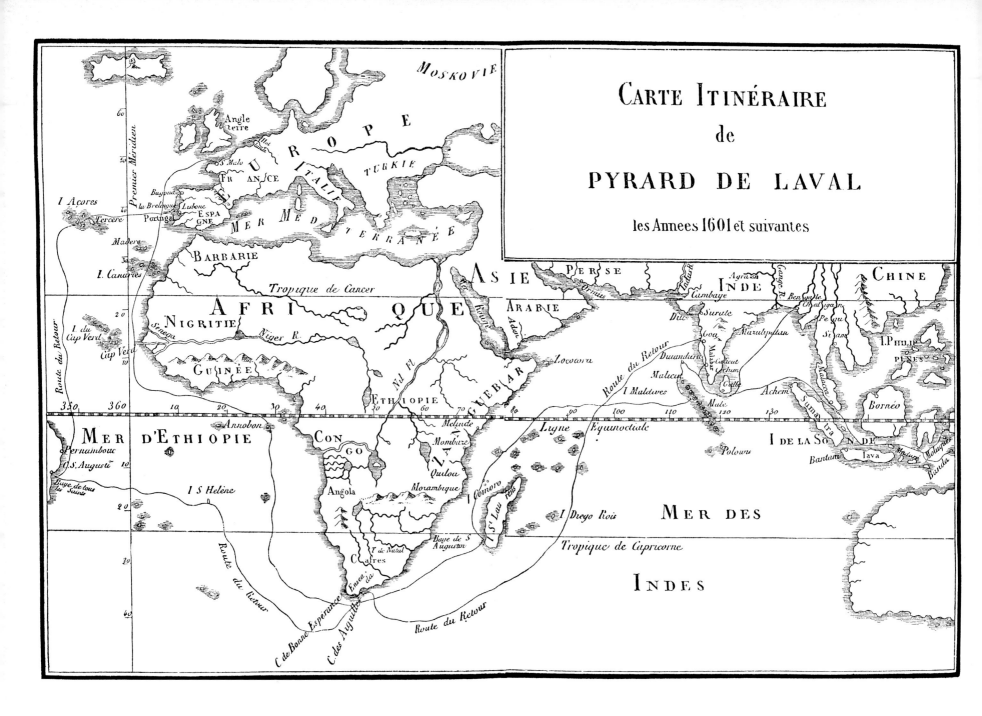

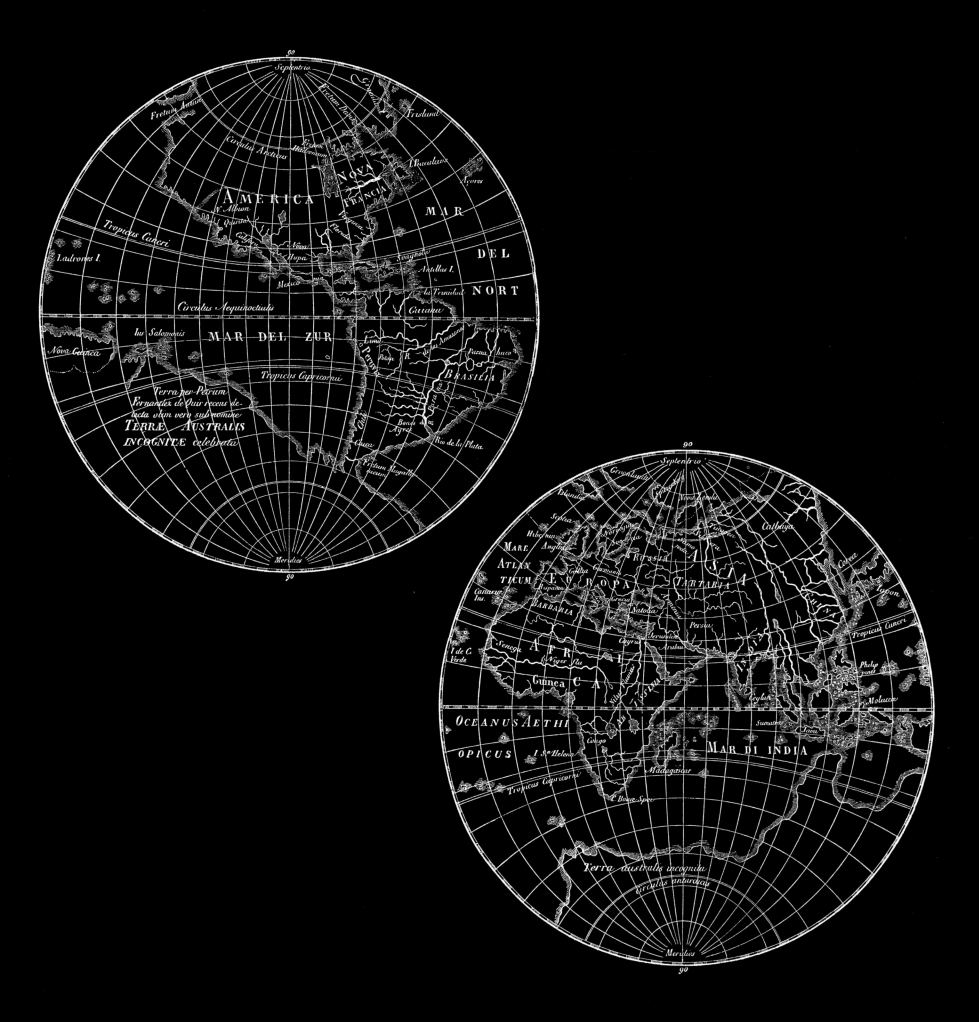

33

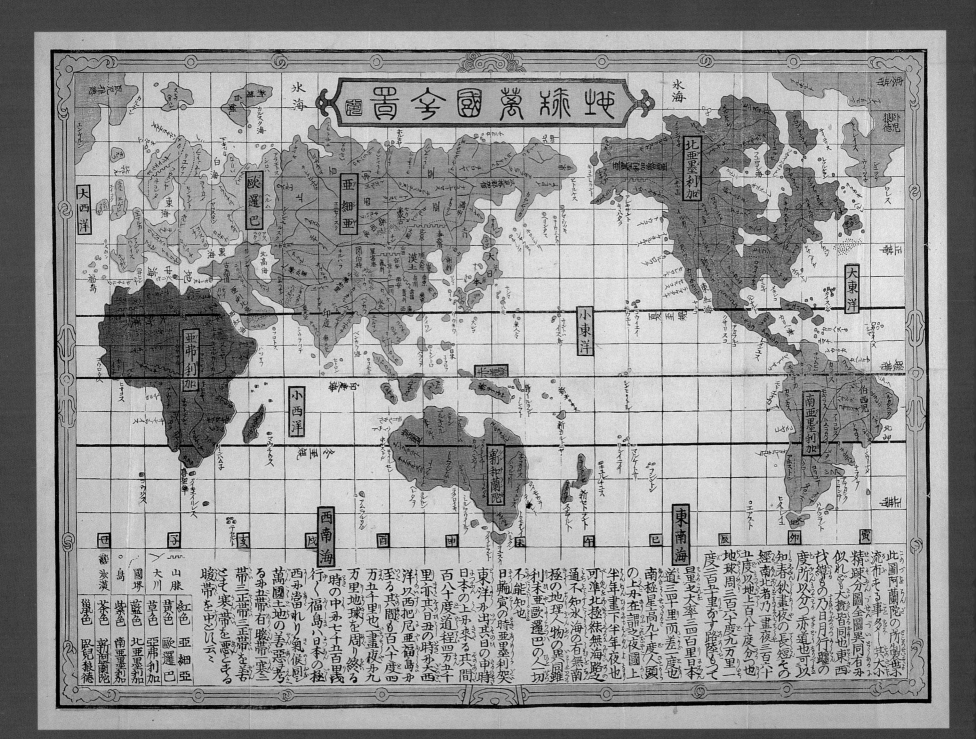

地球萬國全圖

GENERAL CARTE DER GANZEN ERDKUGEL.

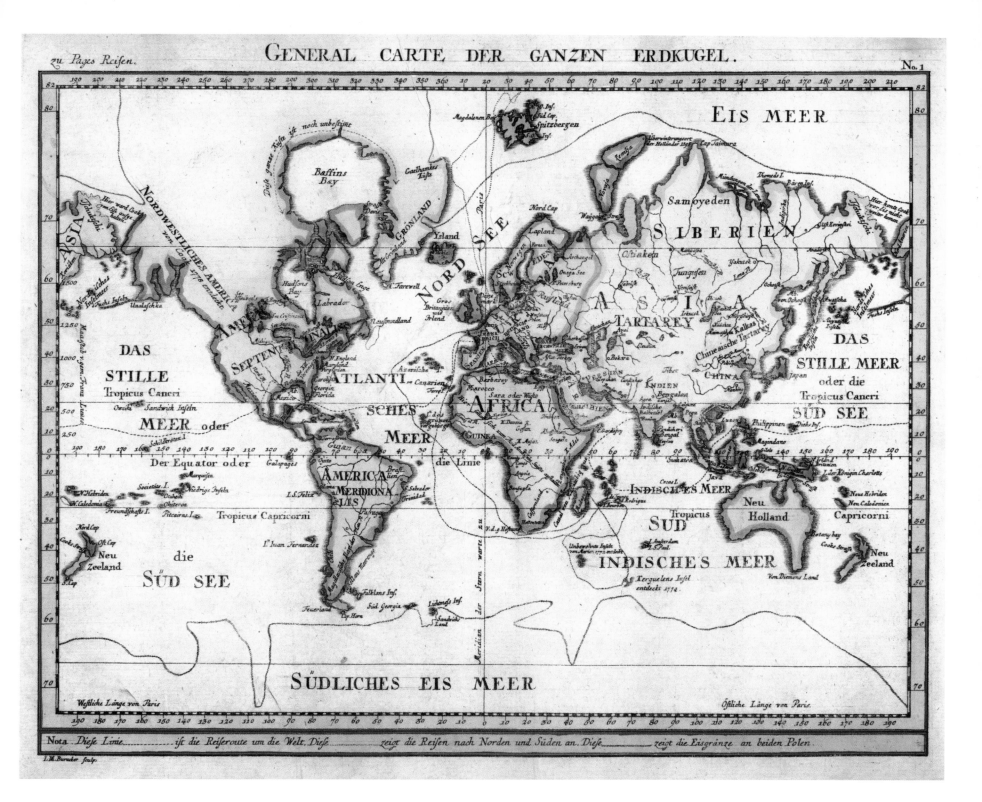

EIS MEER

Spitzbergen

NORDWESTLICHES AMERICA von Cook 1778 entdeckt

Baffins Bay

GRÖNLAND

Ysland

NORD SEE

Samoyeden

SIBERIEN

ASIA

ASIA

Hudsons Bay

Labrador

SEPTENTRIONAL

DAS STILLE
Tropicus Cancri

MEER oder

ATLANTI

SCHES

MEER

AFRICA

GUINEA

TARTAREY

Chinesische Tartarey

CHINA

INDIEN

DAS STILLE MEER oder die
Tropicus Cancri

SÜD SEE

Der Equator oder die Linie

AMERICA
MERIDIONA
LIS

INDISCHES MEER

Tropicus Capricorni

SÜD

Neu Holland

Capricorni

die SÜD SEE

Neu Zeeland

INDISCHES MEER

Neu Zeeland

SÜDLICHES EIS MEER

Westliche Länge von Paris.

Östliche Länge von Paris.

Nota. Diese Linie ist die Reiseroute um die Welt. Diese zeigt die Reisen nach Norden und Süden an. Diese zeigt die Eisgränze an beiden Polen.

I. M. Burucker sculp.

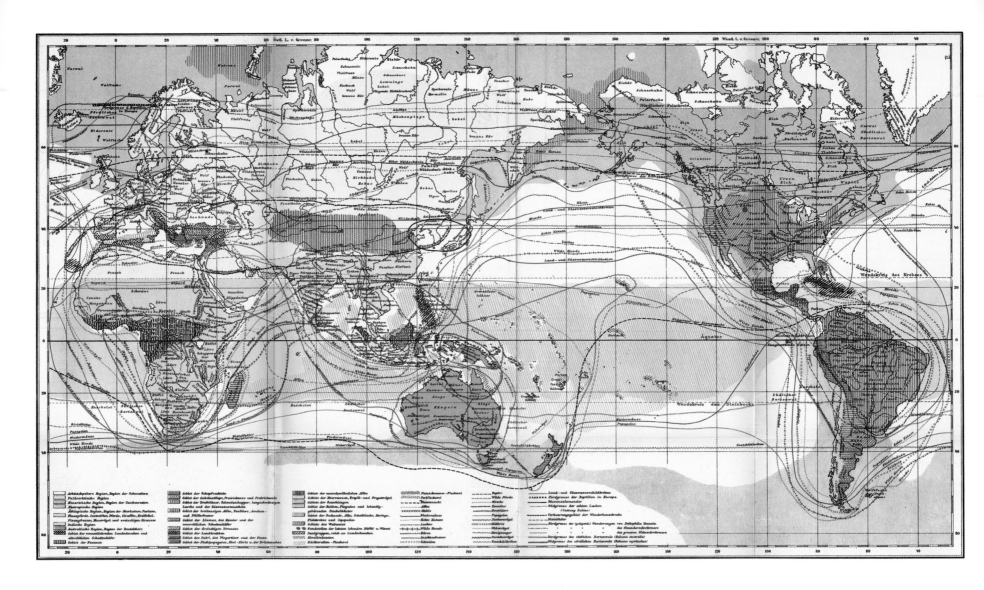

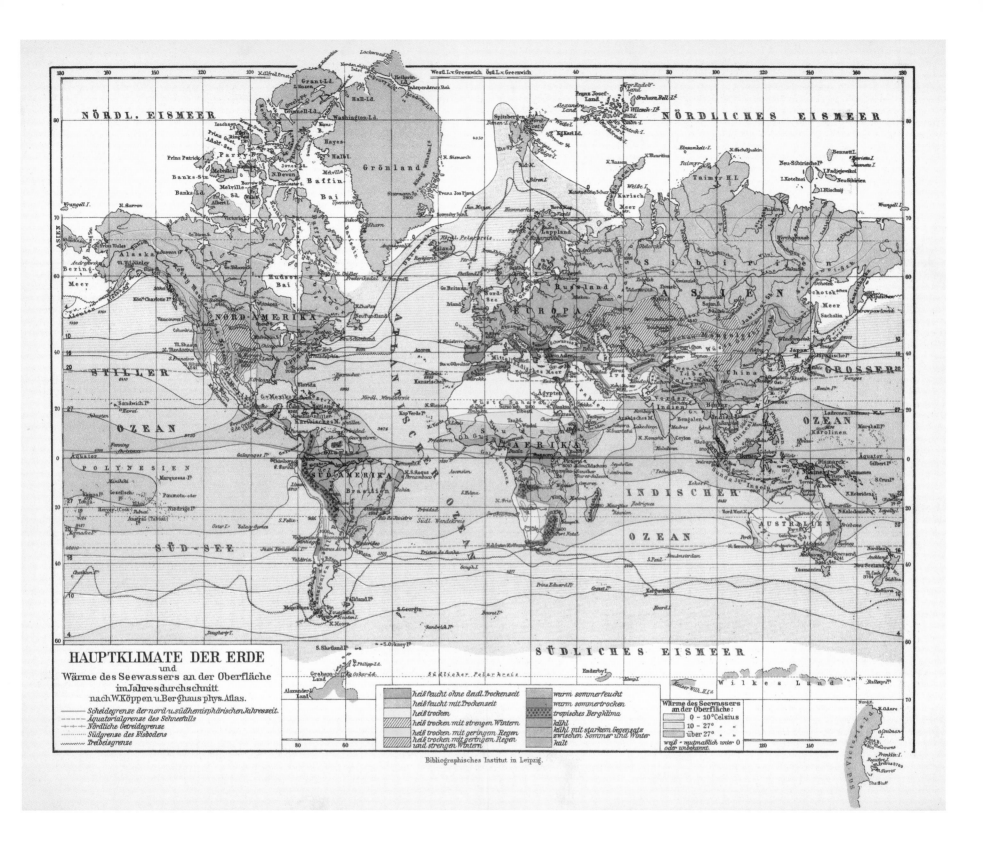

HAUPTKLIMATE DER ERDE
und
Wärme des Seewassers an der Oberfläche
im Jahresdurchschnitt
nach W. Köppen u. Berghaus phys. Atlas.

—————— Scheidegrenze der nord.u.südhemisphärischen Jahreszeit.
--------- Äquatorialgrenze des Schneefalls
-+-+-+-+- Nördliche Getreidegrenze
·········· Südgrenze des Eisbodens
~~~~~~~~ Treibeisgrenze

heiß feucht ohne deutl. Trockenzeit
heiß feucht mit Trockenzeit
heiß trocken
heiß trocken mit strengen Wintern
heiß trocken mit geringem Regen
heiß trocken mit geringem Regen und strengen Wintern

warm sommerfeucht
warm sommertrocken
tropisches Bergklima
kühl
kühl mit starkem Gegensatz zwischen Sommer und Winter
kalt

Wärme des Seewassers
an der Oberfläche:
0 – 10° Celsius
10 – 27°  "
über 27°  "
weiß = mutmaßlich unter 0
oder unbekannt

Bibliographisches Institut in Leipzig.

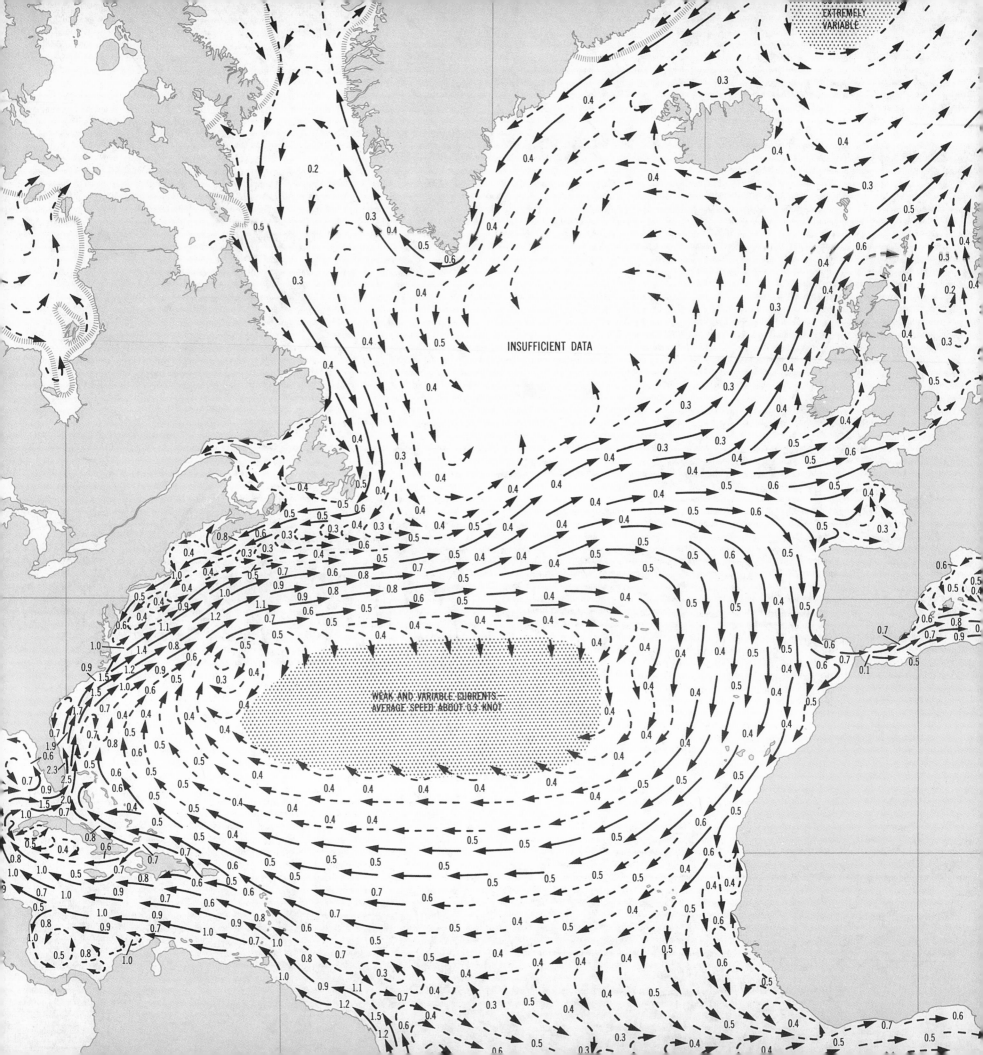

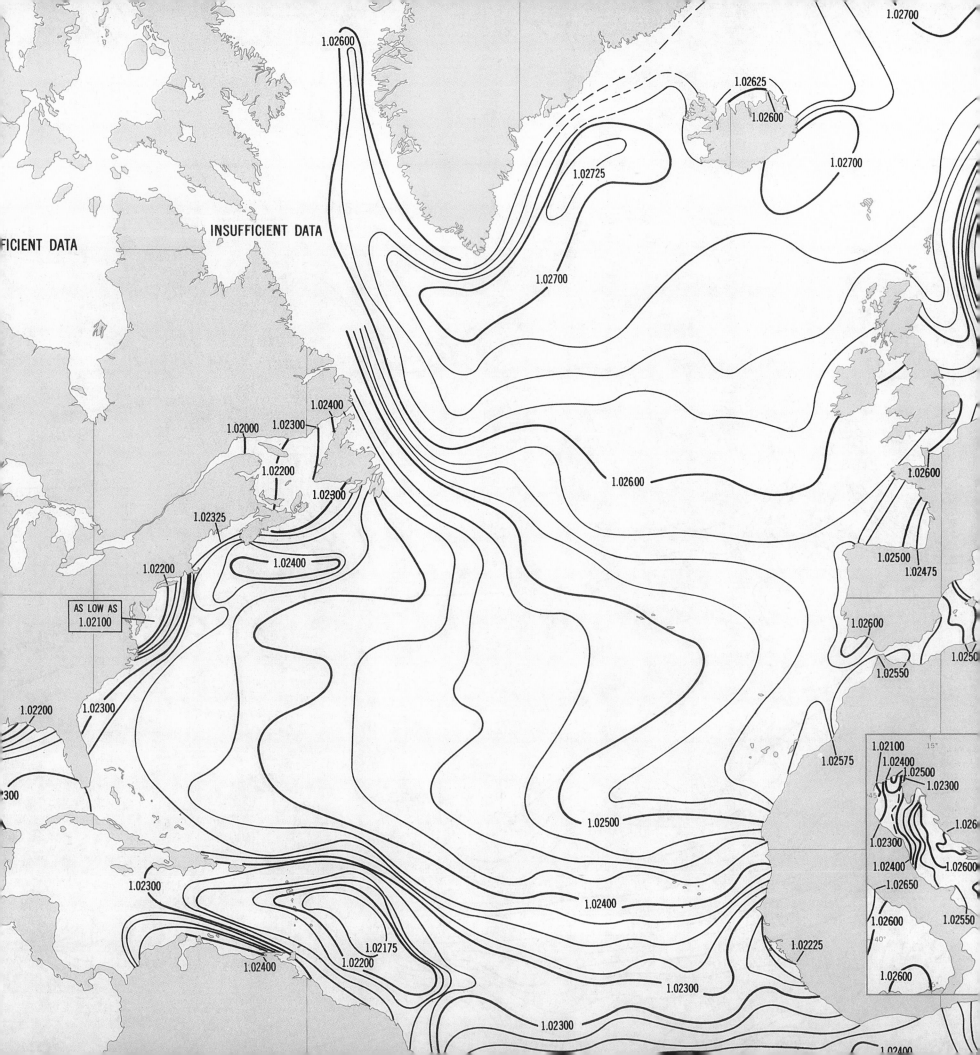

SURFACE CURRENTS      NOVEMBER

CHART 127

DENSITY      AUGUST

CHART 176

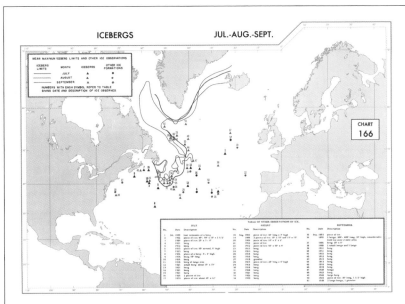

ICEBERGS      JUL.-AUG.-SEPT.

CHART 166

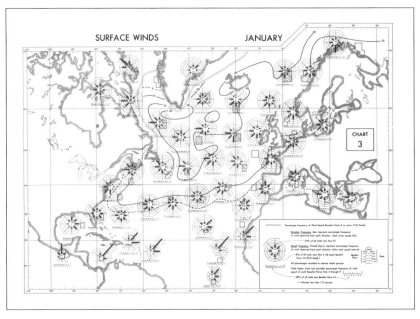

SURFACE WINDS      JANUARY

CHART 3

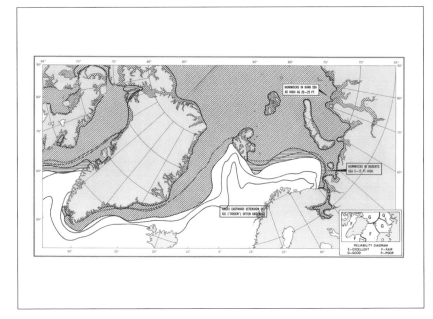

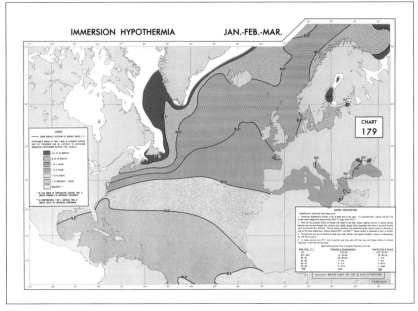

IMMERSION HYPOTHERMIA      JAN.-FEB.-MAR.

CHART 179

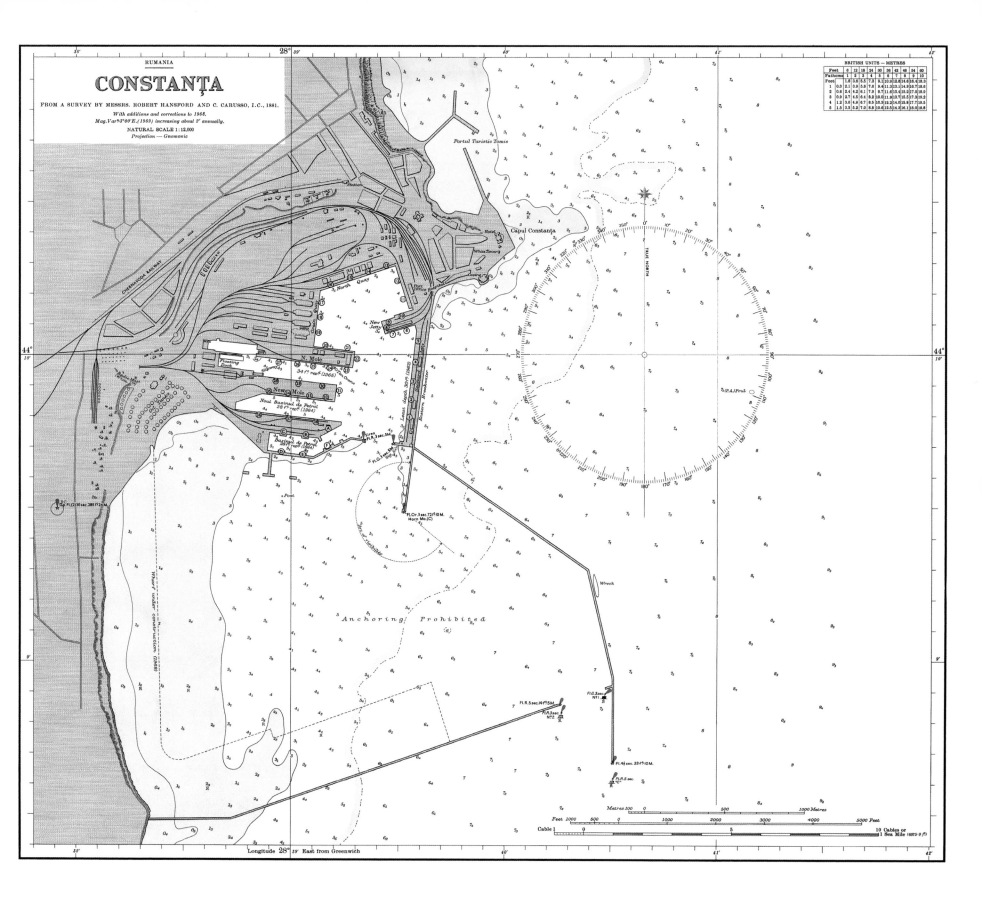

RUMANIA

# CONSTANŢA

FROM A SURVEY BY MESSRS. ROBERT HANSFORD AND C. CARUSSO, I.C., 1881.

With additions and corrections to 1968.
Mag.Var.3°00′E.(1969) increasing about 2′ annually.

NATURAL SCALE 1 : 12,000
Projection — Gnomonic

Portul Turistic Tomis

Capul Constanţa

CERNAVODA RAILWAY

N. Mole

New Mole

Noul Bazinul de Petrol

Bazinul de Petrol

Anchoring Prohibited

Wharf under construction (1968)

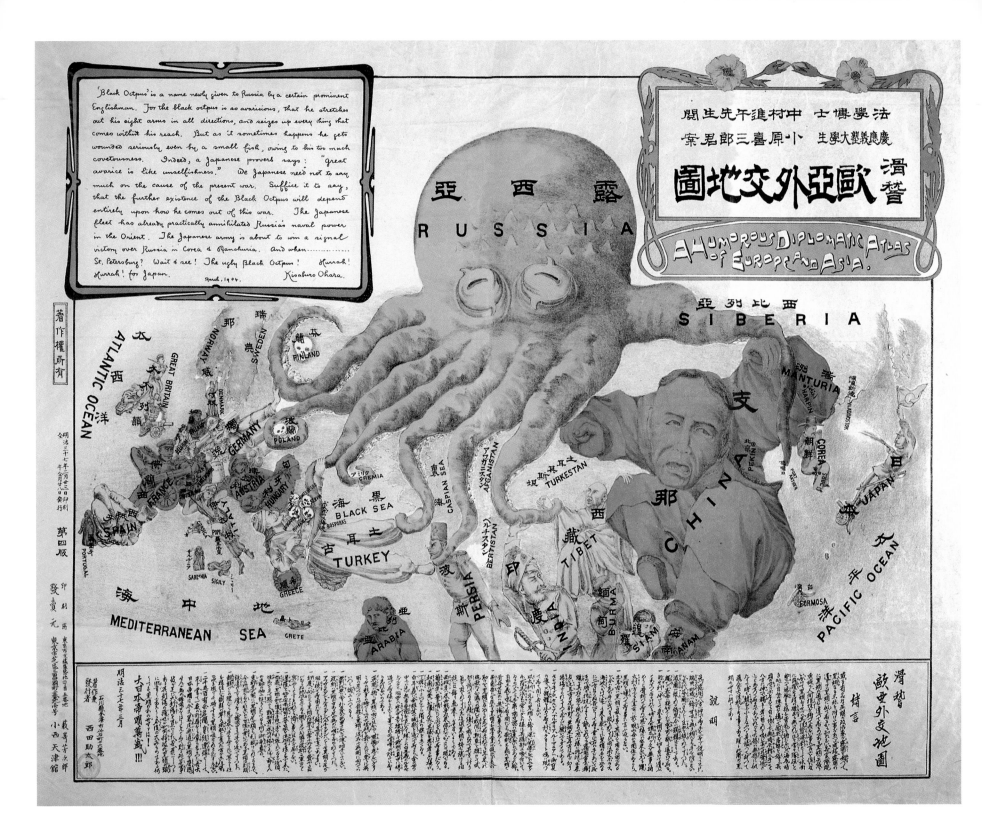

'Black Octpus' is a name newly given to Russia by a certain prominent Englishman. For the black octpus is so avaricious, that he stretches out his eight arms in all directions, and seizes up every thing that comes within his reach. But as it sometimes happens he gets wounded seriously even by a small fish, owing to his too much covetousness. Indeed, a Japanese proverb says: "great avarice is like unselfishness." We Japanese need not to say much on the cause of the present war. Suffice it to say, that the further existence of the Black Octpus will depend entirely upon how he comes out of this war. The Japanese fleet has already practically annihilated Russia's naval power in the Orient. The Japanese army is about to win a signal victory over Russia in Corea & Manchuria. And when ......... St. Petersburg? Wait & see! The ugly Black Octpus! Hurrah! Hurrah! for Japan.

March, 1904.          Kisaburo Ohara.

A HUMOROUS DIPLOMATIC ATLAS OF EUROPE AND ASIA.

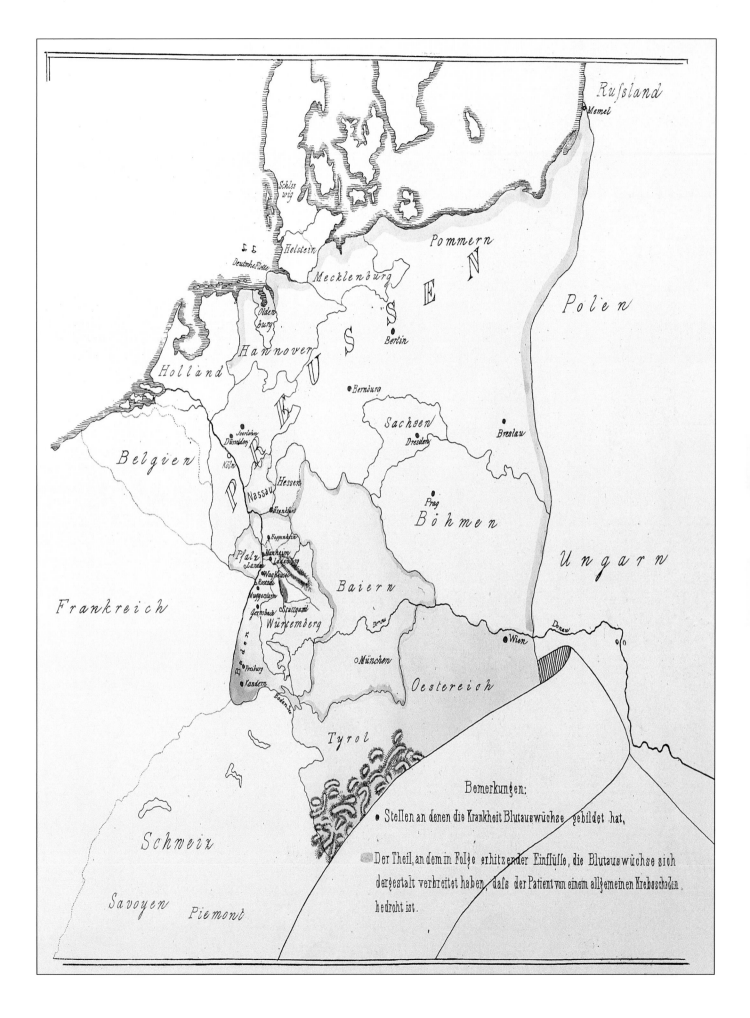

Bemerkungen:

• Stellen an denen die Krankheit Blutauswüchse gebildet hat,

Der Theil, an dem in Folge erhitzender Einflüsse, die Blutauswüchse sich dergestalt verbreitet haben, dafs der Patient von einem allgemeinen Krebsschaden bedroht ist.

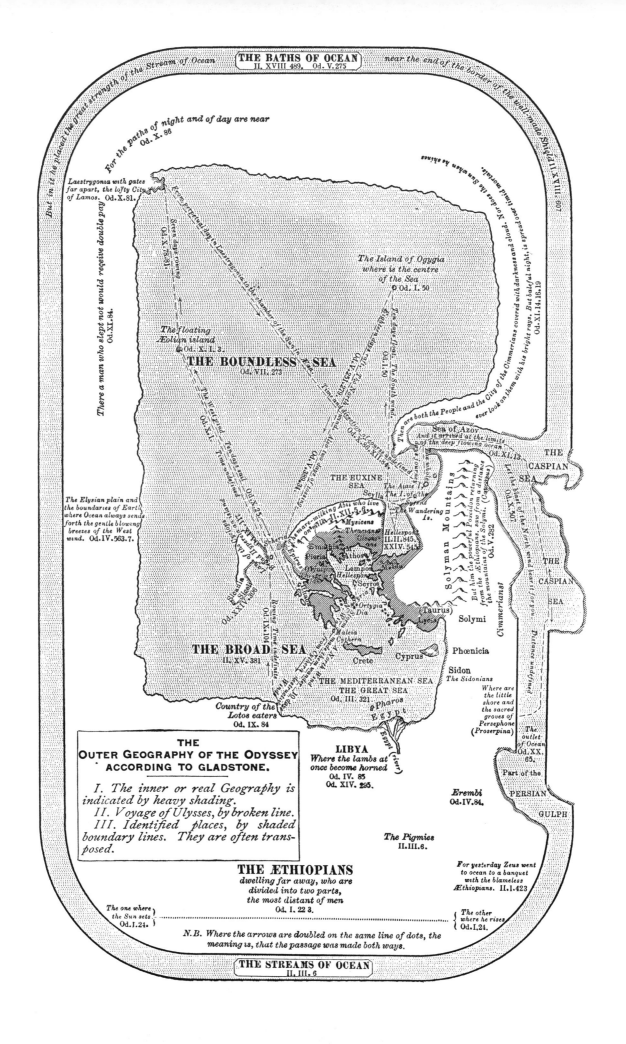

**THE BATHS OF OCEAN**
Il. XVIII. 489,   Od. V. 275

*near the end of the borders of the well-made Shield Il. XVIII. 607*

*But in its place its great strength of the Stream of Ocean*

*For the paths of night and of day are near*
Od. X. 86

*Nor does the Sun when he shines ever look on them with its bright rays. But baleful night, is spread over them with darkness and cloud. Od. XI.14.16.19*

*There a man who slept not would receive double pay.*
Od.XI.84.

Laestrygonia with gates
far apart, the lofty City
of Lamos. Od. X. 81.

*There are both the People and the City of the Cimmerians covered*

The Island of Ogygia
where is the centre
of the Sea
Od. I. 50

The floating
Æolian island
Od. X. I. 3.

**THE BOUNDLESS SEA**
Od. VII. 273

Sea of Azov
*And it arrived at the limits
of the deep flowing ocean*
Od. XI.13.

THE
CASPIAN
SEA

The Elysian plain and
the boundaries of Earth
where Ocean always sends
forth the gentle blowing
breezes of the West
wind. Od. IV. 563.7.

THE EUXINE
SEA

The Aiaie
Scylla The I. of the

Solyman Mountains

*But him the powerful Poseidon returning
from the Aethiopians, saw from a distance
the mountain of the Solymi. (Caucasus)*

THE
CASPIAN
SEA

Mysicens
Thracians

Hellespont
Il. II. 845,
XXIV. 545

The Wandering
Is.

Cimmerians

Pieria

Athos
Lemnos

Scyros

Solymi

Ortygia
Dia

(Taurus)

Malea
Cythera

Phœnicia

**THE BROAD SEA**
Il. XV. 381

Crete

Cyprus

Sidon
The Sidonians

Where are
the little
shore and
the sacred
groves of
Persephone
(Proserpina)

The
outlet
of Ocean
Od. XX.
65.

**THE MEDITERRANEAN SEA
THE GREAT SEA**
Od. III. 321

Pharos

Egypt

Country of the
Lotos eaters
Od. IX. 84

THE
**OUTER GEOGRAPHY OF THE ODYSSEY
ACCORDING TO GLADSTONE.**

I. The inner or real Geography is
indicated by heavy shading.
II. Voyage of Ulysses, by broken line.
III. Identified places, by shaded
boundary lines. They are often trans-
posed.

**LIBYA**
Where the lambs at
once become horned
Od. IV. 85
Od. XIV. 295.

Egypt (river)

Erembi
Od. IV. 84.

Part of the
PERSIAN
GULPH

The Pigmies
Il. III. 6.

*For yesterday Zeus went
to ocean to a banquet
with the blameless
Æthiopians. Il. I. 423*

**THE ÆTHIOPIANS**
dwelling far away, who are
divided into two parts,
the most distant of men
Od. I. 22 3.

The one where
the Sun sets
Od. I. 24.

The other
where he rises
Od. I. 24.

*N.B. Where the arrows are doubled on the same line of dots, the
meaning is, that the passage was made both ways.*

**THE STREAMS OF OCEAN**
Il. III. 6

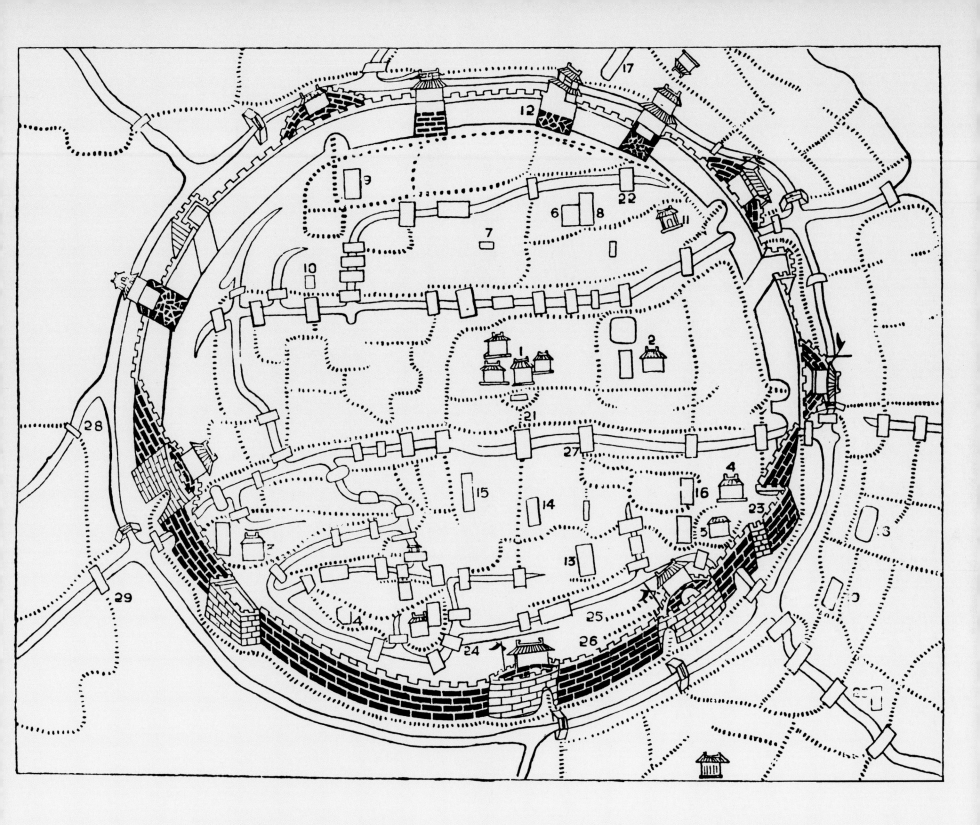

49

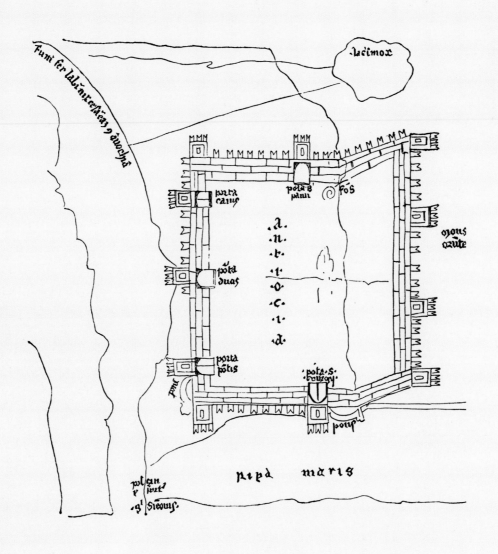

50

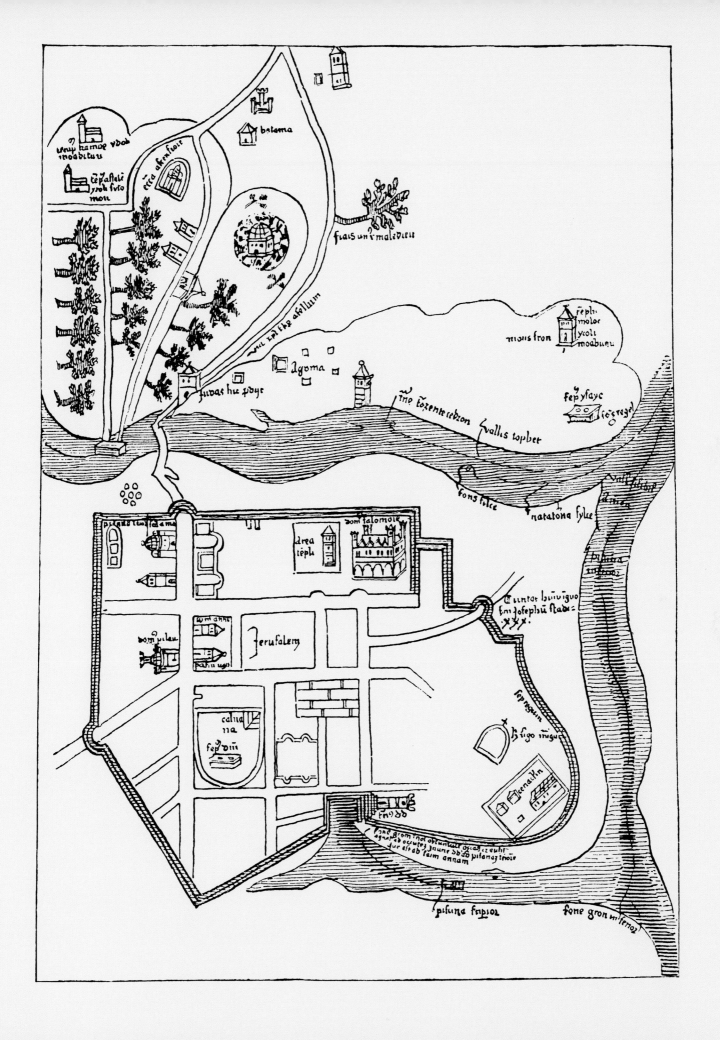

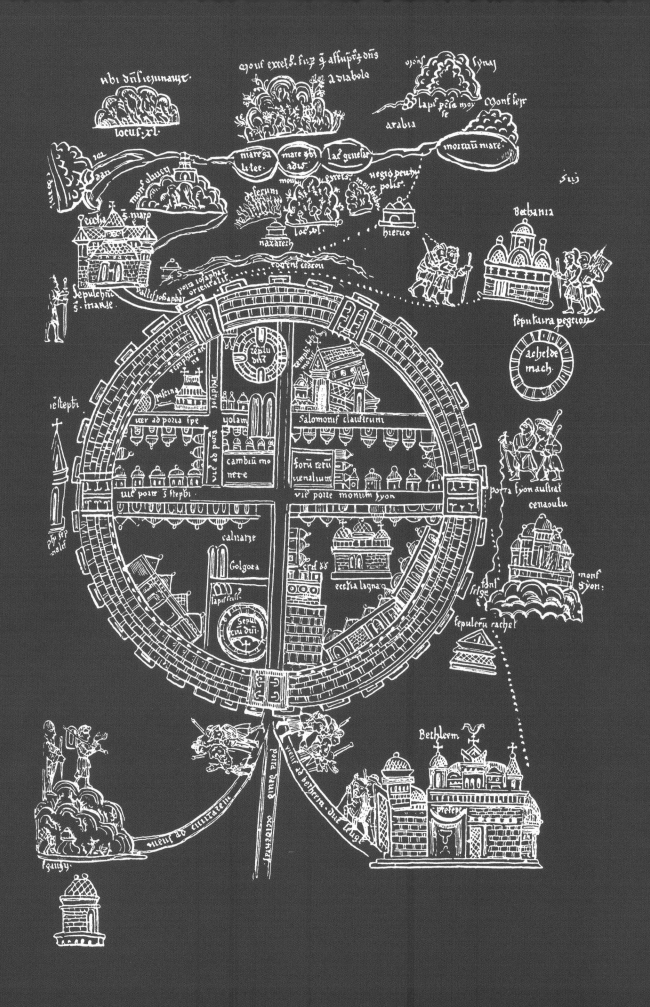

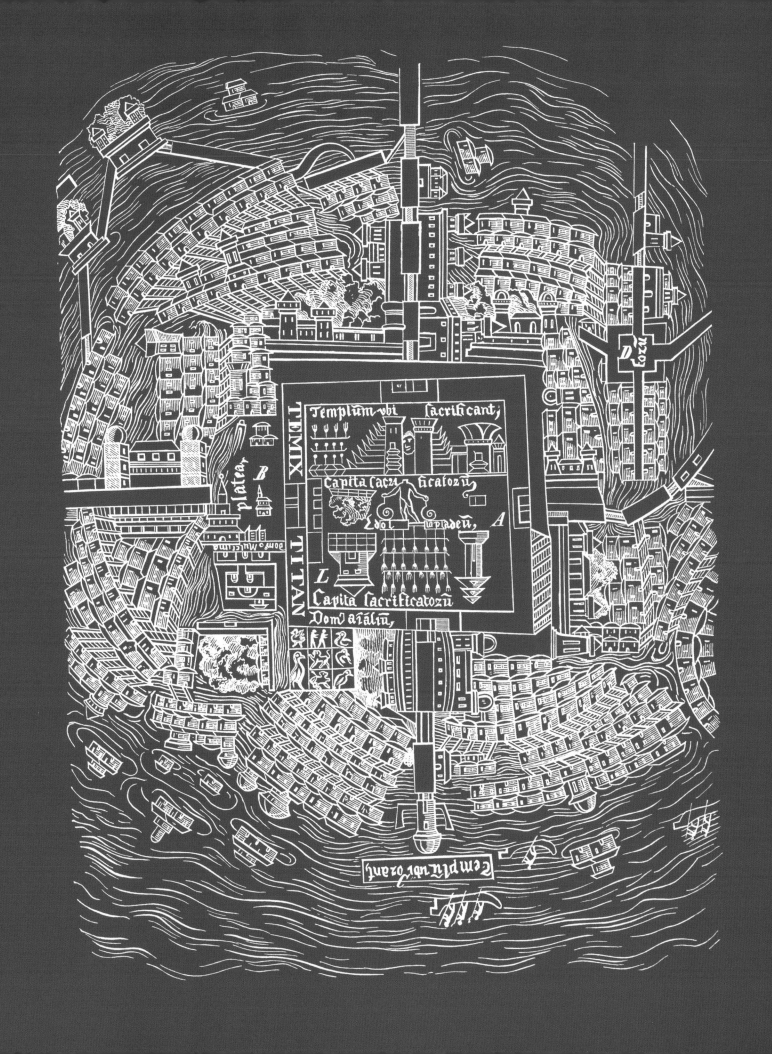

53

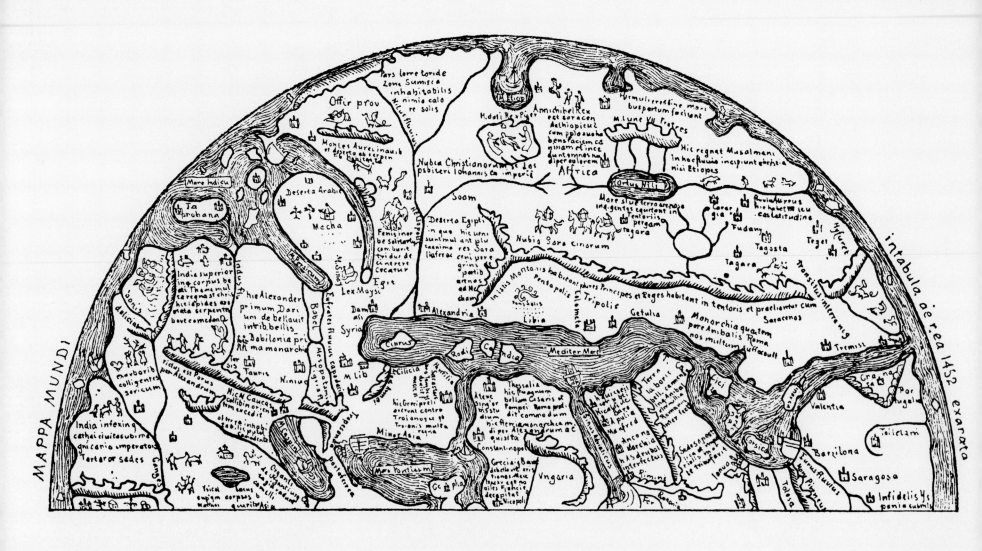

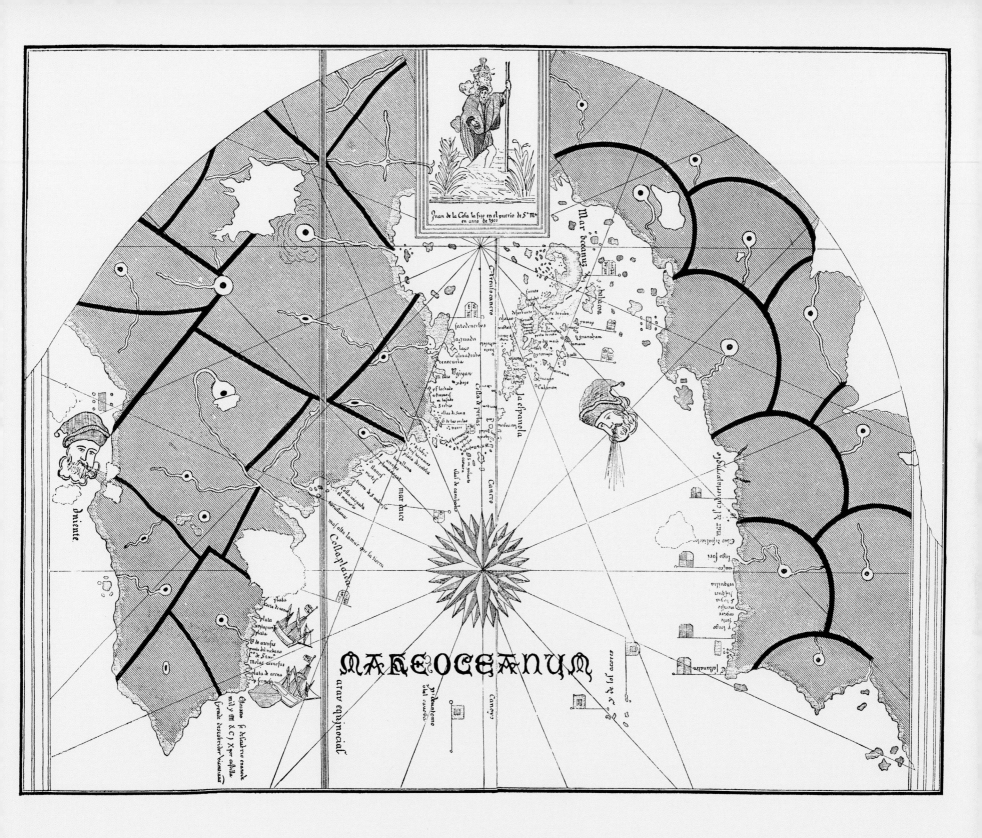

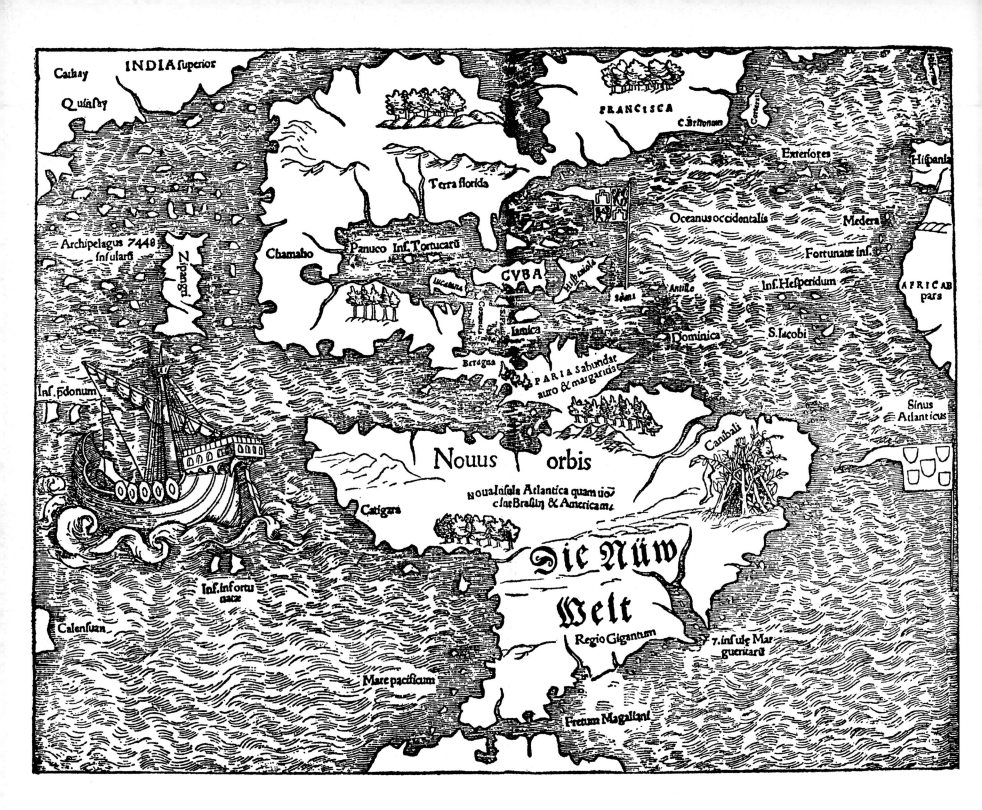

Cathay

INDIA superior

Quisfay

FRANCISCA

C.Britonum

Exteriores

Hispania

Oceanus occidentalis

Medera

Terra florida

Archipelagus 7448 insularum

Zipangri

Chamaho

Panuco Inf.Tortucarū

Fortunate inf.

CVBA

Inf.Hesperidum

Lucaiana

AFRICÆ pars

Hispaniola

Antille

Corterea

Iamica

Dominica

S.Iacobi

Beragua

PARIA Sabundat auro & margariüs

Sinus Atlanticus

Inf. ſdonum

Canibali

Nouus orbis

Noua Insula Atlantica quam uō clur Braſiti & Americam,

Catigara

**Die Nüw**

Inf.Infortu natæ

**Welt**

Calensuan

Regio Gigantum

7.infulæ Mar gueritarū

Mare pacificum

Fretum Magallani

56

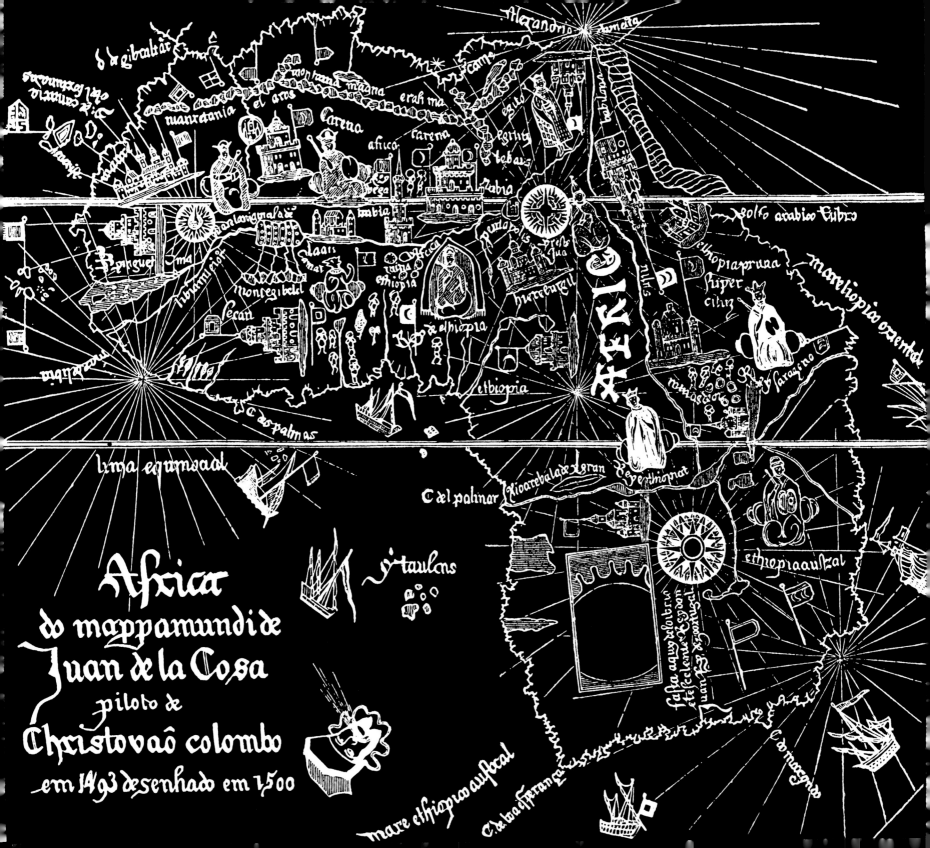

Africa
do mappamundi de
Juan de la Cosa
piloto de
Christovaô colombo
em 1493 desenhado em 1500

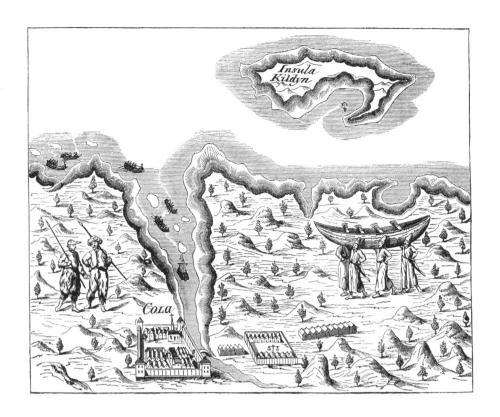

Insula
Kildyn

COLA

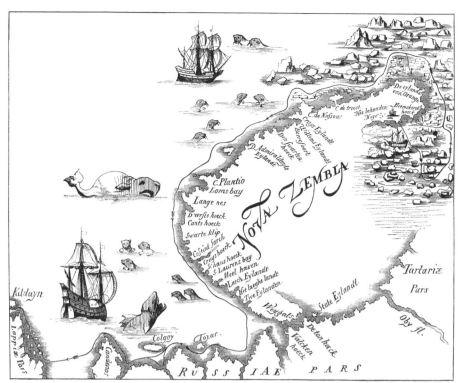

NOVA ZEMBLA

de Nossou
Crays Eylandt
Willem Eylandt
Beer foort
Drie fwerste
hoeck
D'Admiralitoyts
Eylandt

C. Plantio
Loms bay
Lange nes
D'eerste hoeck.
Cants hoeck.
Swarte klip
Cosint farch
Crays hoeck.
Schans hoeck
S. Laurens bay
Meel haven
Laech Eylandt
Het langhe landt
Twe Eylanden

Kilduyn

Lappiæ pars

Candenos

Colgoy

Tozar

Waygats
Vatcken
hoeck

de troost
Het behonden
Wayr

De eylanden
van Orange

Heemskerck
hoeck

State Eylandt

Tartariæ
Pars

Deton hoeck

Oby fl.

RUSSIÆ PARS

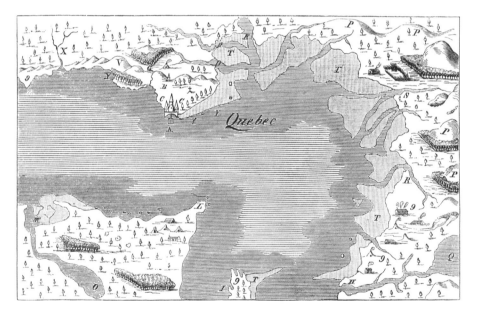

Quebec

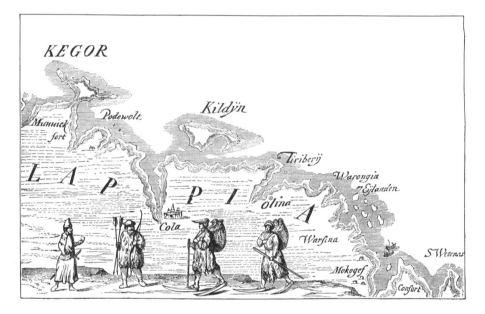

KEGOR

Munnick
fort

Podewolt

Kildyn

Tiriberÿ

Warongia
7 Eylanden

L A P P I A
olina

Cola

Warsina

Mokogef

S Wetenas

Confort

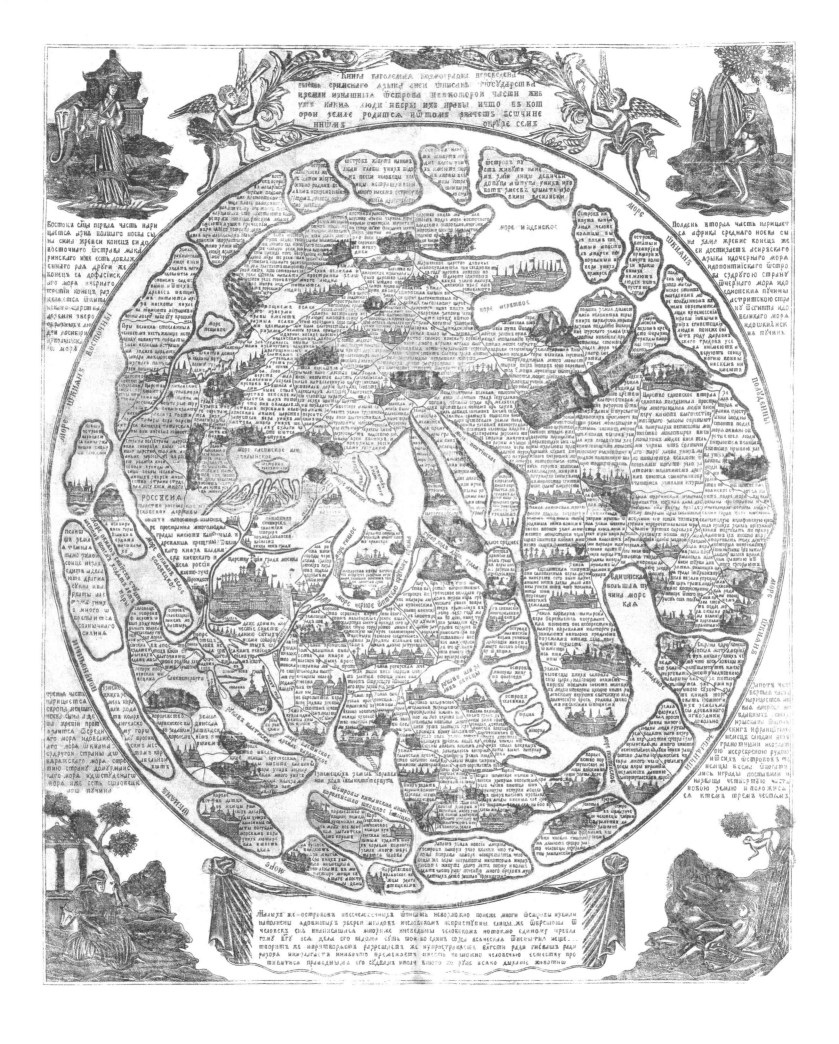

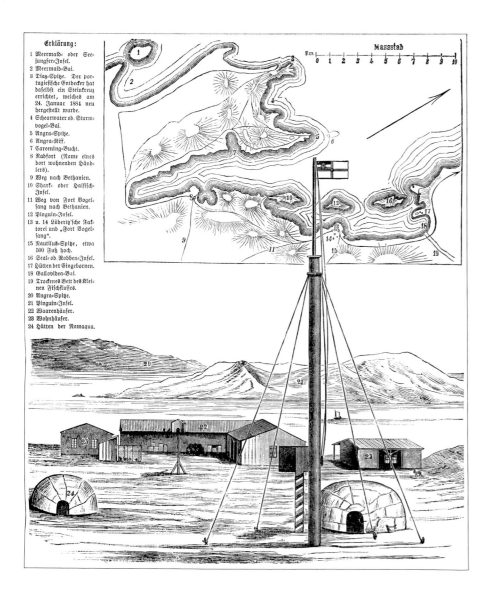

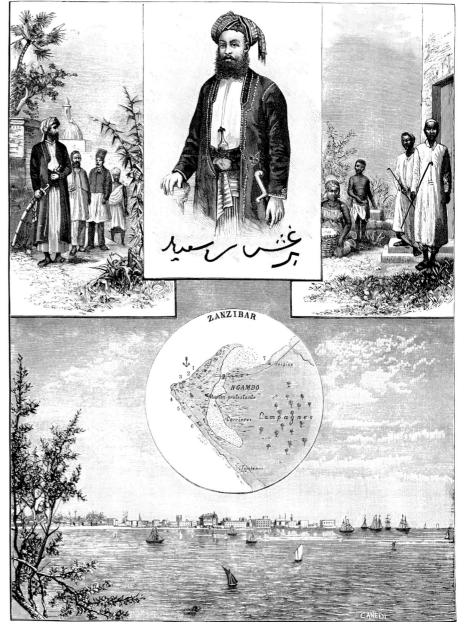

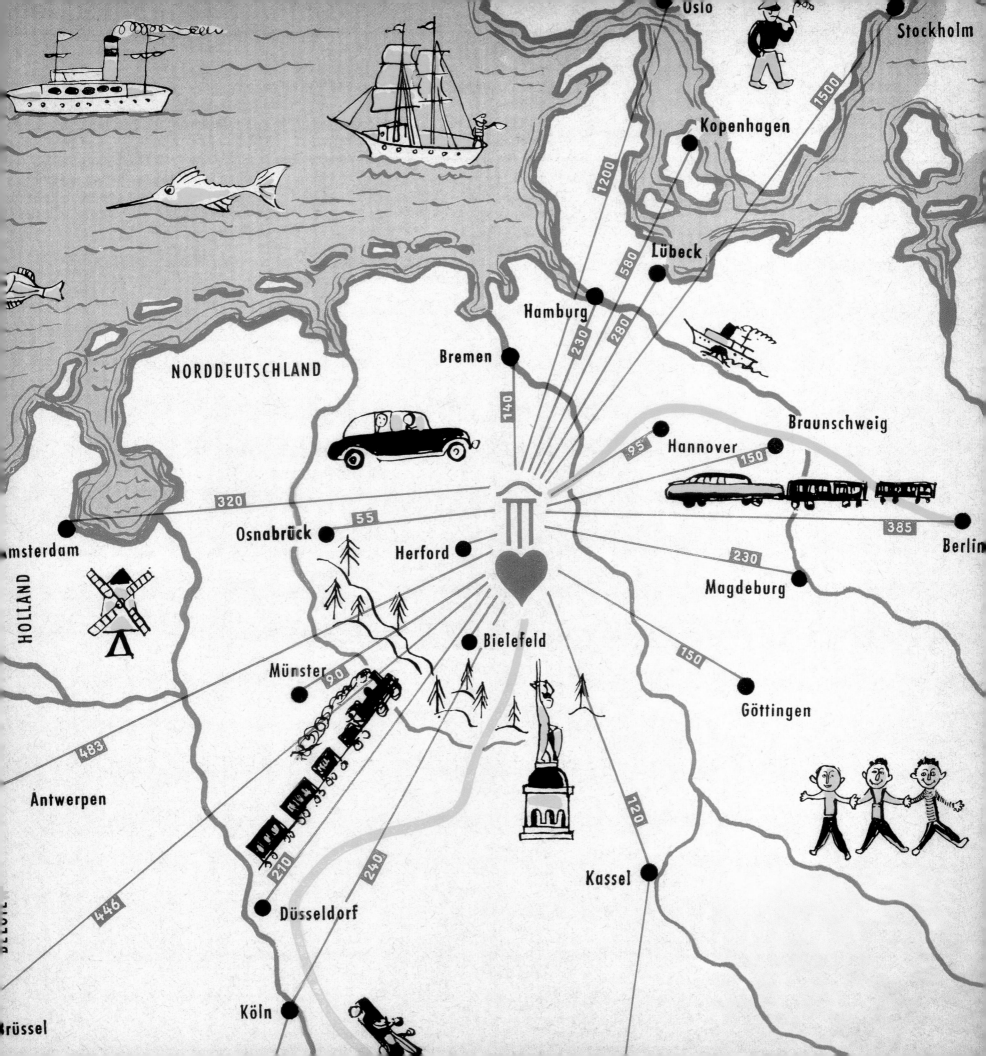

Oslo

Stockholm

Kopenhagen

1500

1200

Lübeck

580

280

230

Hamburg

Bremen

NORDDEUTSCHLAND

Braunschweig

140

95

Hannover

150

320

55

Osnabrück

385

Amsterdam

Berlin

HOLLAND

Herford

230

Magdeburg

Bielefeld

150

Münster

90

Göttingen

483

Antwerpen

120

210

240

446

Kassel

Düsseldorf

Brüssel

Köln

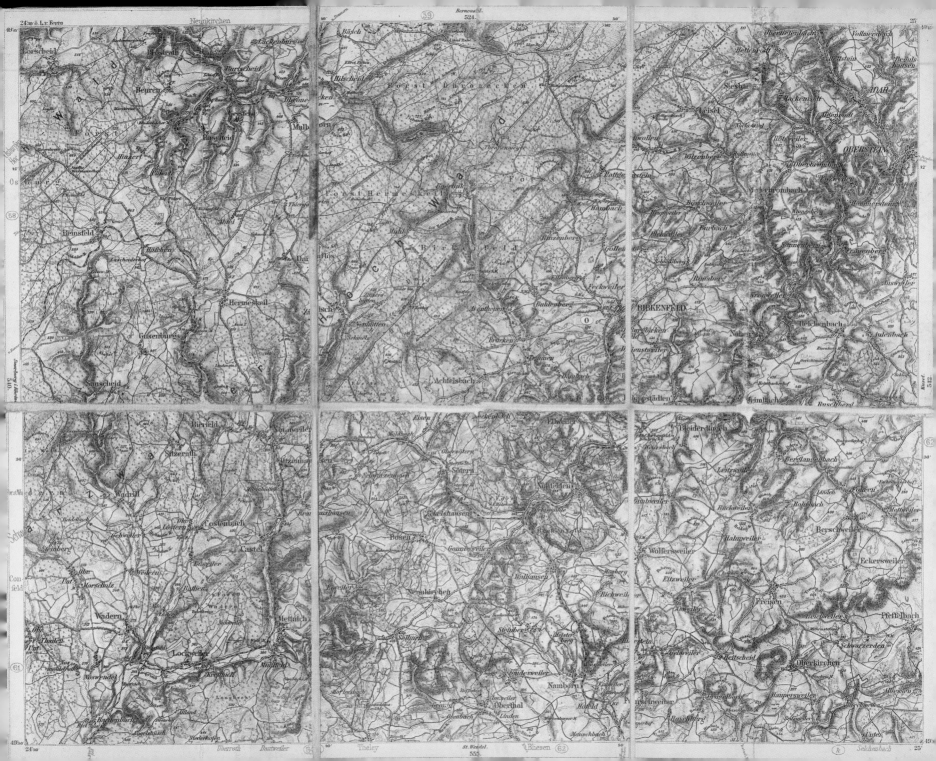

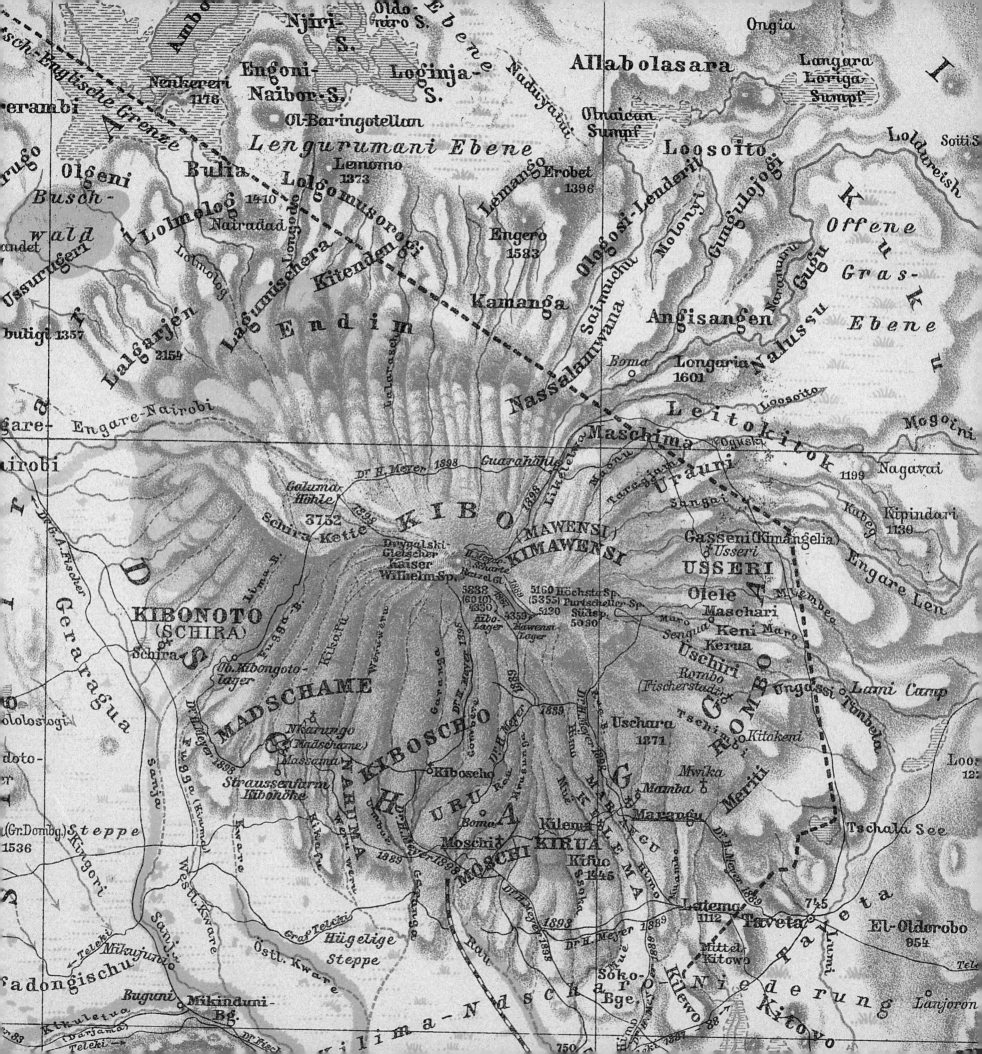

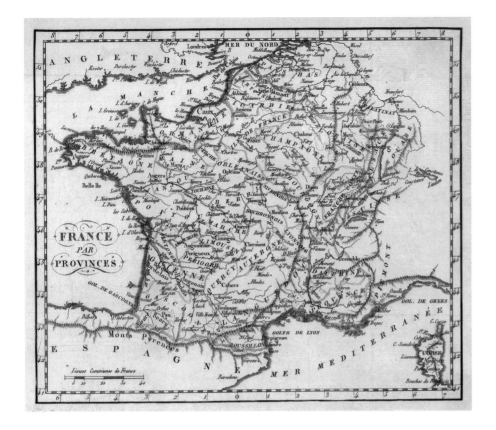

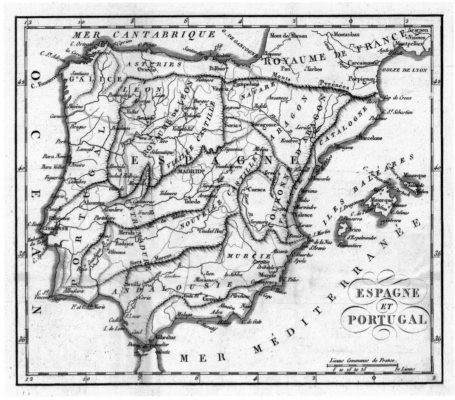

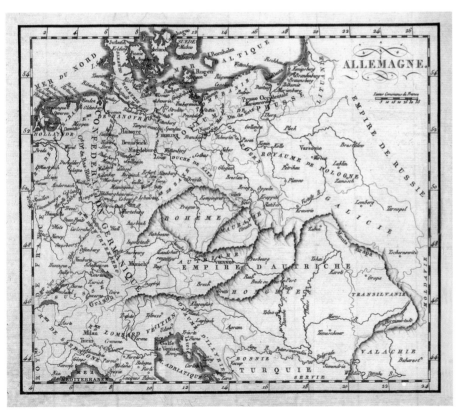

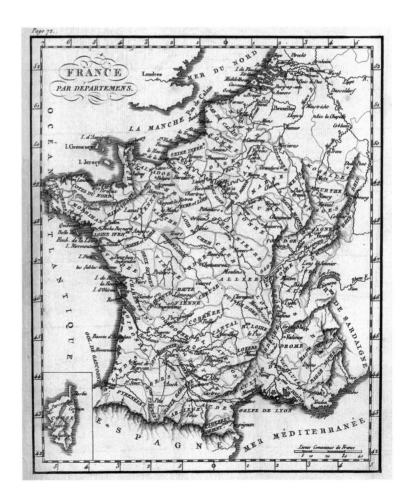

68

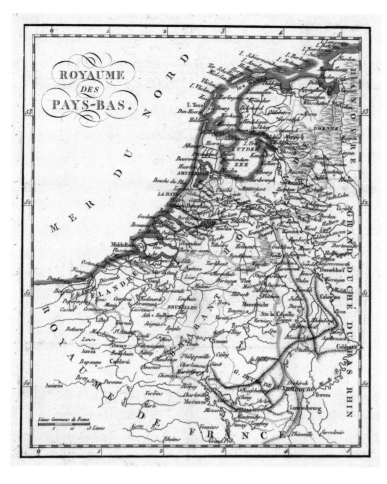

ROYAUME DES PAYS-BAS.

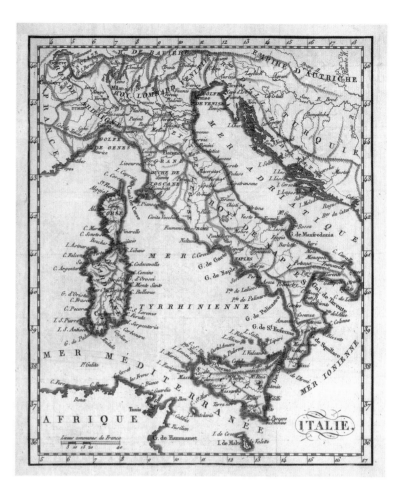

ITALIE.

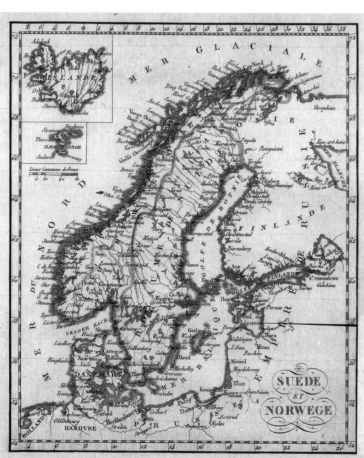

SUEDE ET NORWEGE

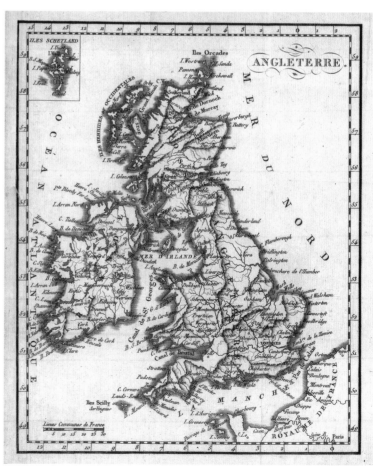

ANGLETERRE.

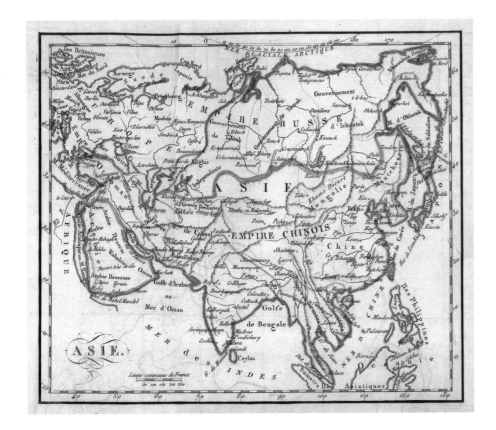

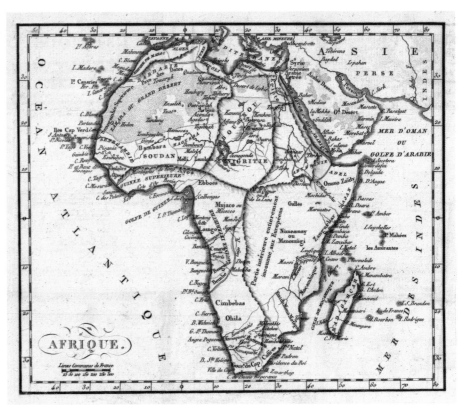

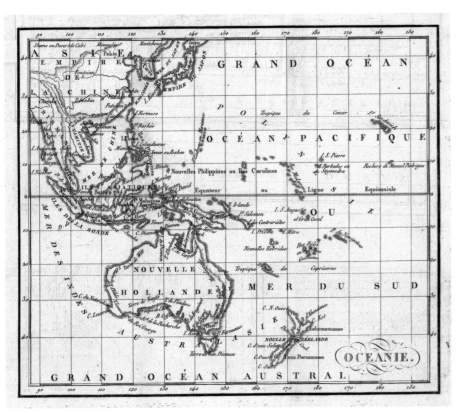

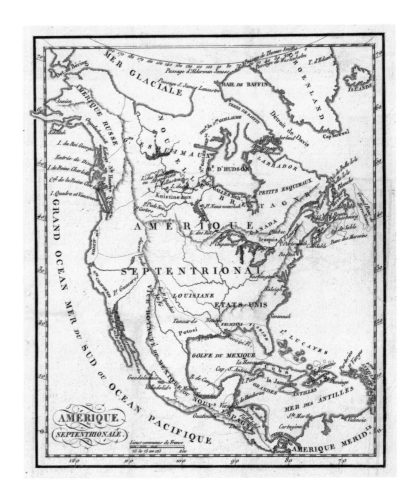

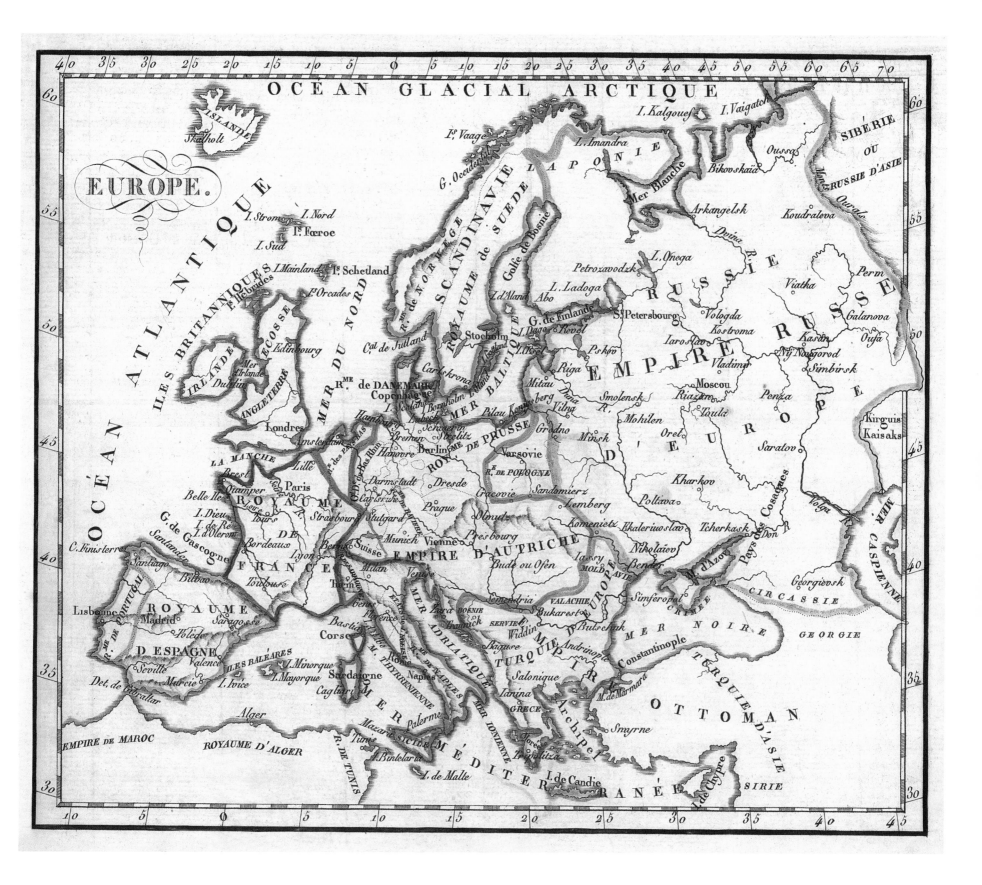

71

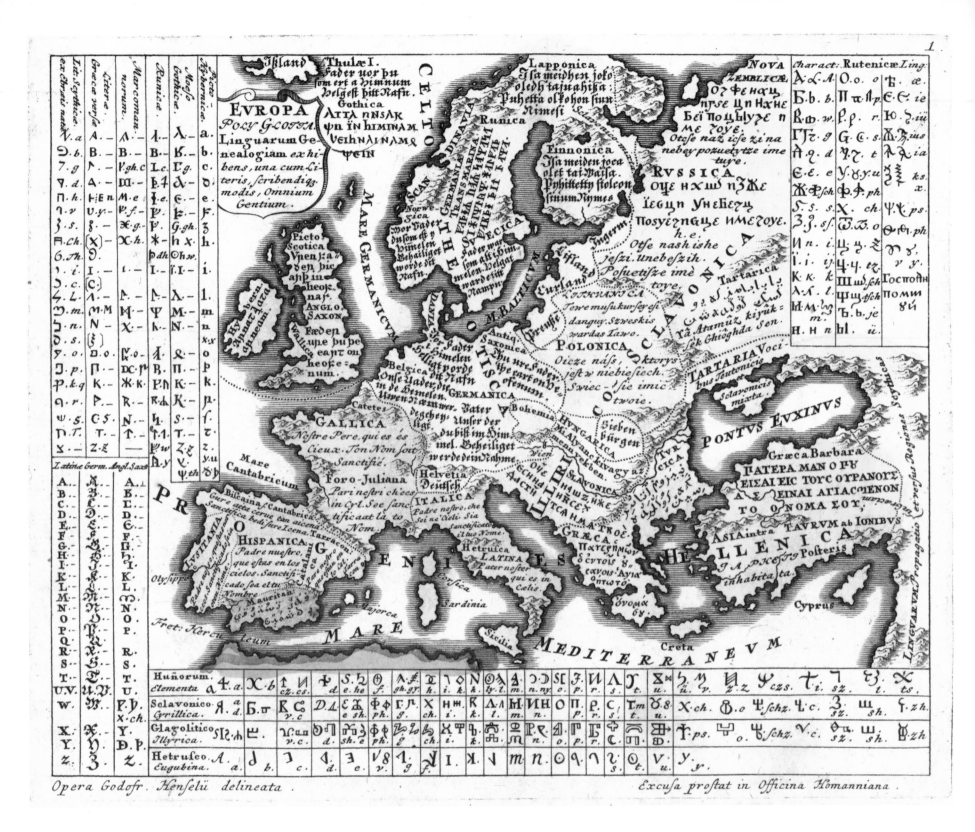

120 130 140 150 160 170 180 190 200 210 220 230 240 250 260 270

CARTE
DE TOUTES LES
N.LES DÉCOUVERTES
DANS LA MER DU SUD,
ou est tracée la Route
du Célèbre Capitaine Cook,
dans son dernier Voyage.

Ici Mr. Cook a été arrêté par les Glaces

Partie Nord Ouest de l'Amerique, decouverte par le Capitne. Cook en 1778

Pays des Tichuktchi

R. Andian
Kouyma R.
Cercle Arctique

SIBERIE
TARTARIE RUSSE

Ochotsk
Mer D'OCHOTSK

R. Amoor
Sakalin Ula
Uromusir
Launsar
Marikan
Nudesha
Natcani
Sisters
Sigurnoi
Urin
Iraschir
Matsumai
ISLES DU
Niphon
JAPON

TARTARIE CHINOISE
PÉKIN
CORÉE

CHINE
Cambodia
Canton
Macao
I. Haynan
Mindoro
Malaca
BORNEO
CELEBES

C. du Prince de Galles
Canal de Norton
S. Titi
S. Diomede
S. Samuel
S. André
Brulante
B. Bristol

Golfe d'Anadir
S. Laurent
I. St. André
S. Mathieu

Ukinskoi
Kamtchatka
OCEAN Preobraschui ORIENTALE

S. Julien
Chemiga
Anatu
Amatcha ou de S. Pierre et S. Paul
route Remarquée par Kronitzin déc. en 1768

Is. Aleutiennes

Is. Sanganuda

M. Cook se radoubla Canal Hitchinbroke
Canal du Princes Wales
C. S. Elias

Canal du RoiGeorge
M. Cook se radoubla ici
R. Ouest decouverte en 1603
C. Blanco
P. de la Trinité
NOUVELLE

AMERIQUE SEPTENTRIONALE

Port S. Francois de la Bodega
P. Monte Rey
C. Conception
Drake ou de ALBION

MEXIQUE
MER VERMEILLE
CALIFORNIE

MER PACIFIQUE

Route de Manille à Acapulco

Tropique du Cancer  Is. Sandwich
Owhy-hee  C'est ici que le Capitaine Cook a été tué

DU NORD

Guadalupe
Morro Hermoso
B. Christoval
C. S. Lucas
C. Corientes
S. Blas
MEXICO
A.
Galise

Manilla
PHILIPPINES
Samar
Leyte
Paragua
Pulo Condore
I. Mindanao

Gilolo
I. Wagiou

I. de la Tortue

EQUATEUR ou LIGNE EQUINOXCIALE

MER PACIFIQUE

N. Hanovre
Nle. Irlande
Bretagne

DU SUD

Nle. Hebrides
Nle. Caledonie

Spiritu Santo
Aurora
Egmont
Sandwich
Is. des Amis
I. Palmerston
I. Sauvage
le Hervey
Bobola
Otha
Enod
Ulieta
Bualabou
Is. de la Société
O. Tahiti

allant en 1777
O. Tahiti
Oheteora

Tropique du Capricorne

B. des Requins ou des Goulus
C. de Lyon
Terre découverte par P. Nuitz
C. de Fumée
Port Stephens
Baye de Botanique
C. de Hick

NOUVELLE HOLLANDE

C. Sandy ou de Sable
C. Morton
C. Nord
Detroit de Cook
Cap Est

Nle. ZÉLANDE
Canal de la Reine Charlotte
C. de Banch
Cap Sud

en allant à O. Tahiti en 1777  Terre de Diemen

I. du Prince ou de la Tortue
Billiton
Lomboc
Ende
Timor
Cumbava
Rotto
Bali
Detroit d'Endeavour
C. de la Delivrance
Is. de la Reine Charlotte

120 130 140 150 160 170 180 190 200 210 220 230 240 250 260 270

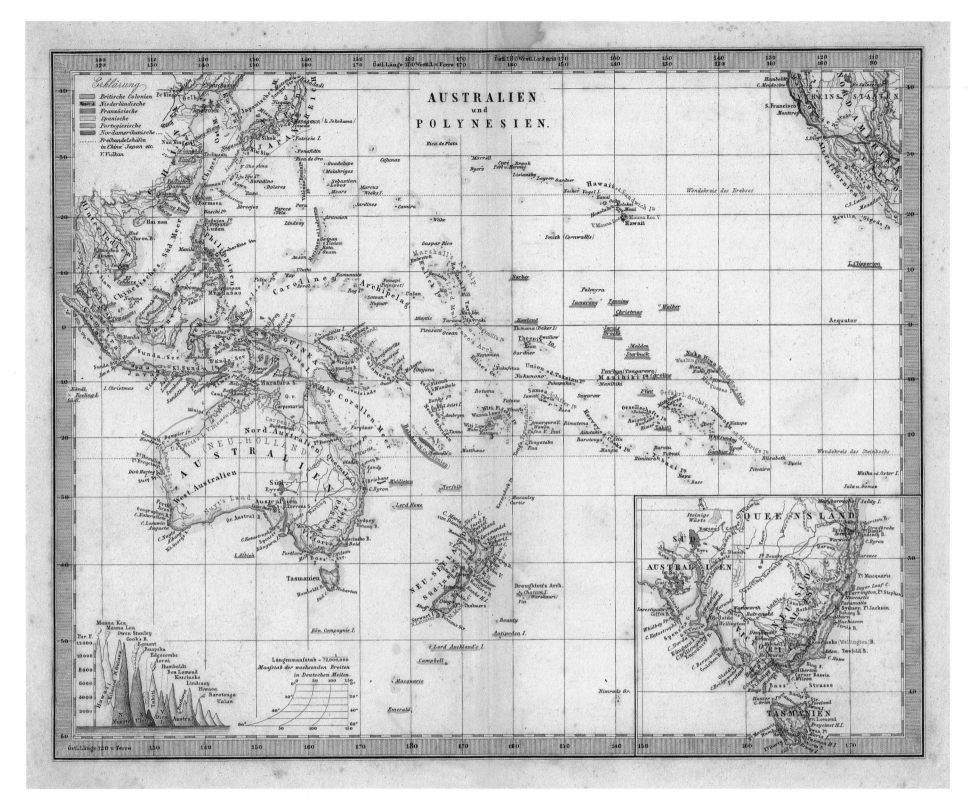

# AUSTRALIEN und POLYNESIEN.

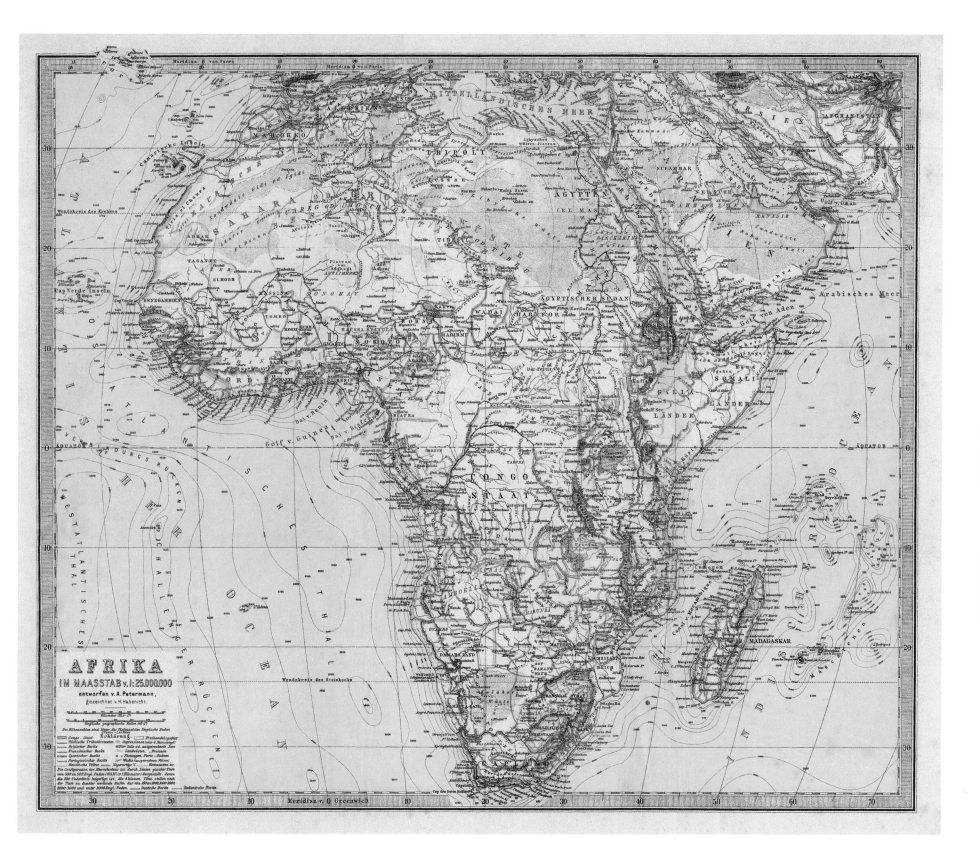

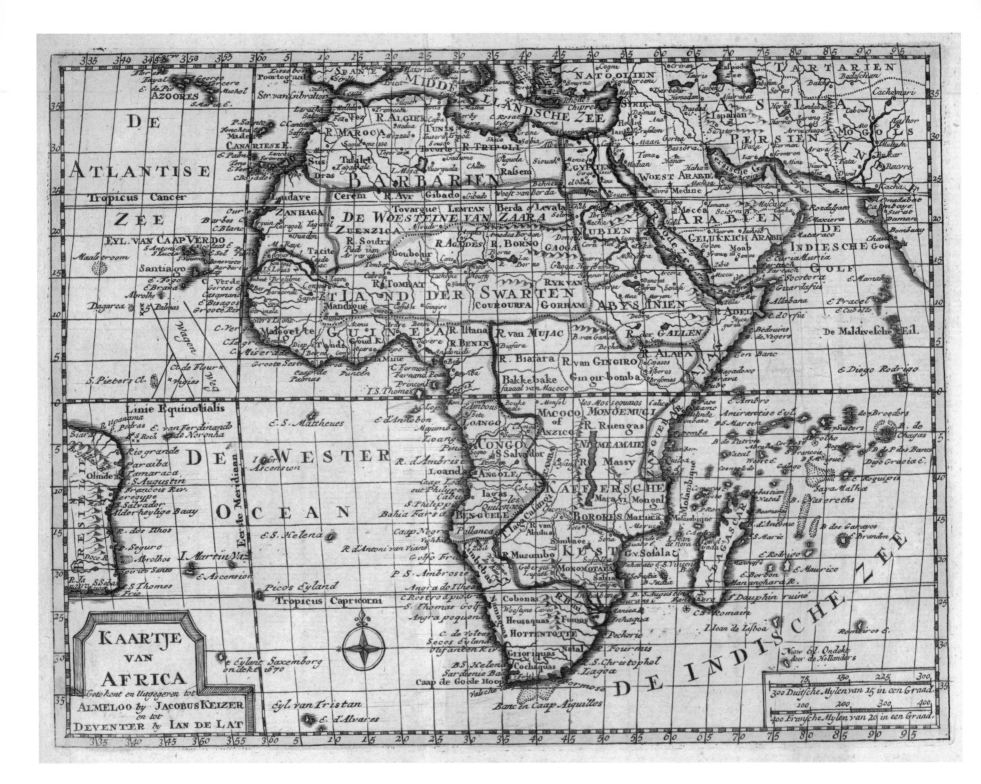

76

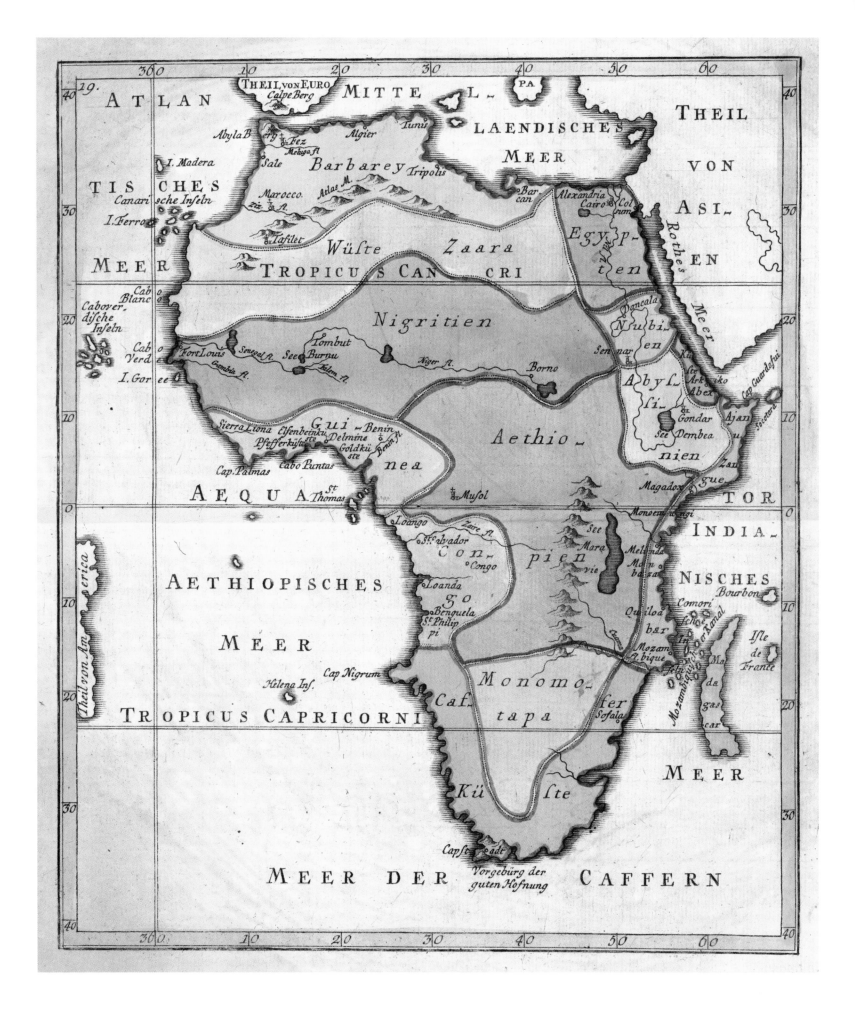

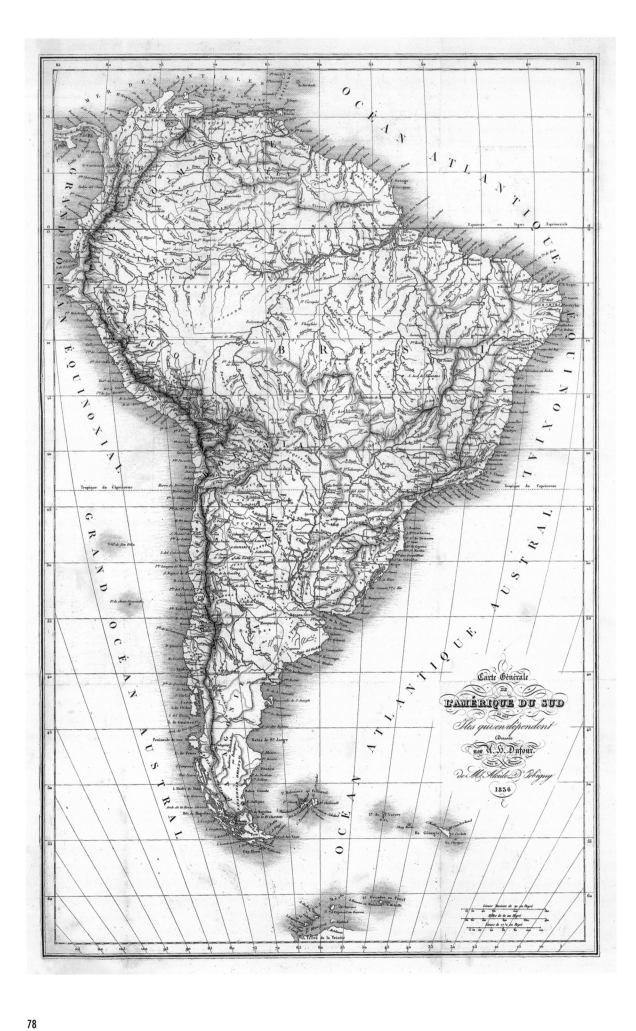

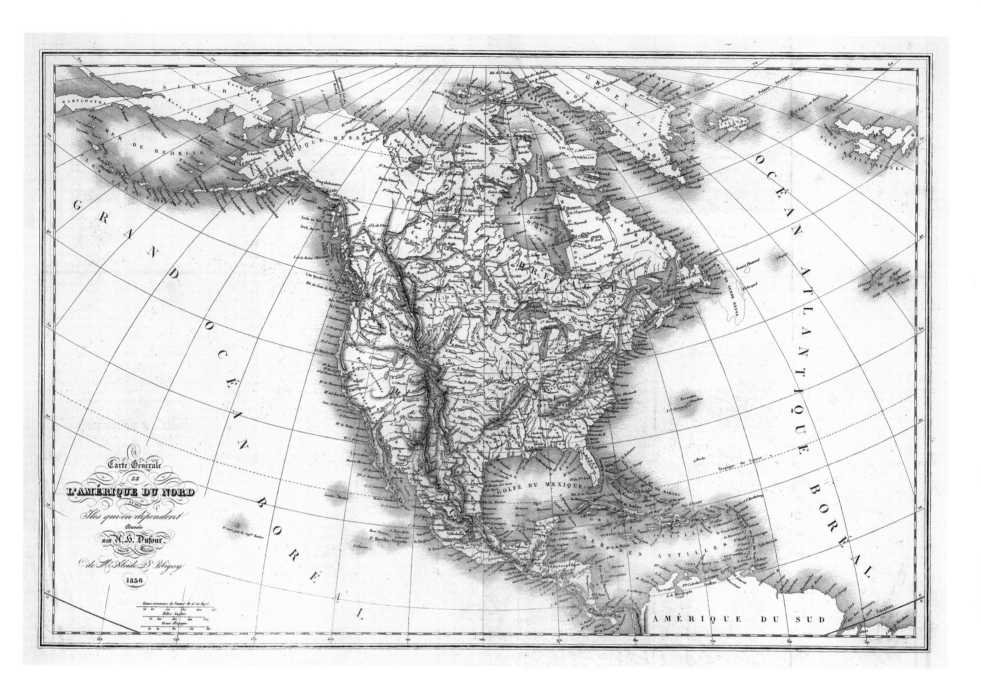

Carte Générale
DE
L'AMÉRIQUE DU NORD
ET DES
Iles qui en dépendent
Dressée
PAR A. H. Dufour.

De Mr Alcide D'Orbigny
1856

79

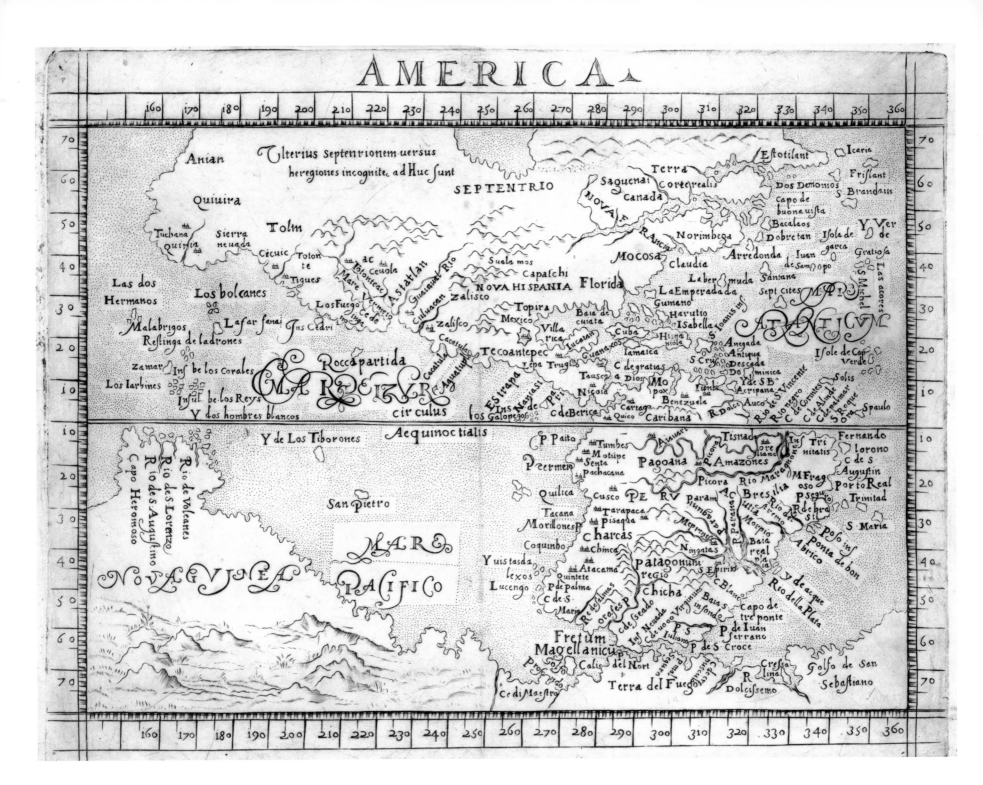

# AMERICA

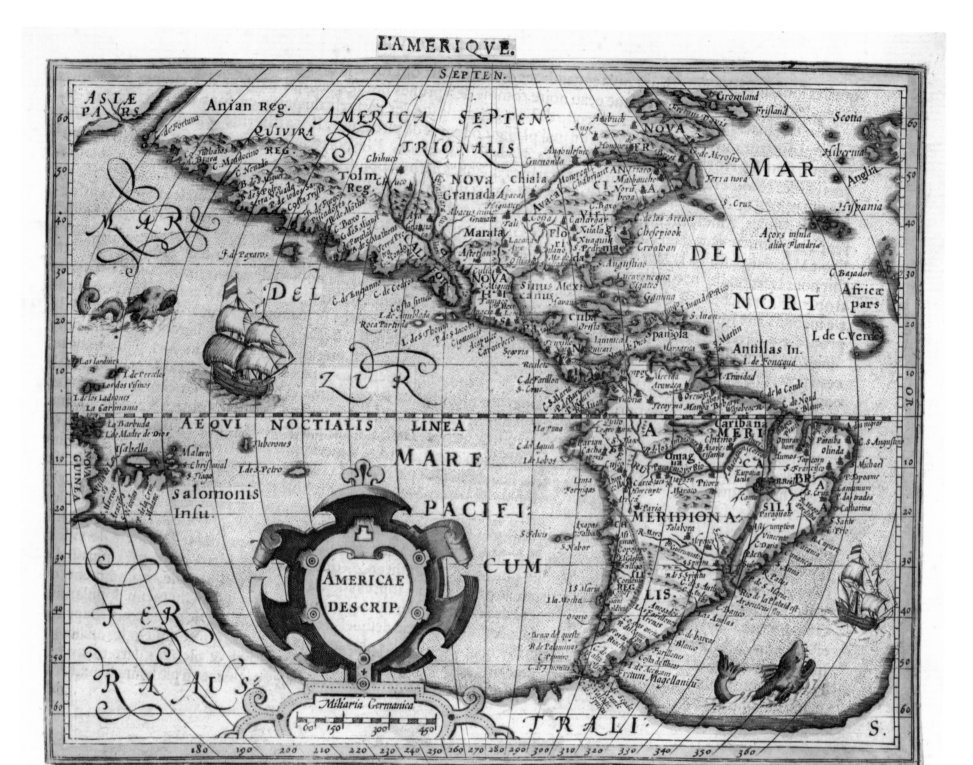

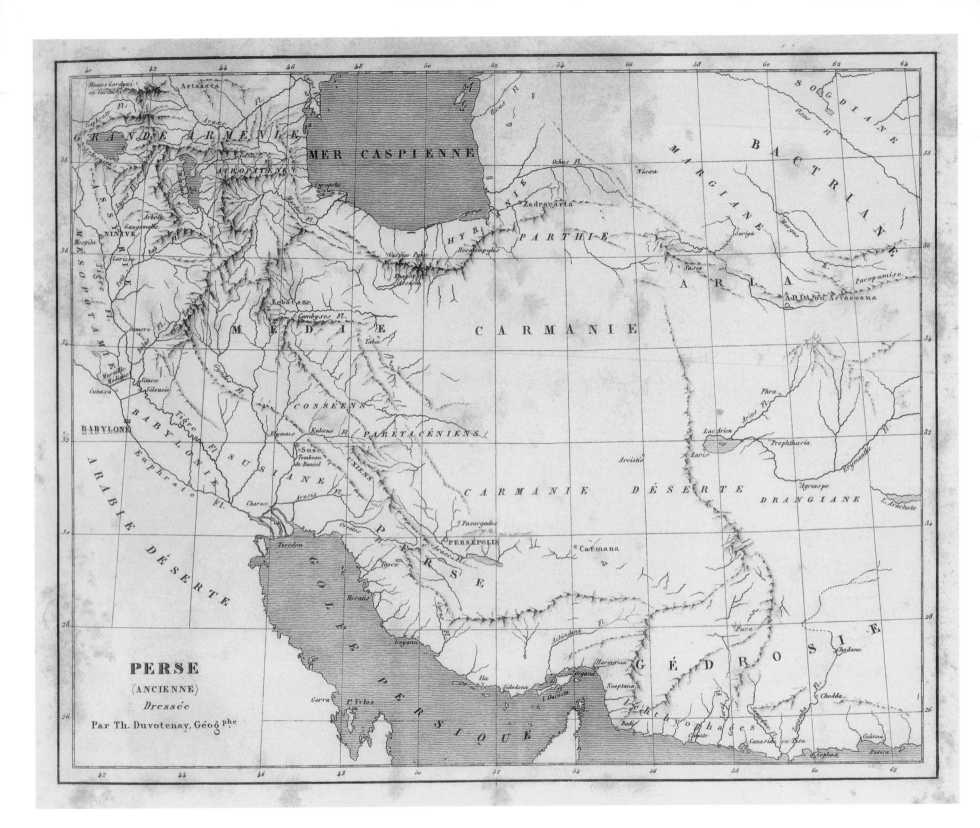

PERSE
(ANCIENNE)
Dressée
Par Th. Duvotenay, Géogᵖʰᵉ

82

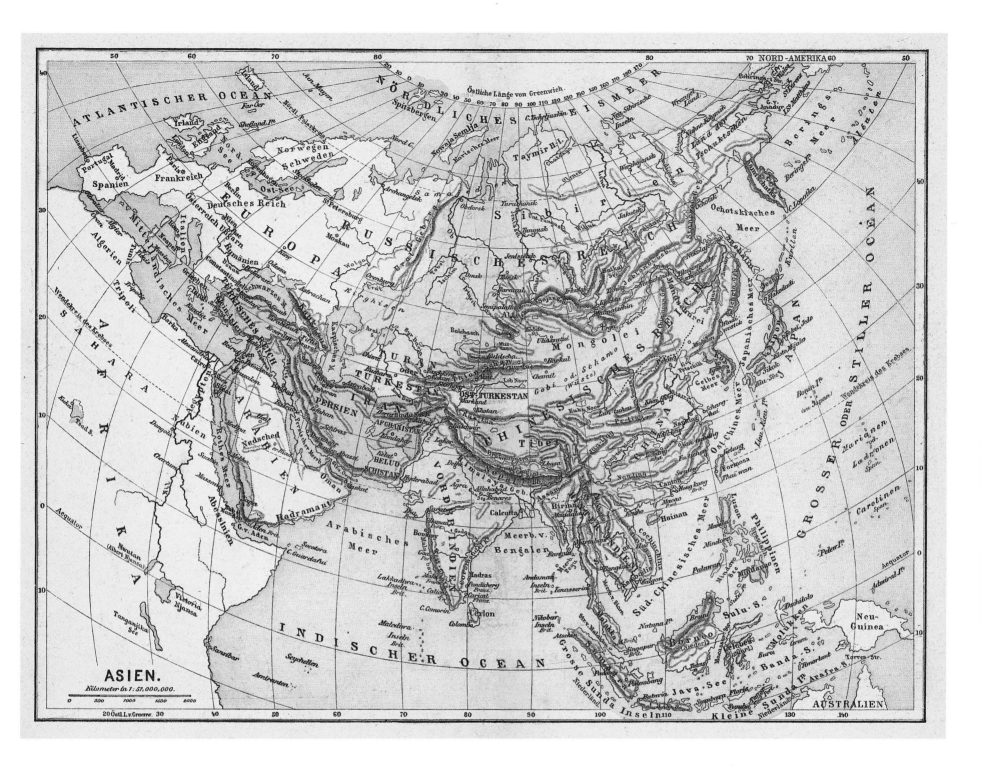

ASIEN.

*Kilometer in 1:57,000,000.*

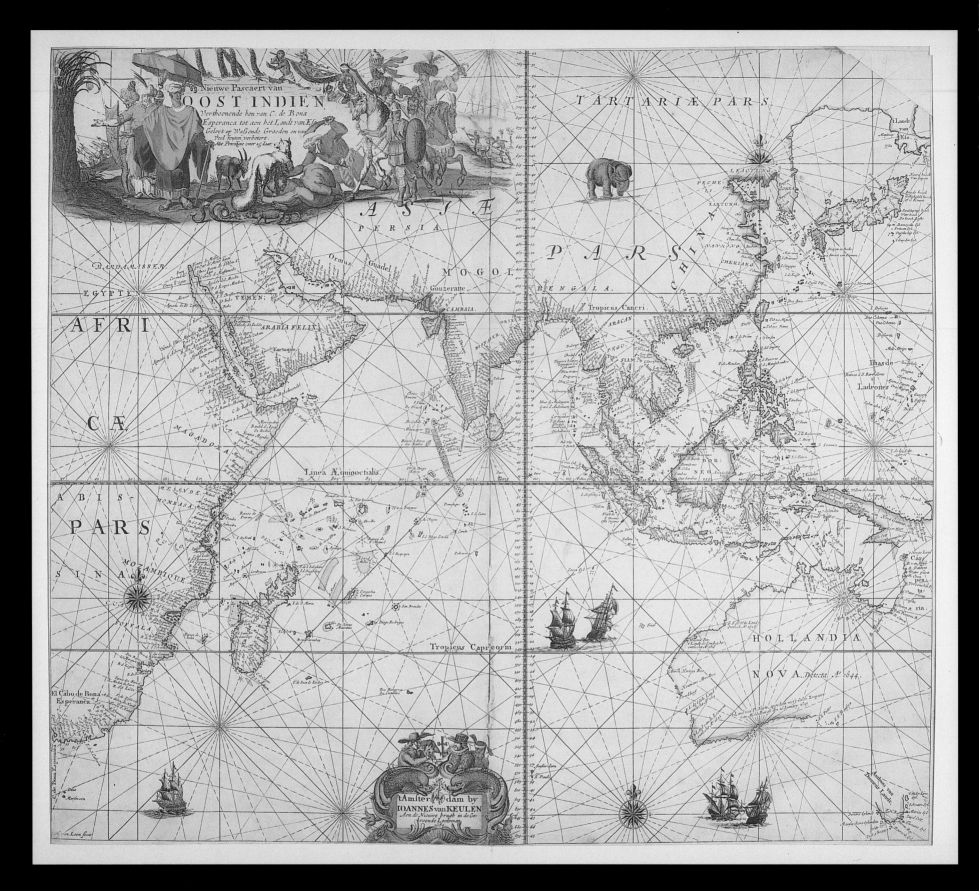

Nieuwe Pascaert van
OOST INDIEN
Verthoonende hen van C. de Bona
Esperança, tot aen het Landt van Eso
Gelevt op Waßende Graeden en van
Veel fouten verbetert
Alle Prentjen over 15 Jaar

TARTARIÆ PARS

ASIÆ

PERSIA

PARS

CHINA

MOGOL

BENGALA

Tropicus Cancri

AFRI

ARABIA FELIX

ARACAN

CA

PEGU

SIAM

Ilhas de

MAGADOXA

Ladrones

PARS

Linea Æquinoctialis

SINA

MOMBASA

MOZAMBIQUE

SOFALA

Tropicus Capricorni

HOLLANDIA

NOVA. Detecta A° 1644

El Cabo de Bona
Esperança

tAmsterdam by
IOANNES van KEULEN
Aen de Nieuwe brugh in de Ge-
kroonde Lootsman

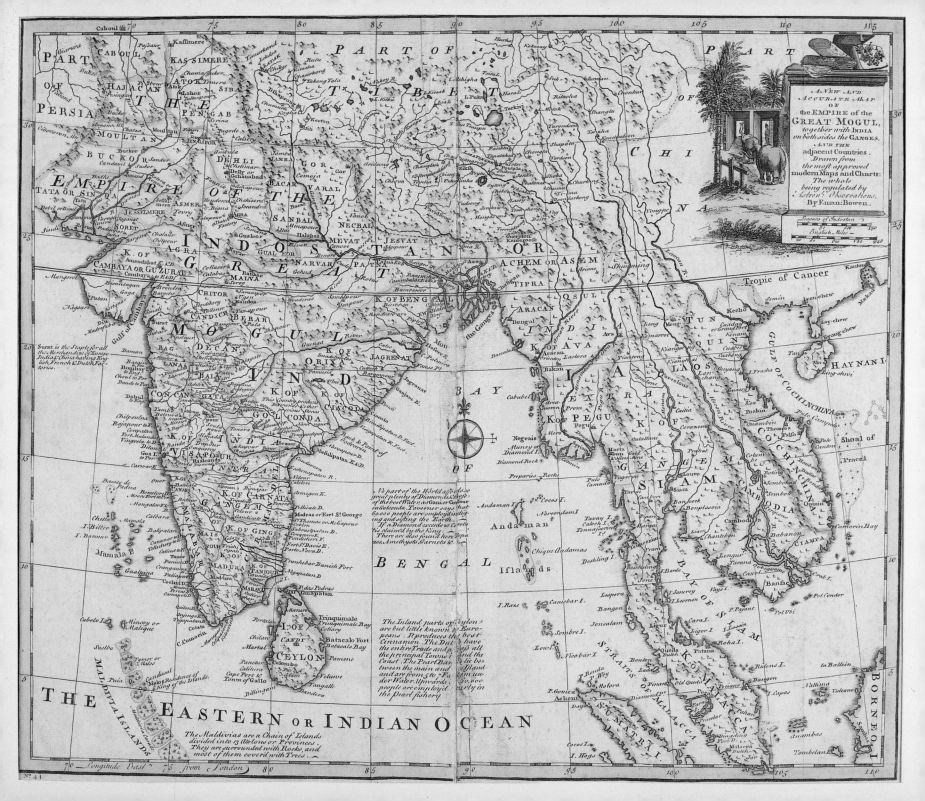

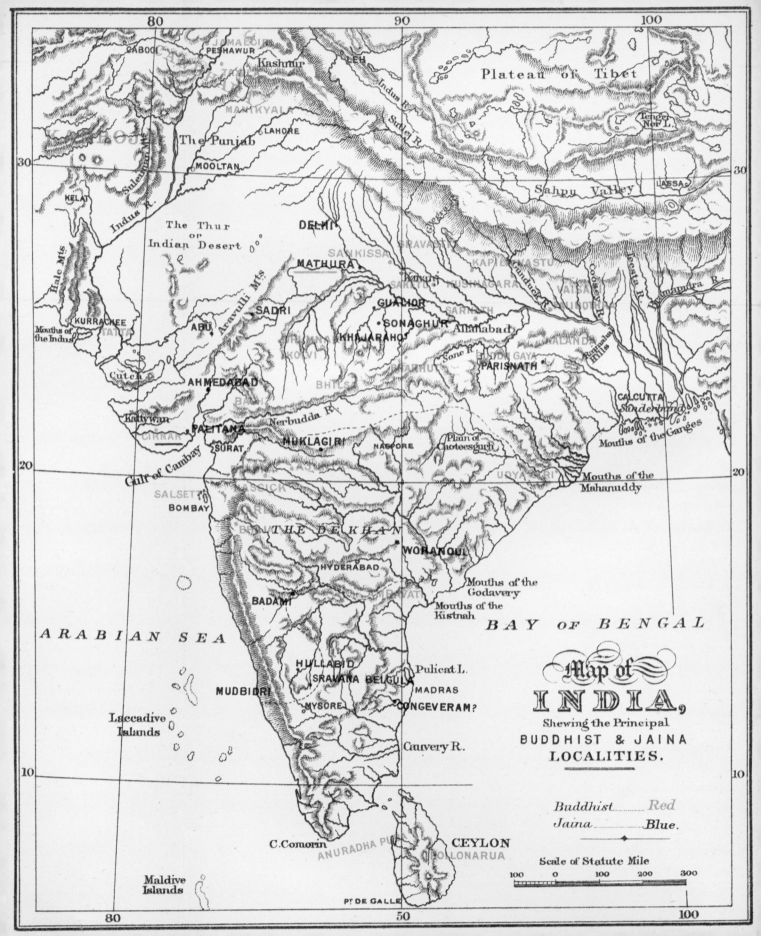

Map of
INDIA,
Shewing the Principal
BUDDHIST & JAINA
LOCALITIES.

Buddhist .......... Red
Jaina ——◆—— Blue.

Scale of Statute Mile
100   0   100   200   300

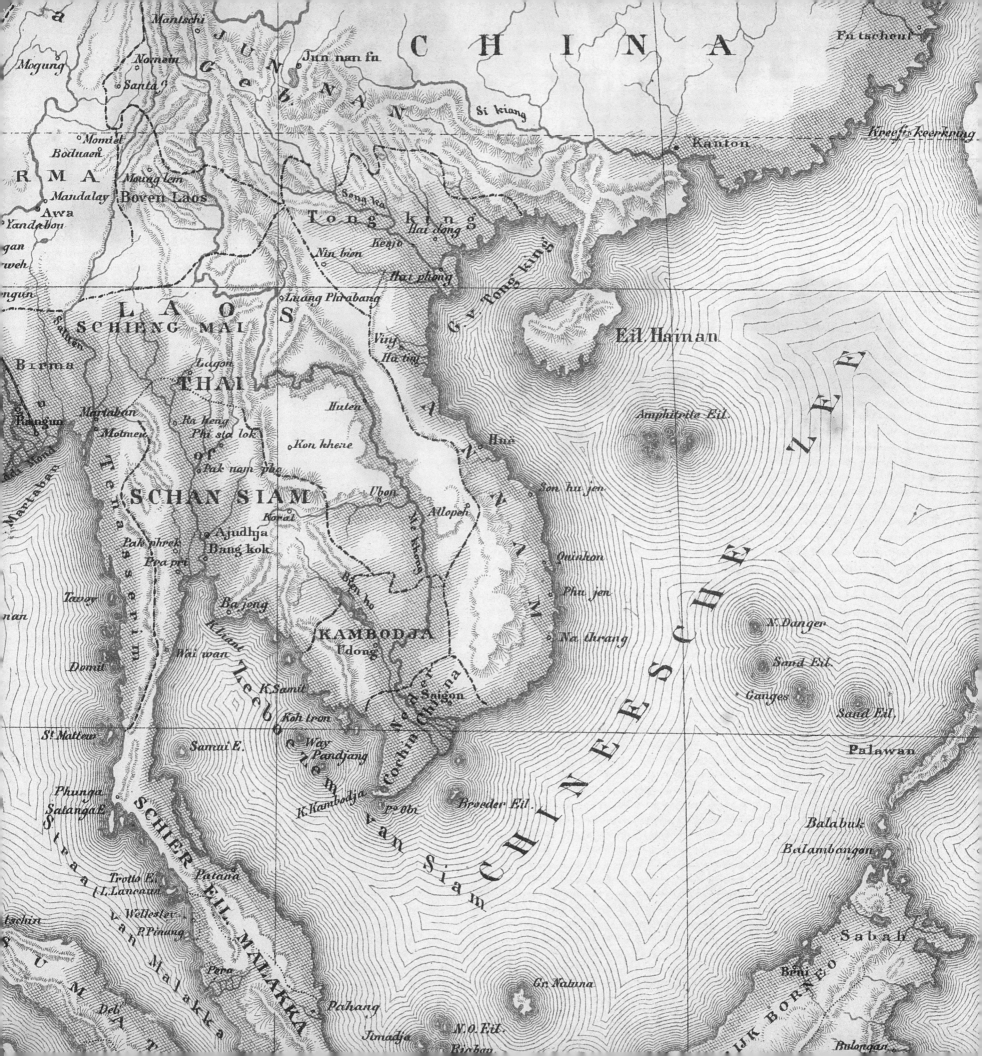

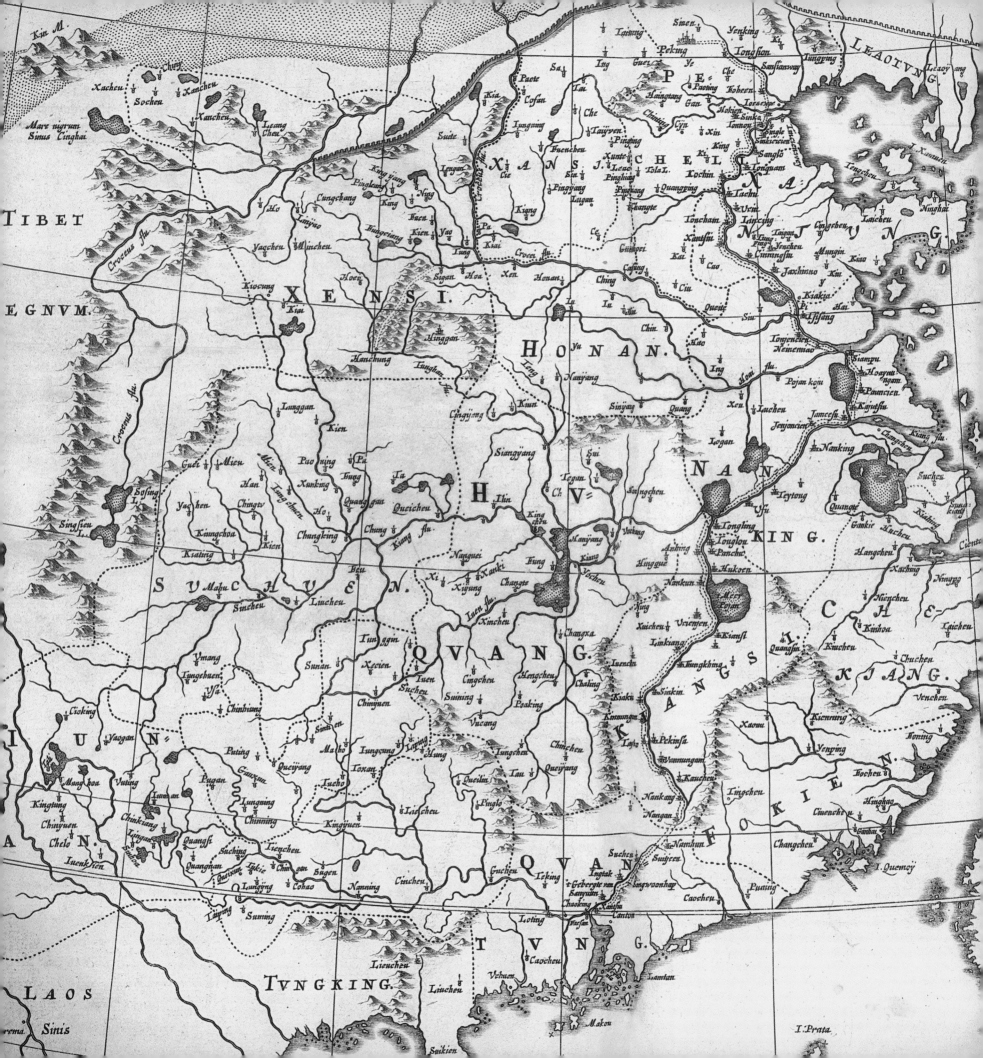

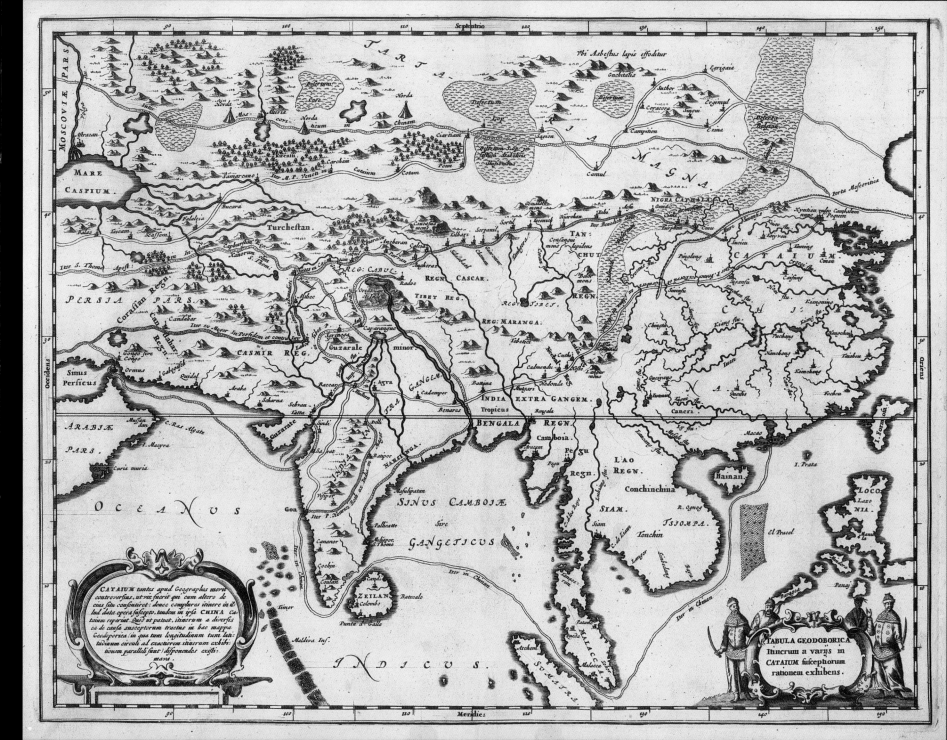

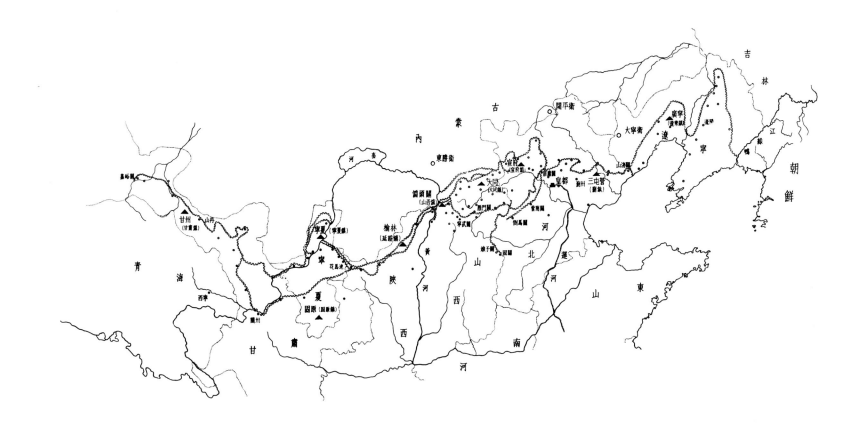

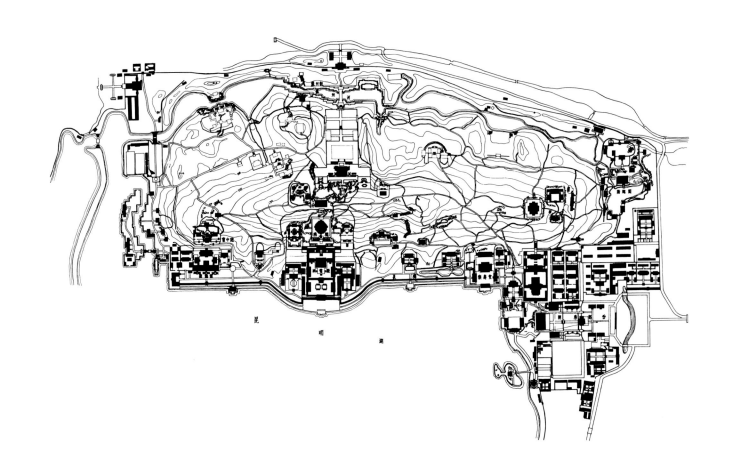

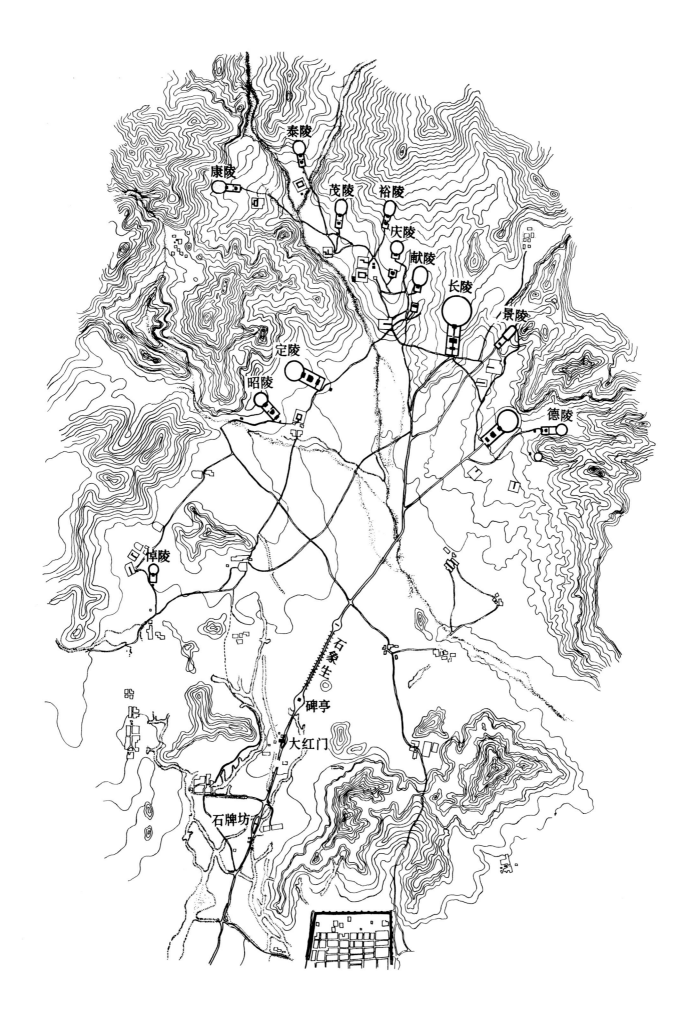

泰陵

康陵

茂陵 裕陵

庆陵

献陵

长陵

景陵

定陵

昭陵

德陵

悼陵

石象生

碑亭

大红门

石牌坊

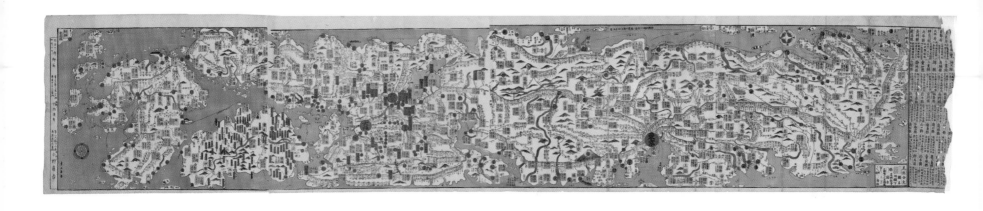

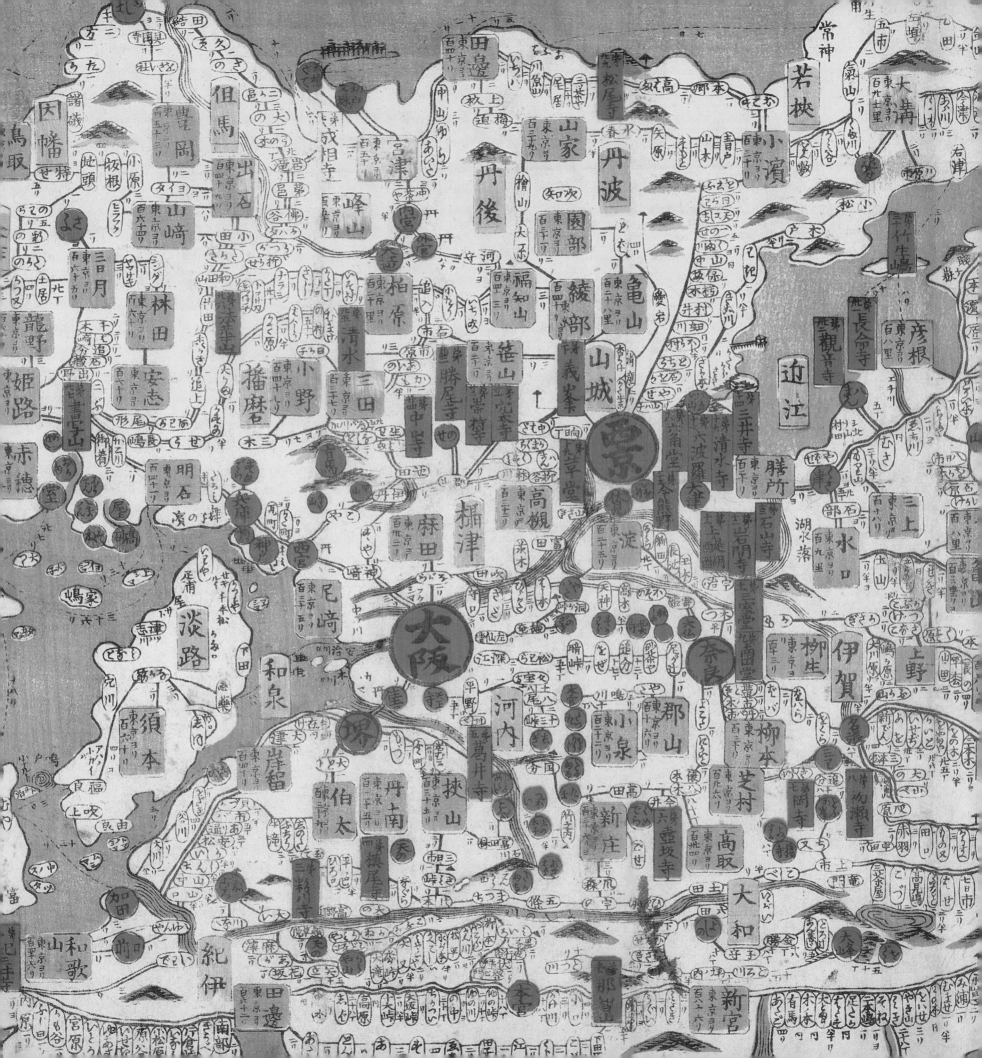

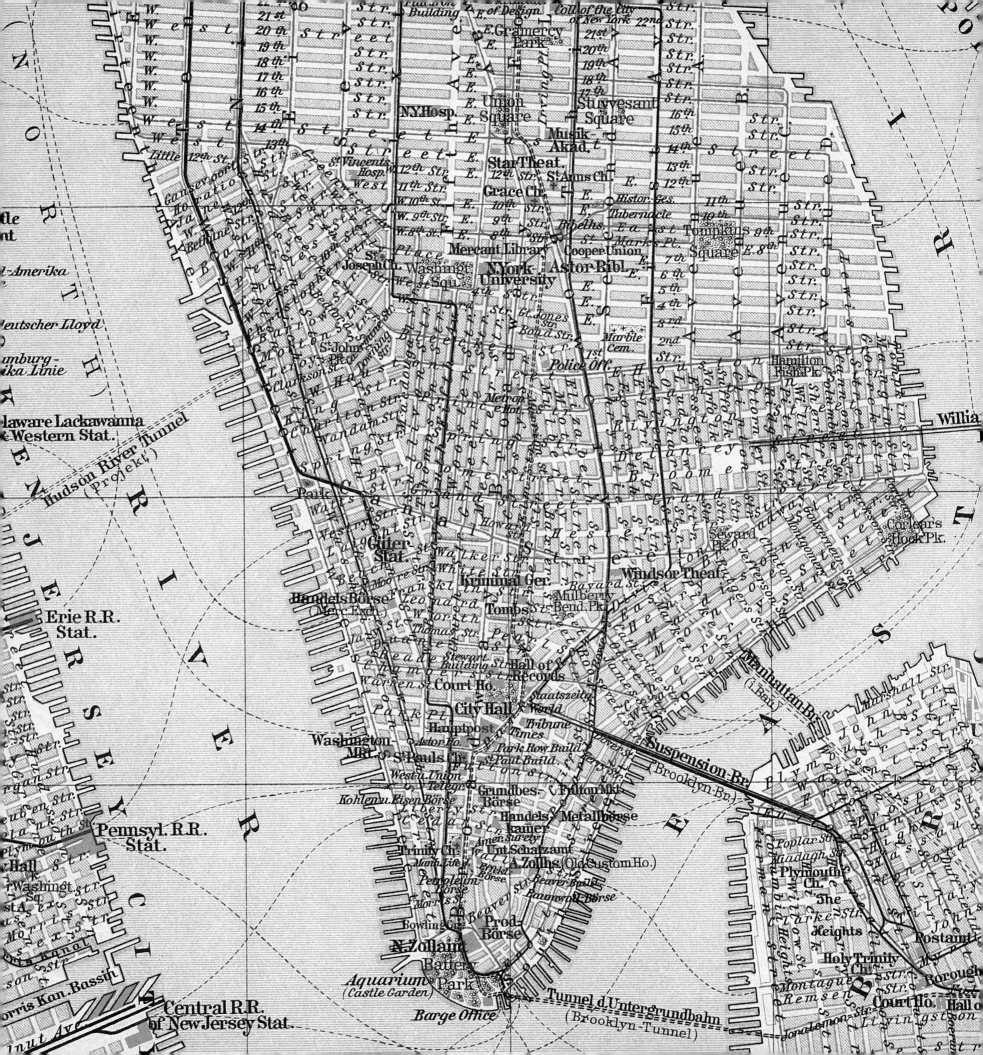

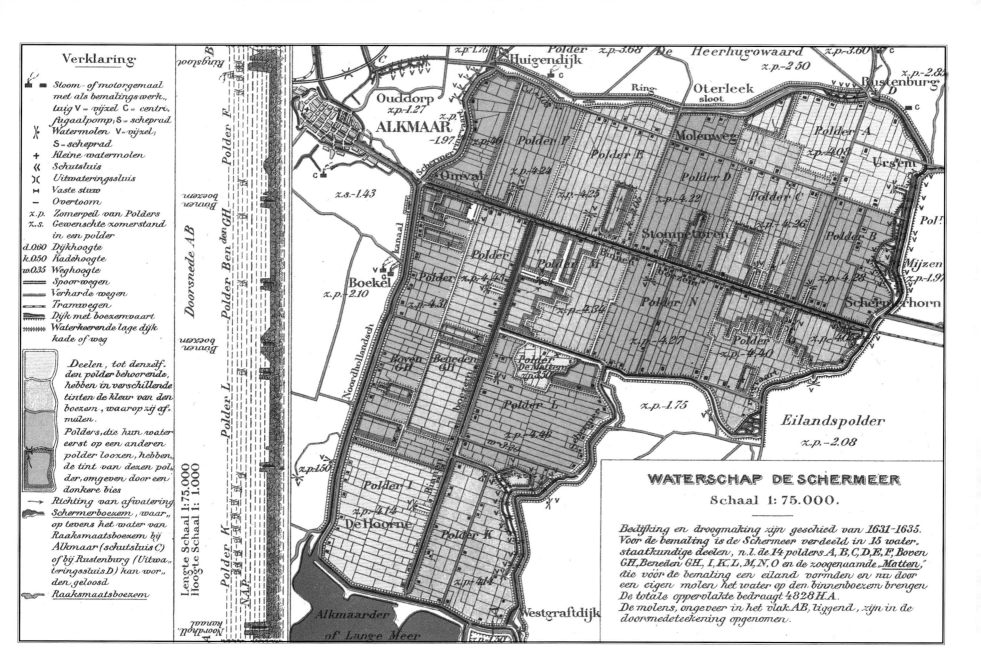

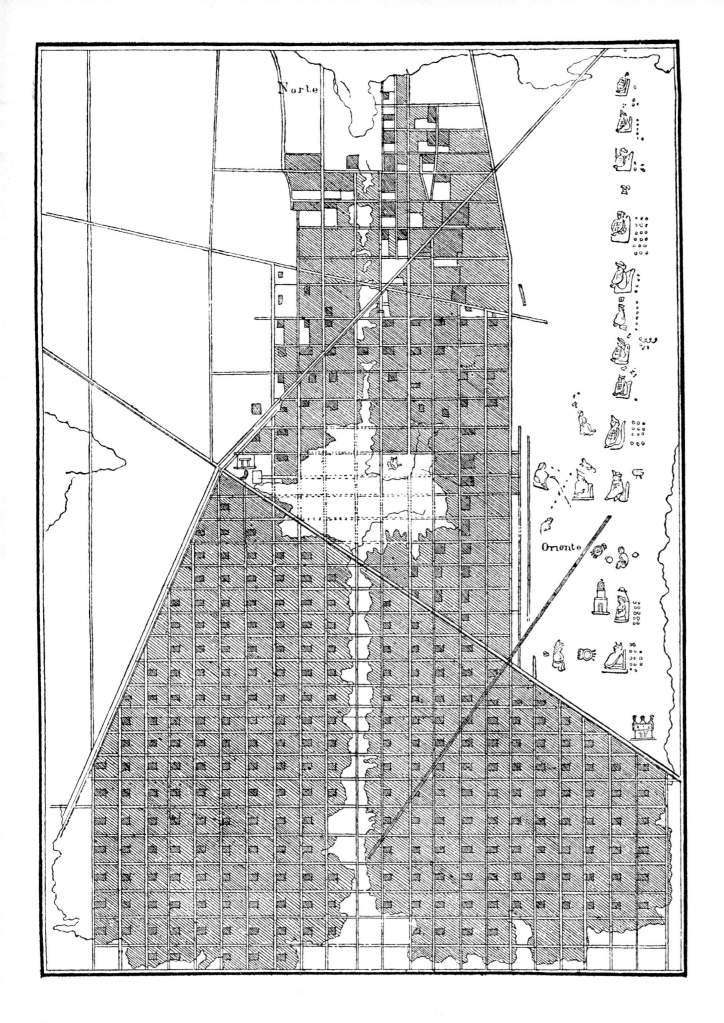

Norte

Oriente

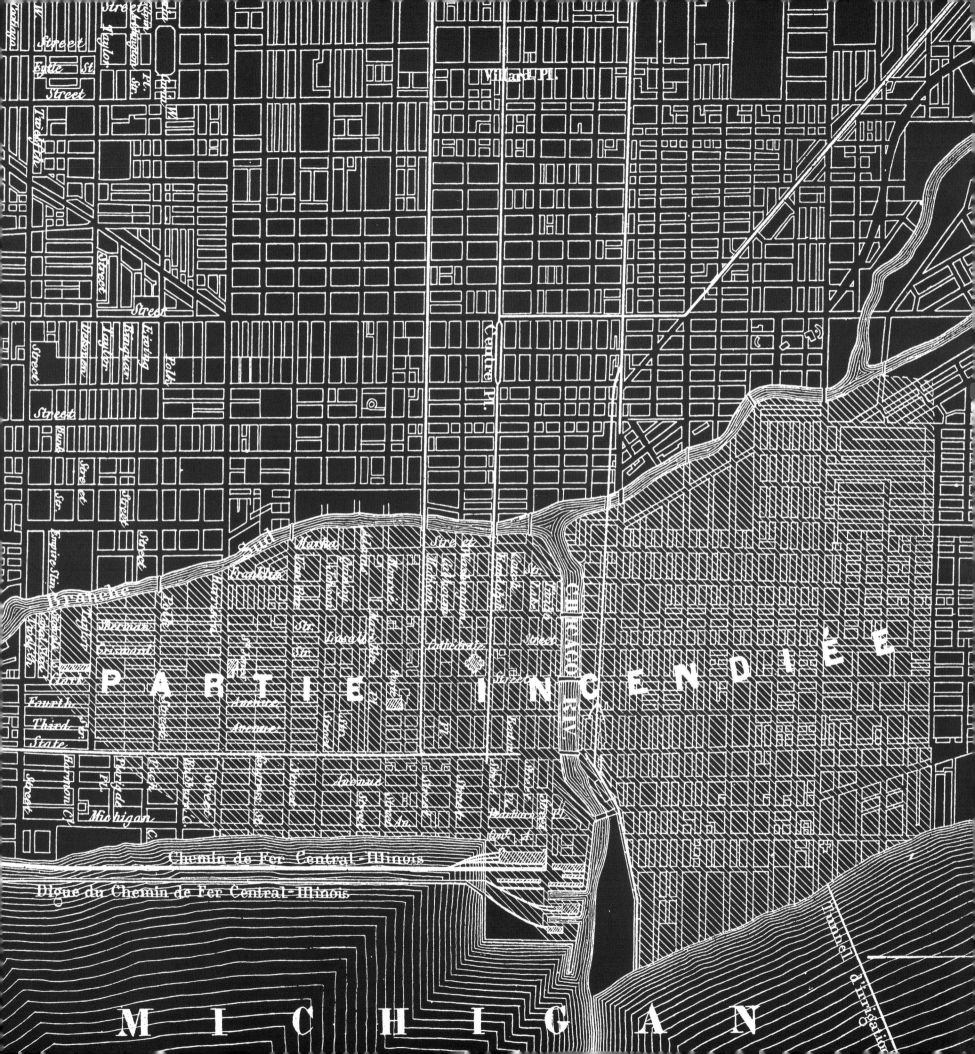

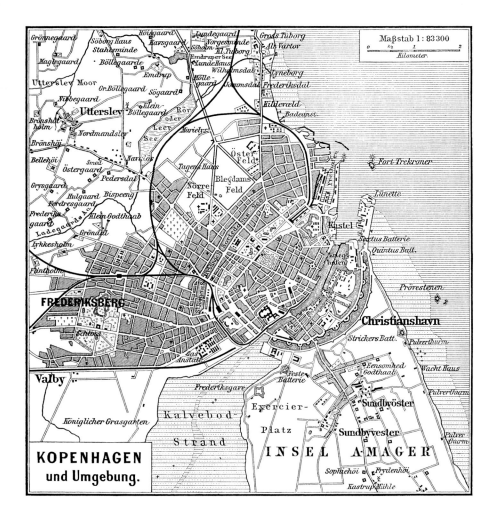

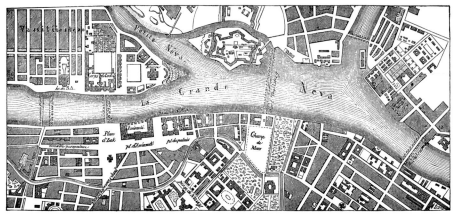

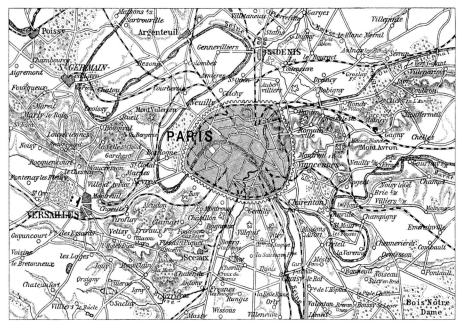

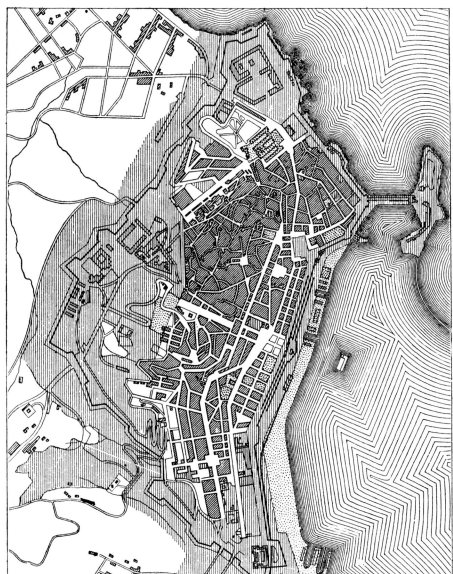

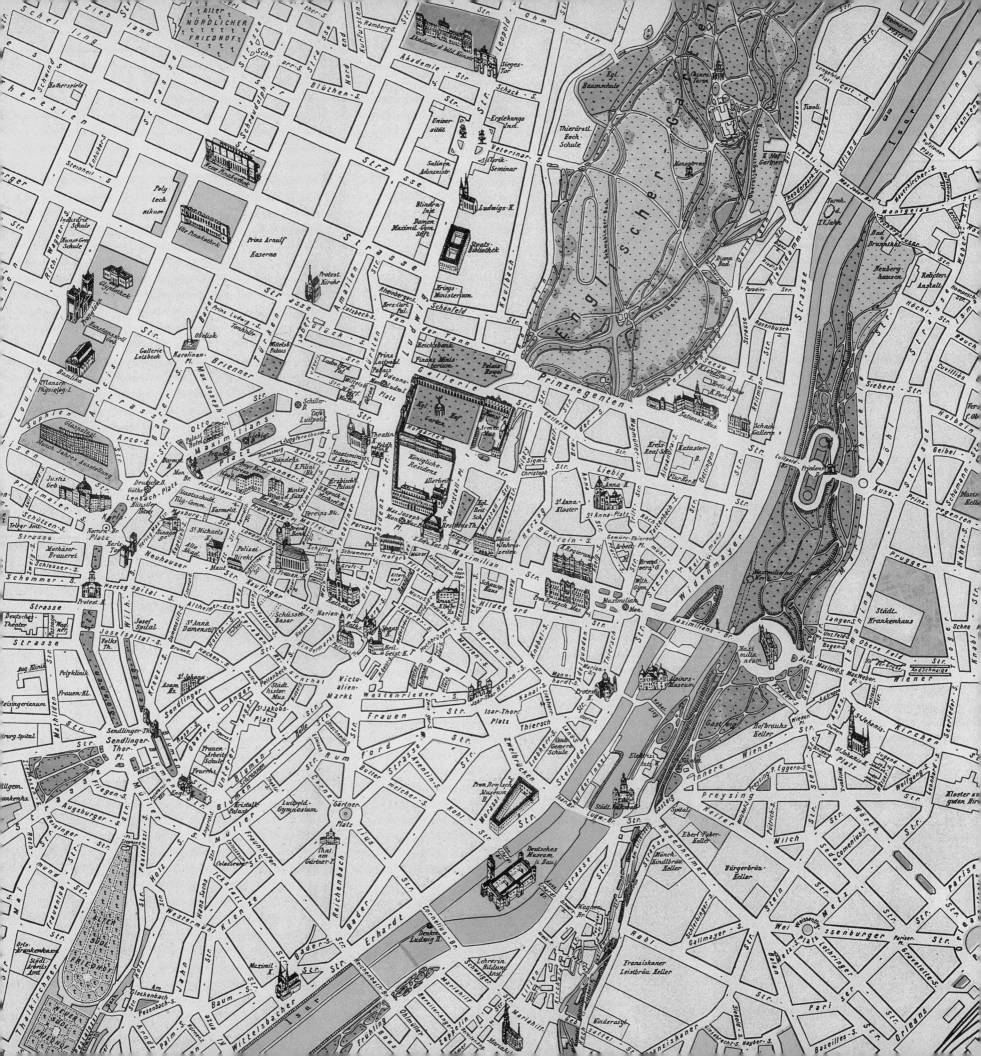

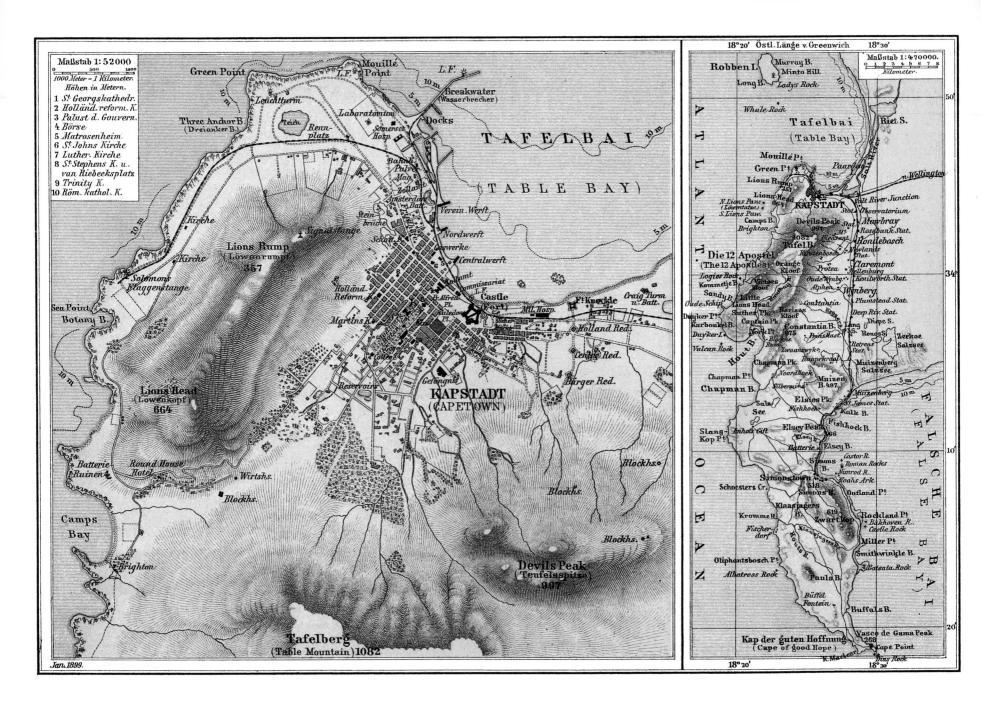

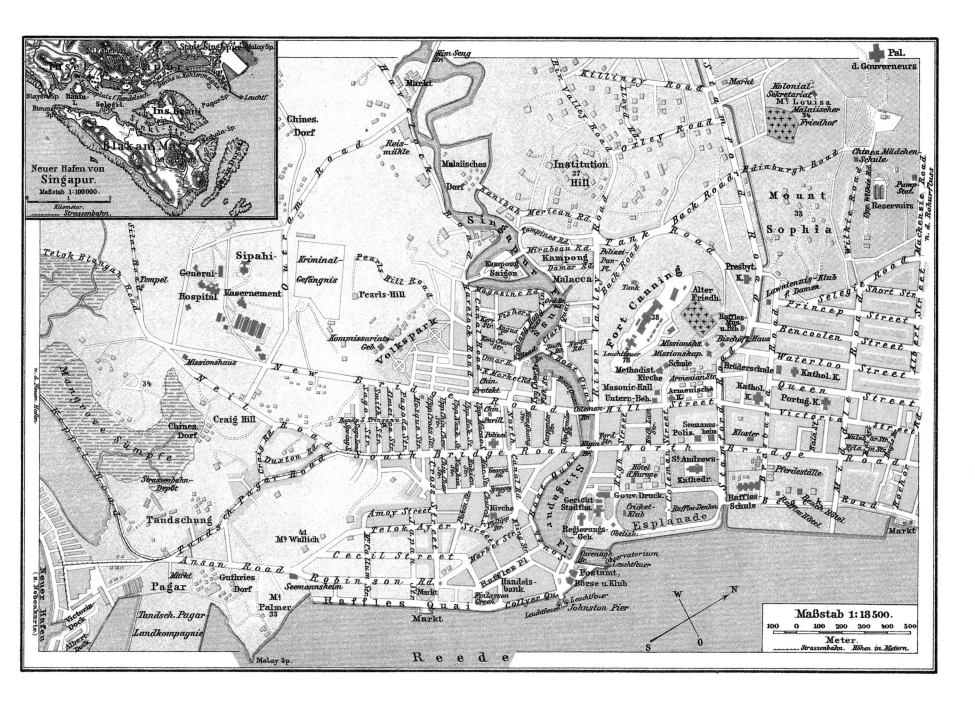

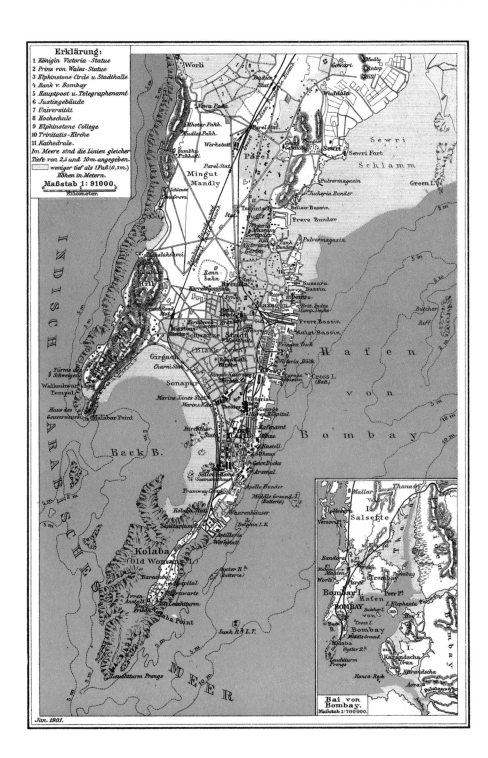

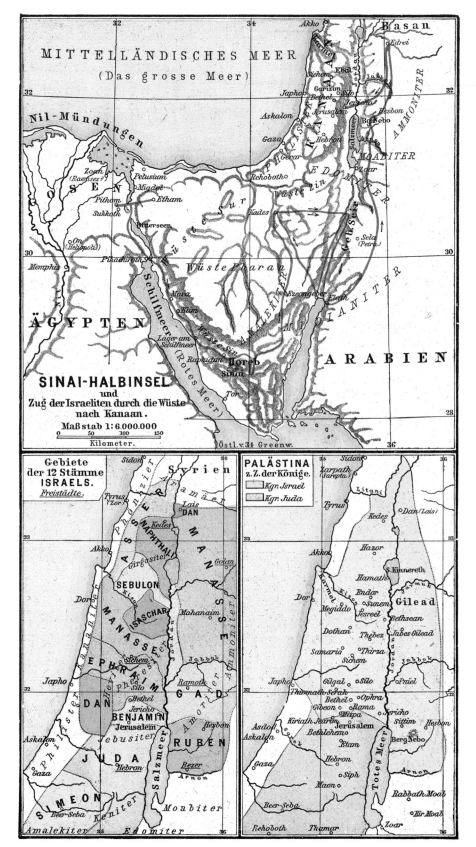

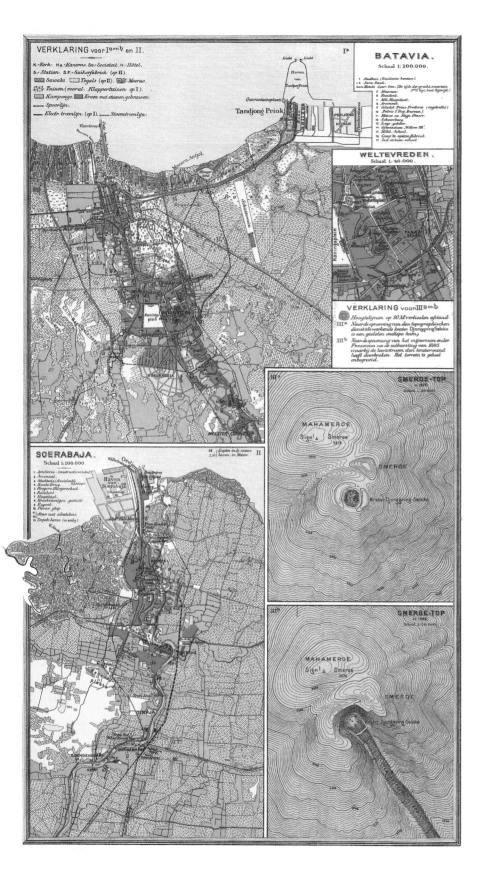

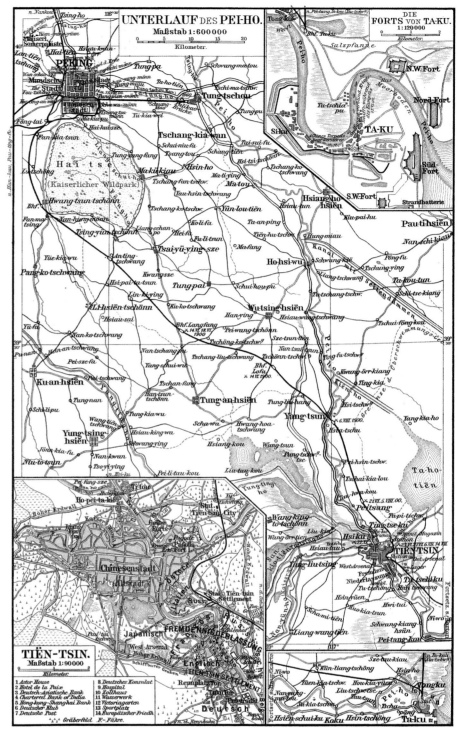

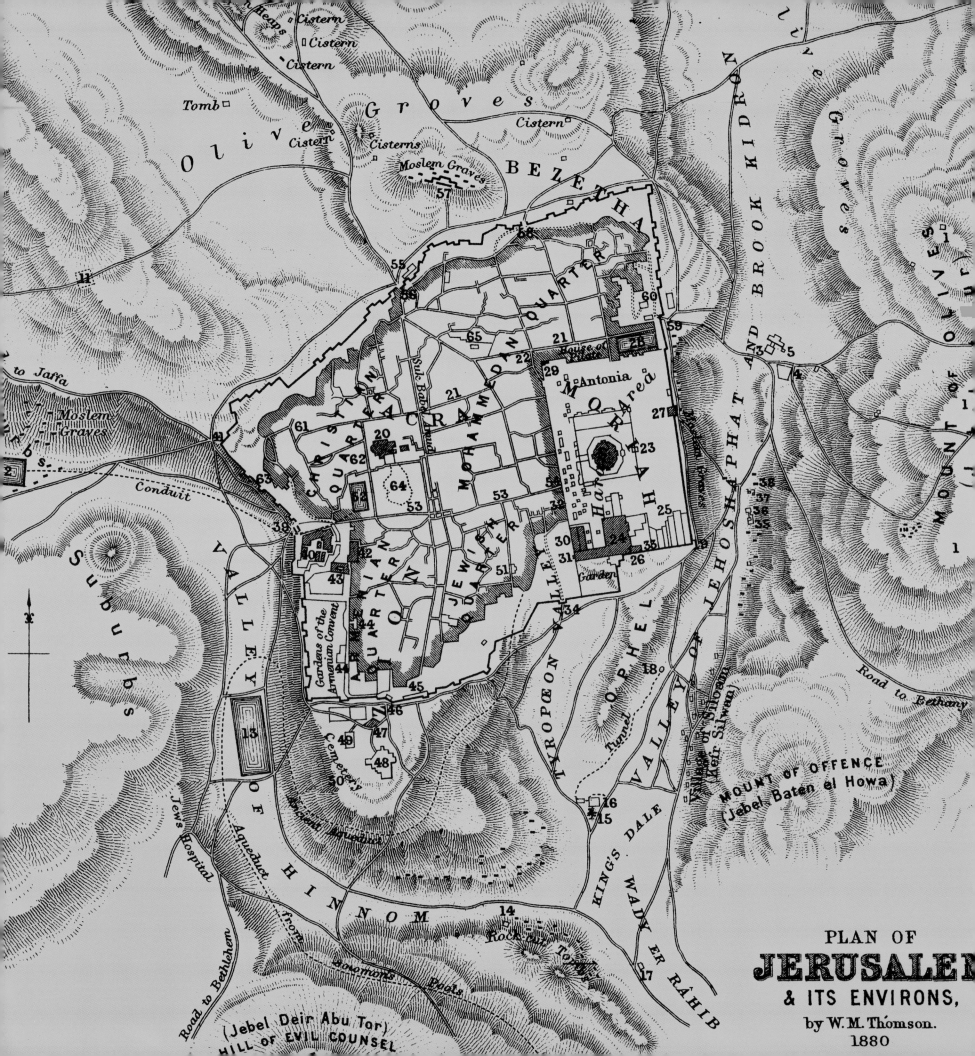

PLAN OF
**JERUSALEM**
& ITS ENVIRONS,
by W. M. Thomson.
1880

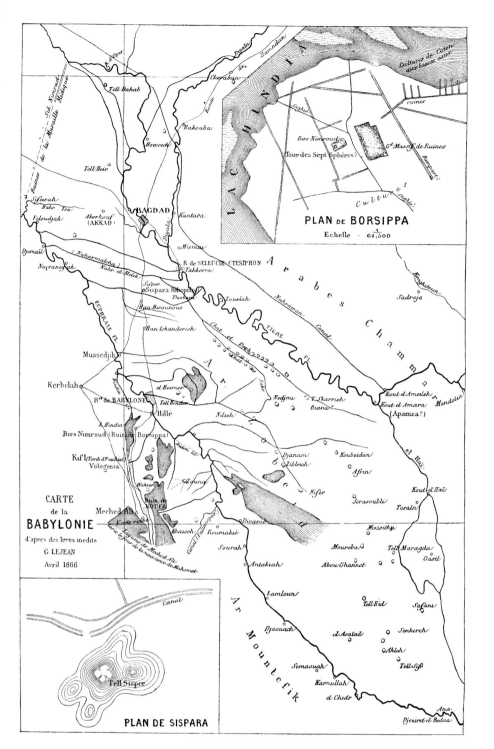

PLAN DE BORSIPPA
Echelle 1 : 62,500

CARTE
de la
BABYLONIE
d'après des leves inedits
G LEJEAN
Avril 1866

PLAN DE SISPARA

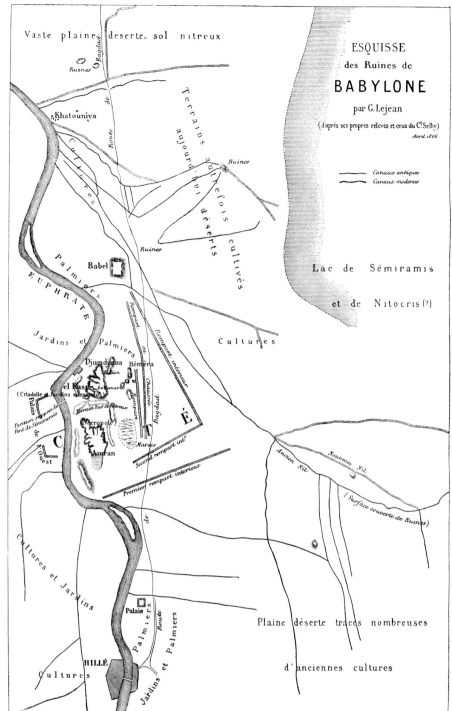

ESQUISSE
des Ruines de
BABYLONE
par G. Lejean
(d'après ses propres relevés et ceux du Ct. Selby)
Avril 1866

Canaux antiques
Canaux modernes

105

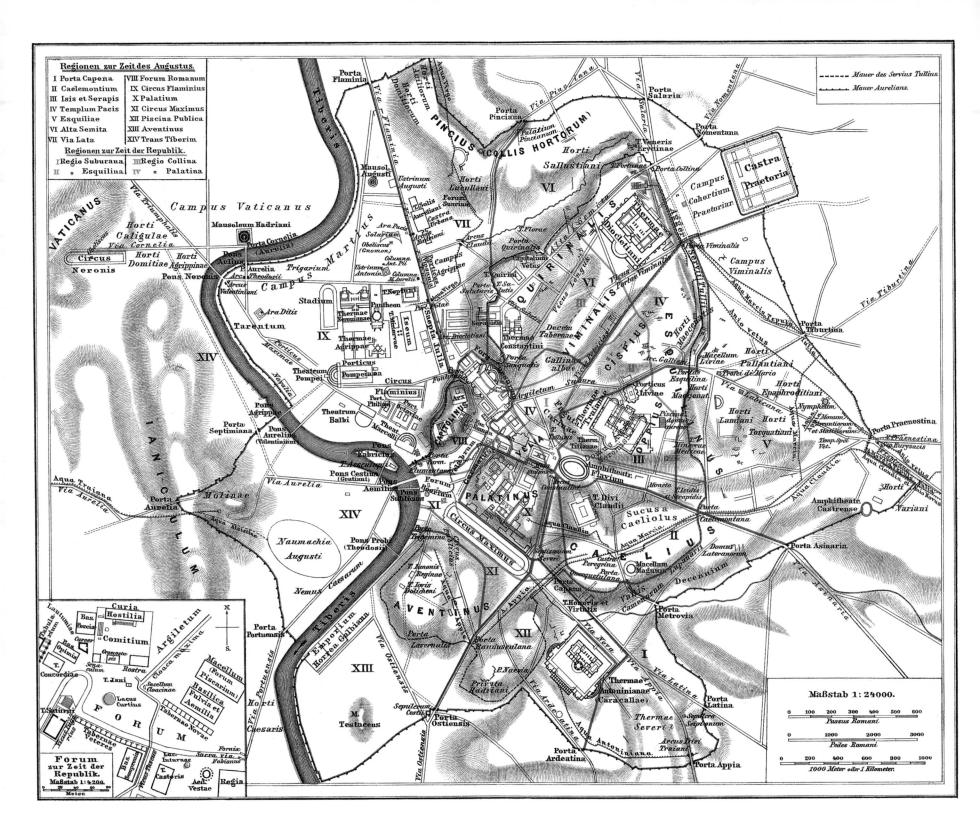

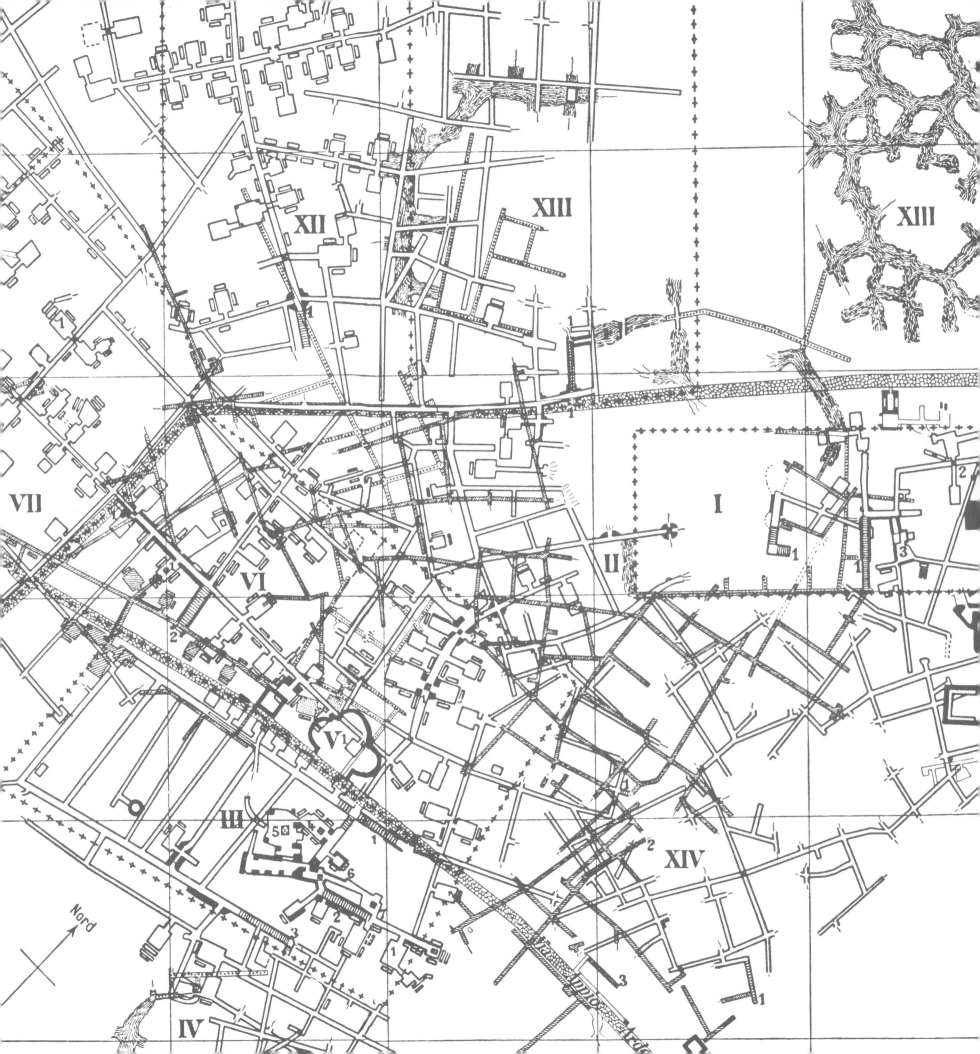

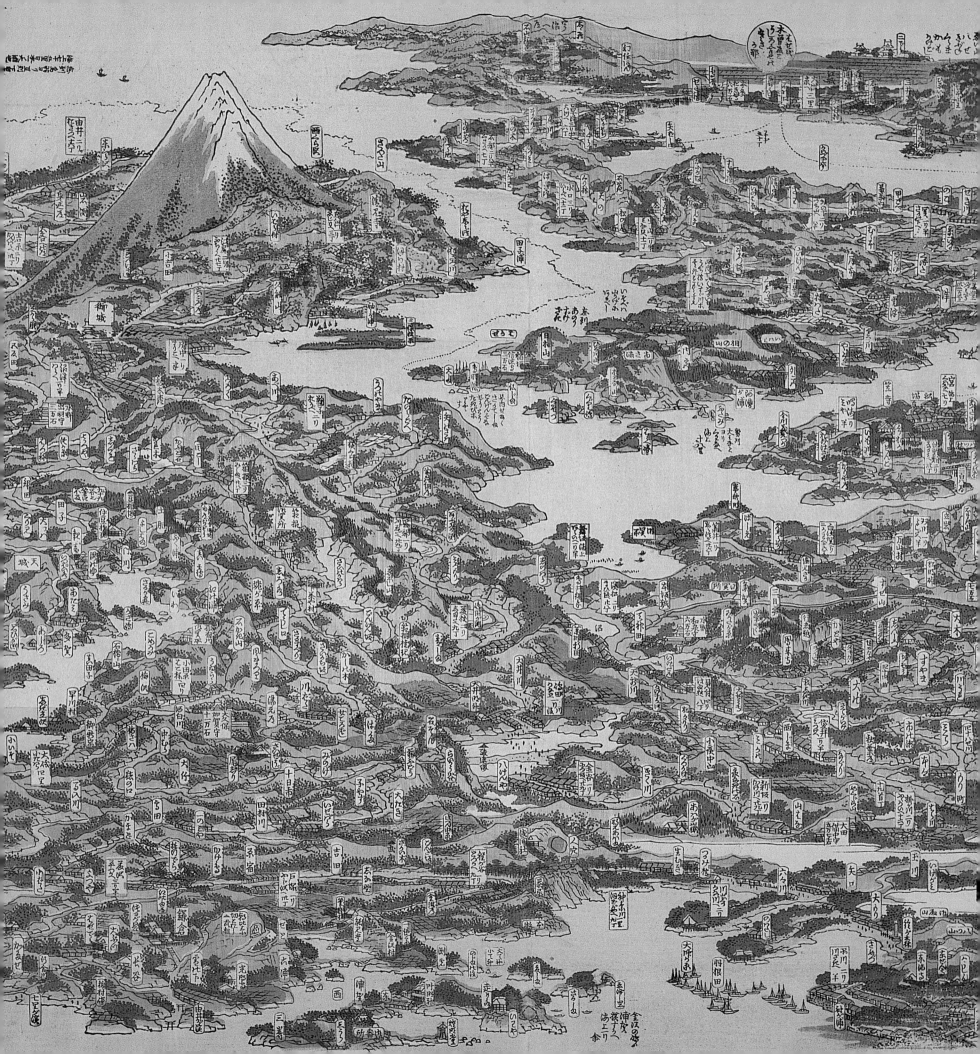

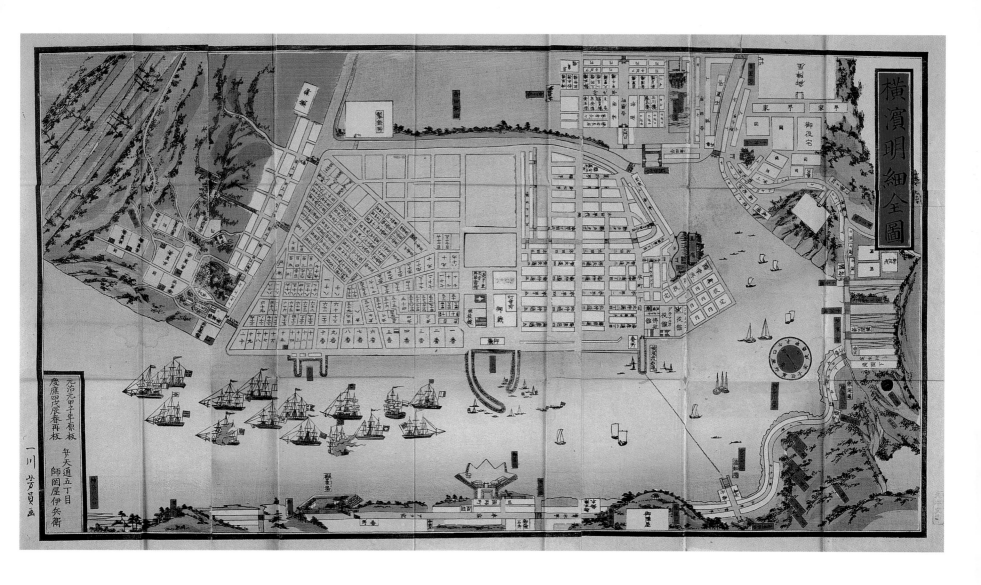

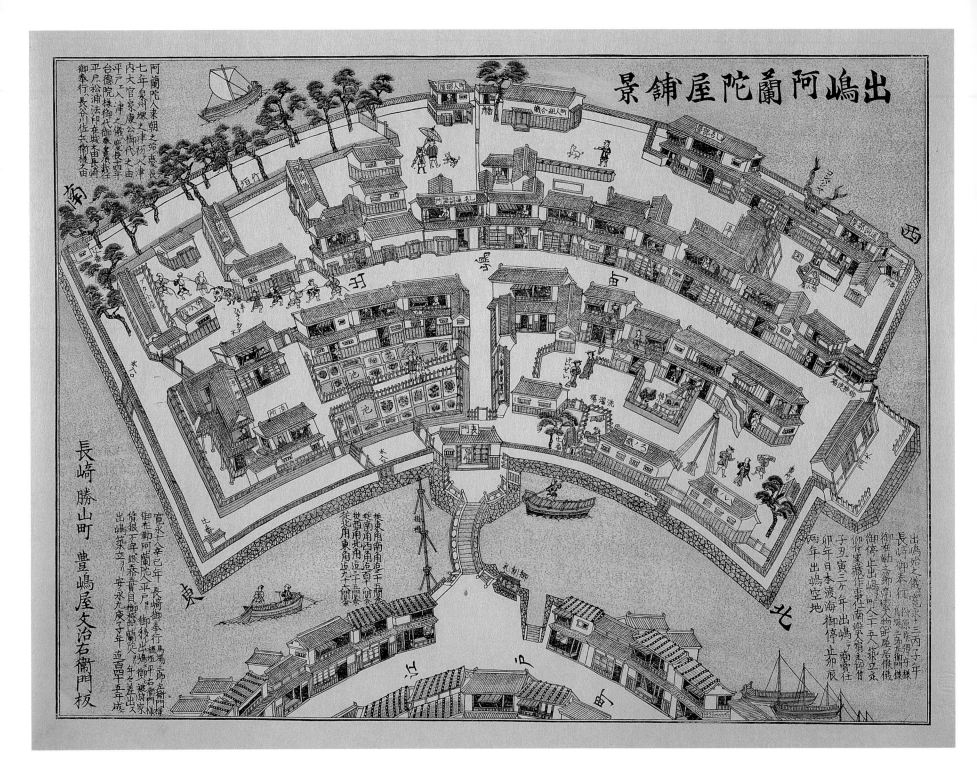

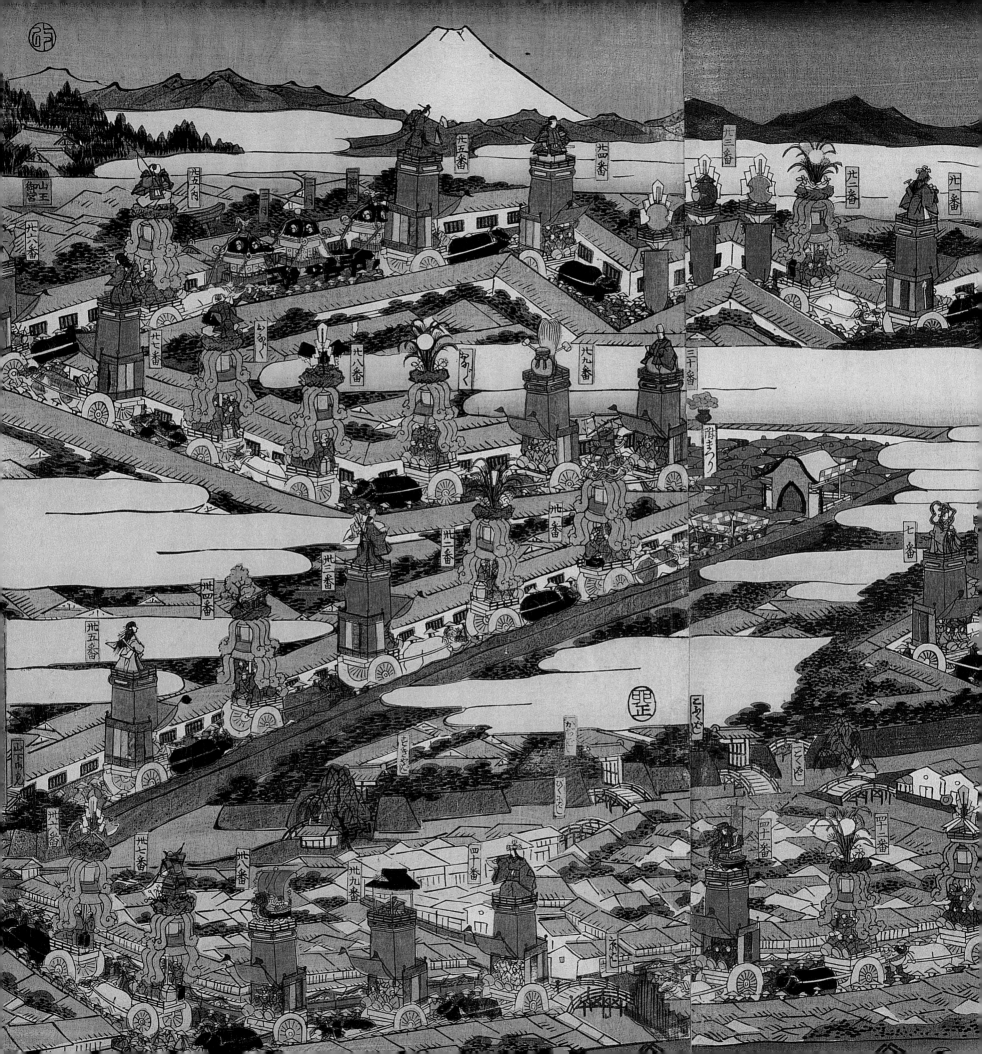

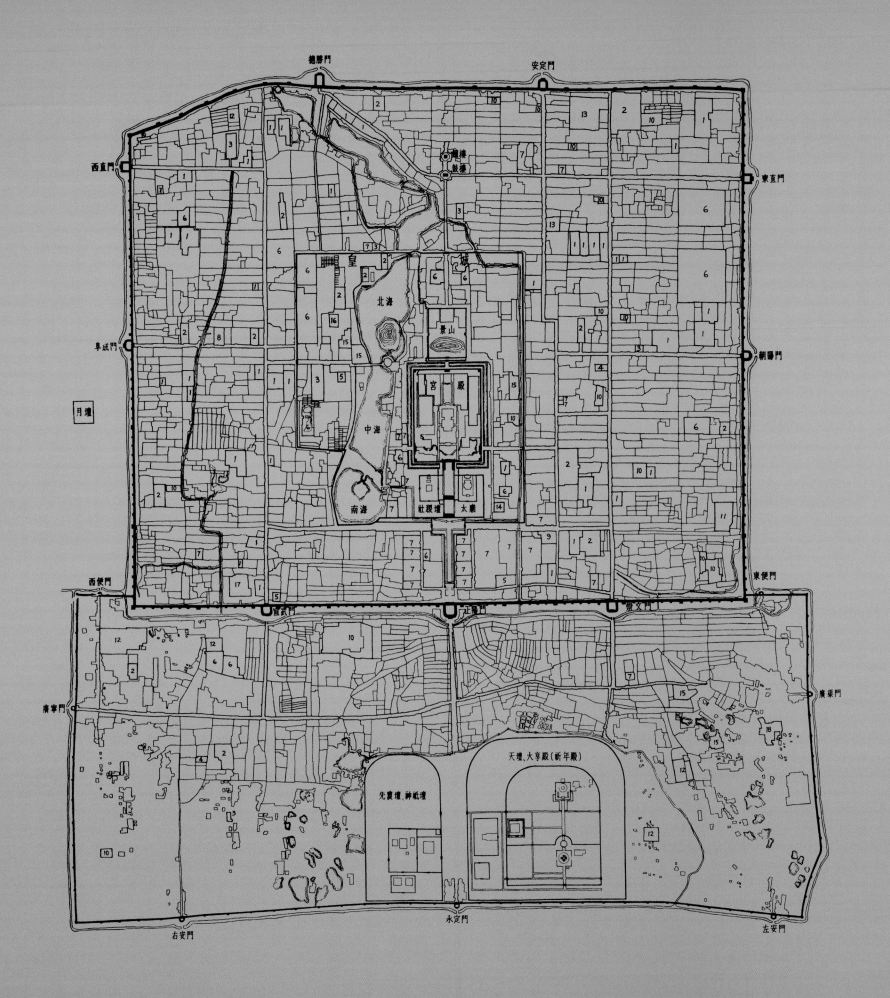

德勝門　　　　　　　　安定門

西直門　　　　　　　　　　　　　　　　東直門

皇城

北海

景山

月壇

阜成門　　　　　　　　　　　　　　　　朝陽門

宮殿

中海

南海　　社稷壇　太廟

西便門　　　　　　　　　　　　　　　　東便門

宣武門　　正陽門　　崇文門

廣寧門　　　　　　　　　　　　　　　　廣渠門

天壇,大享殿(祈年殿)

先農壇,神祇壇

右安門　　　　永定門　　　　左安門

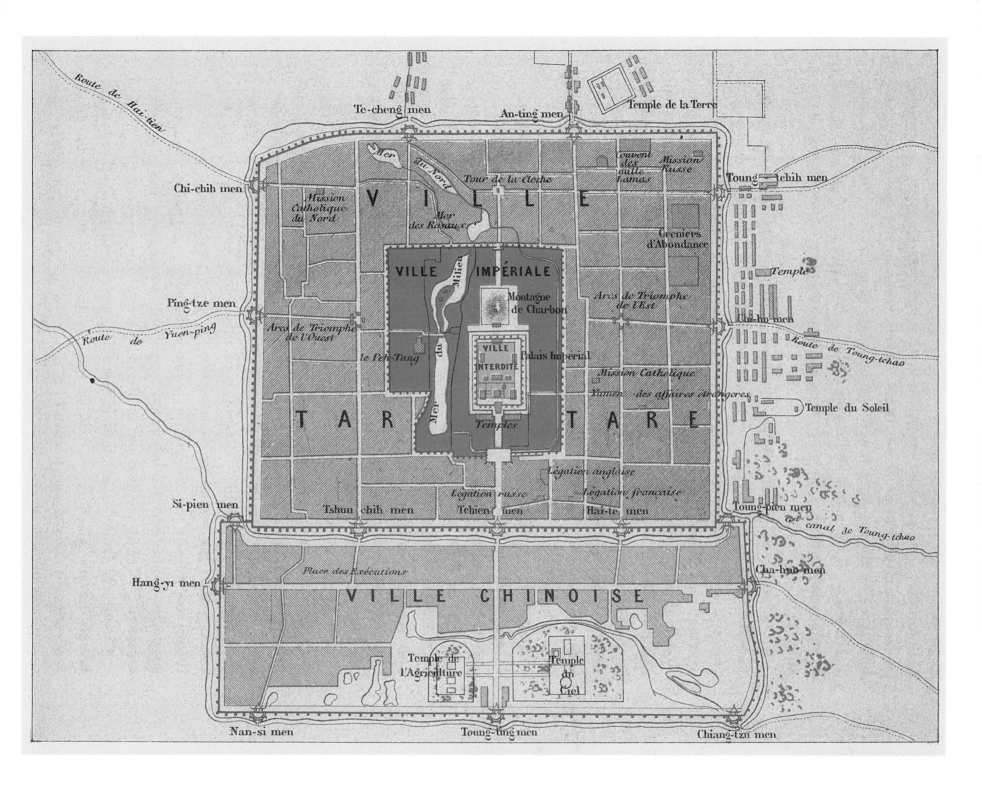

Route de Hai-tien

Te-cheng men     An-ting men     Temple de la Terre

Chi-chih men

Mer du Nord

Tour de la Cloche

Couvent des mille Lamas   Mission Russe

Toung-tchih men

Mission Catholique du Nord

Mer des Roseaux

V I L L E

Greniers d'Abondance

V I L L E   I M P É R I A L E

Ping-tze men

Montagne de Charbon

Arcs de Triomphe de l'Est

Route de Yuen-ping

Arcs de Triomphe de l'Ouest

Mer du Milieu

le Peh-Tang

VILLE INTERDITE

Palais Imperial

Cha-ho men

Route de Toung-tchao

Mission Catholique

T A R

Mer du

Temple

Yamen des affaires etrangeres

T A R E

Temples

Temple du Soleil

Légation anglaise

Légation russe    Légation française

Si-pien men

Tshun-chih men    Tchien men    Hai-te men

Toung-pien men

canal de Toung-tchao

Place des Exécutions

Cha-hua men

Hang-yı men

V I L L E   C H I N O I S E

Temple de l'Agriculture

Temple du Ciel

Nan-si men     Toung-ting men     Chiang-tzŭ men

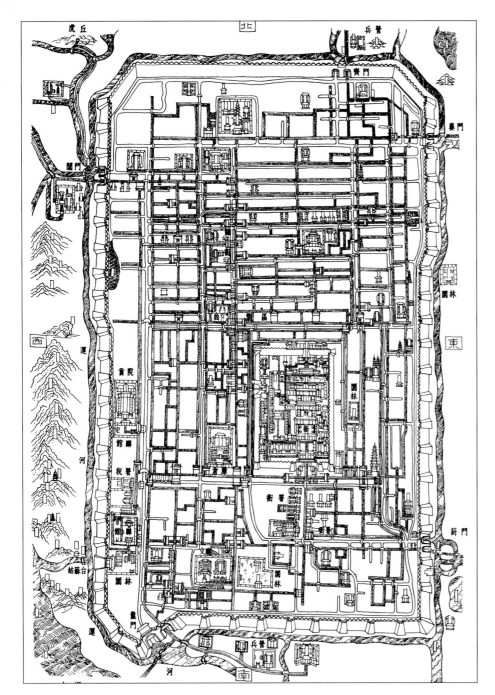

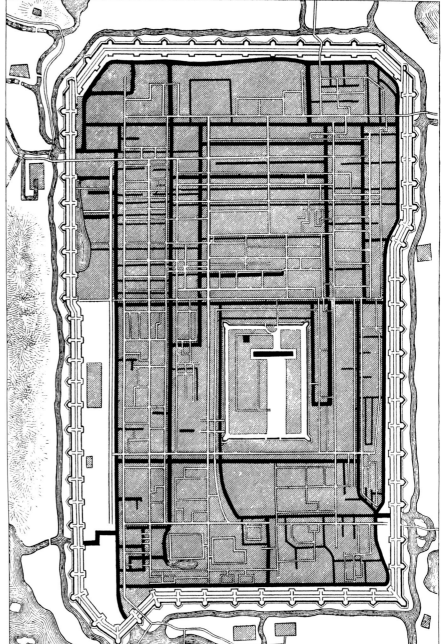

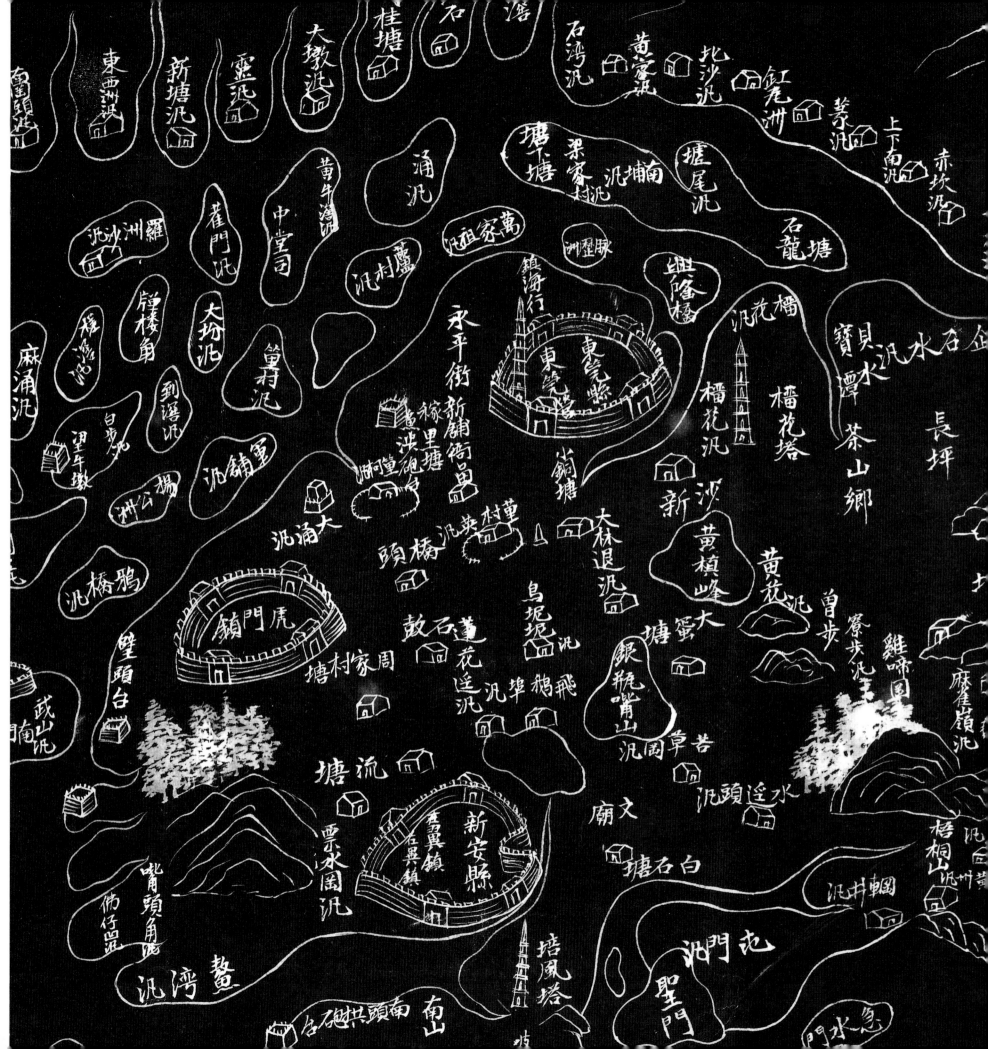

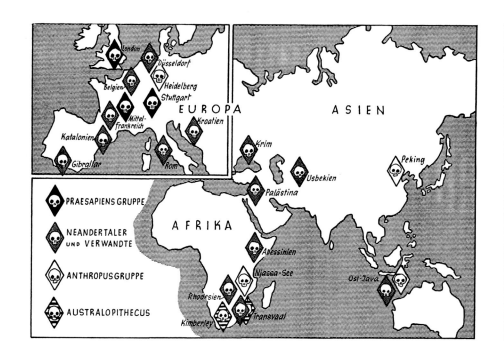

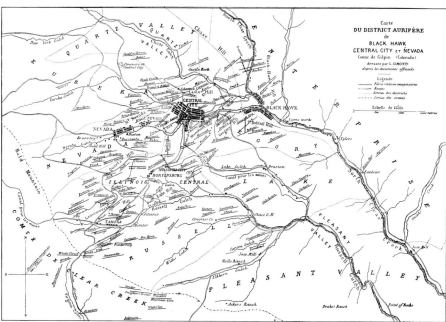

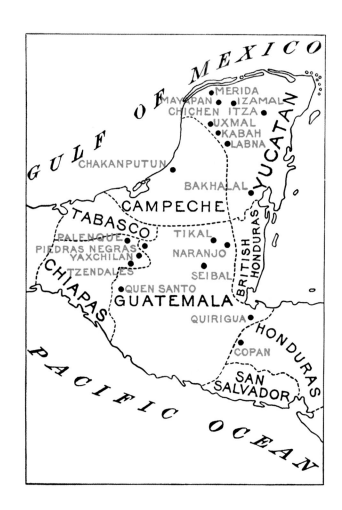

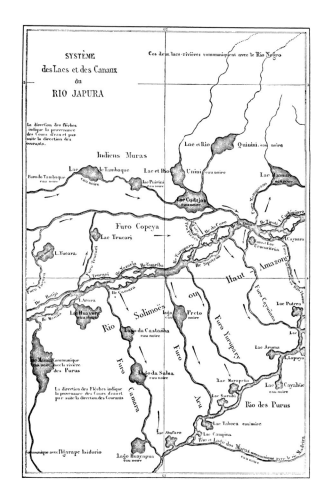

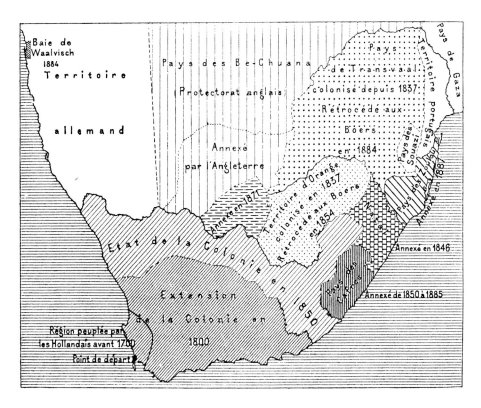

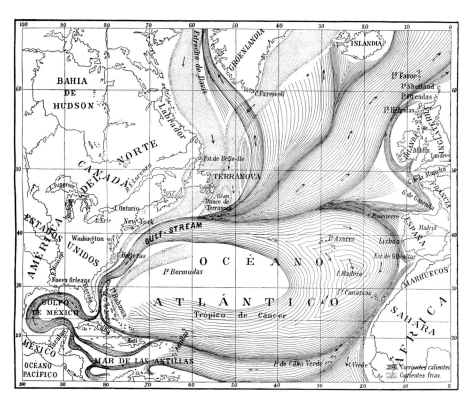

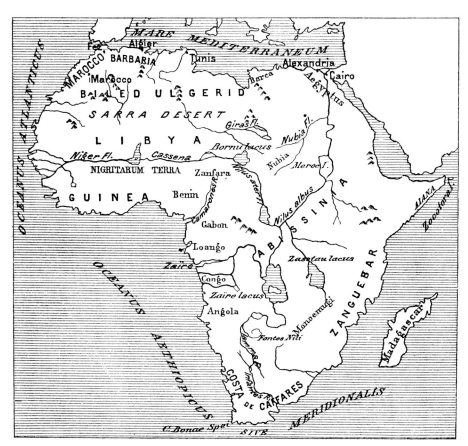

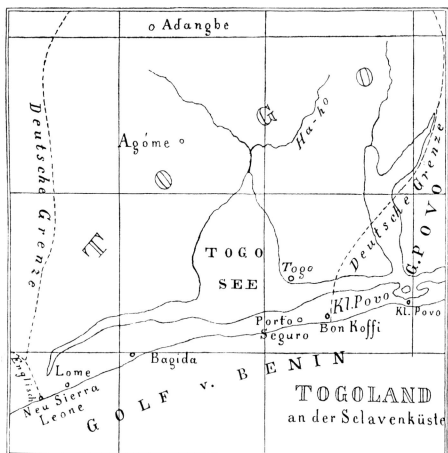

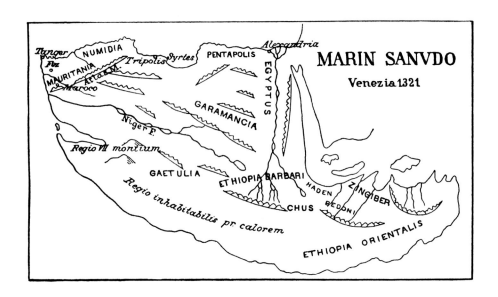

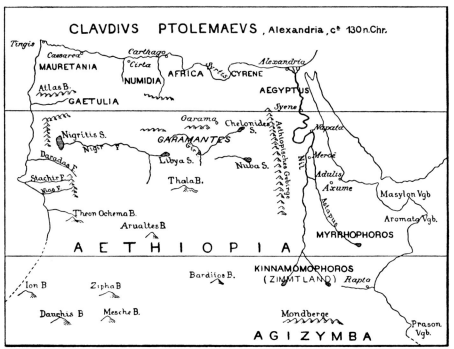

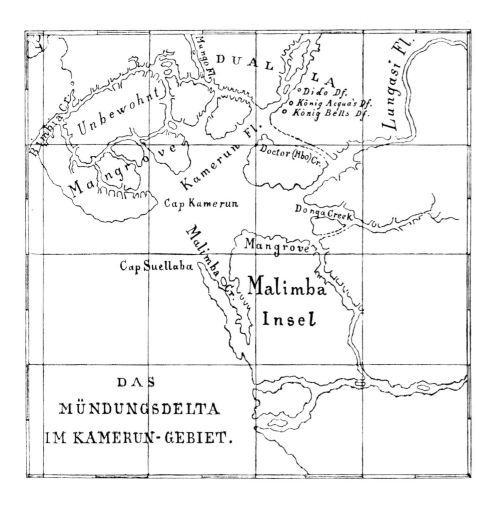

DUALLA

○ Dido Df.
○ König Acqua's Df.
○ König Bells Df.

Bimbra Cr.

Unbewohnt

Mangrove

Kamerun Fl.

Doctor (Mbo) Cr.

Cap Kamerun

Donga Creek

Malimba Cr.

Mangrove

Cap Suellaba

Malimba
Insel

DAS

MÜNDUNGSDELTA

IM KAMERUN-GEBIET.

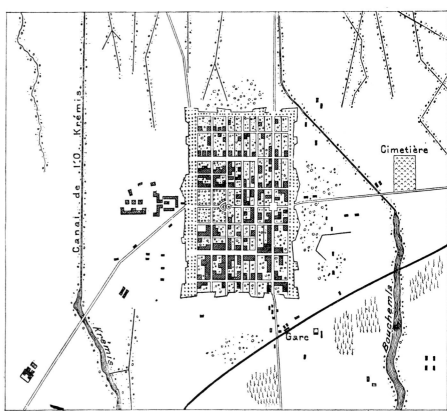

Canal de l'O. Krémis

Cimetière

Kremis

Bouchemla

Gare

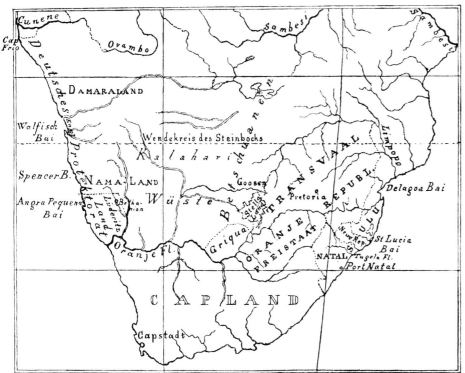

Cunene

Cap Frio

Ovambo

Sambes

Sambes

Deutsches

DAMARALAND

Walfisch Bai

Wendekreis des Steinbocks

Kalahari

Spencer B.

NAMA-LAND

Betschuanen

TRANSVAAL

Limpopo

Wüste

Pretoria

ORANJE

REPUBL.

Delagoa Bai

Angra Pequena Bai

Lüderitzland

Protektorat

Oranje Fl.

Goosen

Stellal.

Griqua

FREISTAAT

ZULU

St Lucia Bai

NATAL

Tugela Fl.

Port Natal

CAPLAND

Capstadt

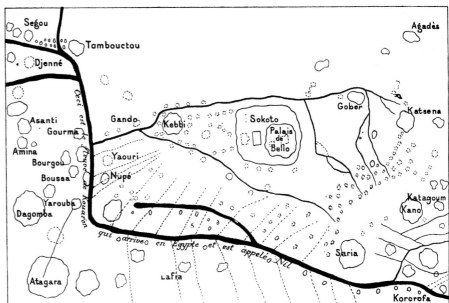

Ségou

Agadès

Tambouctou

Djenné

Asanti

Gourma

Gando

Amina

Bourgou

Boussa

Kebbi

Yaouri

Nupé

Sokoto

Palais
de
Bello

Gober

Katsena

Yarouba

Dagomba

Katagoum

Kano

Atagara

Lafia

qui arrive en Egypte et est appelé Nil

Saria

Kororofa

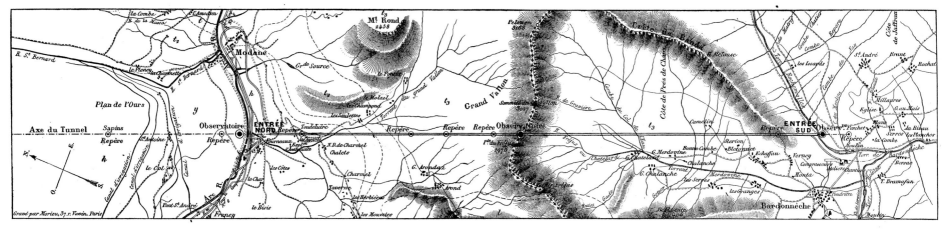

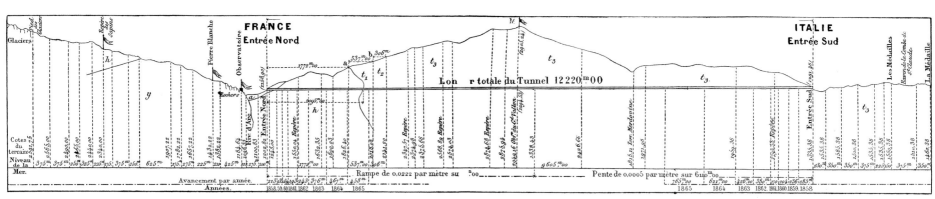

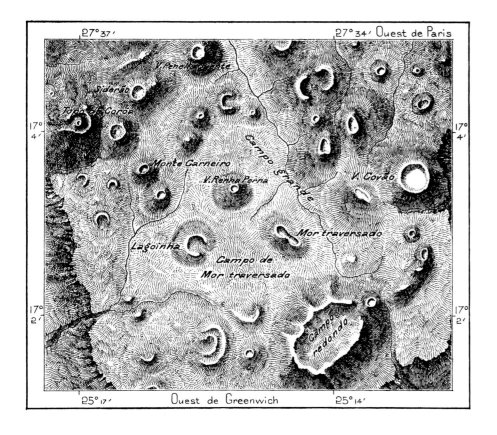

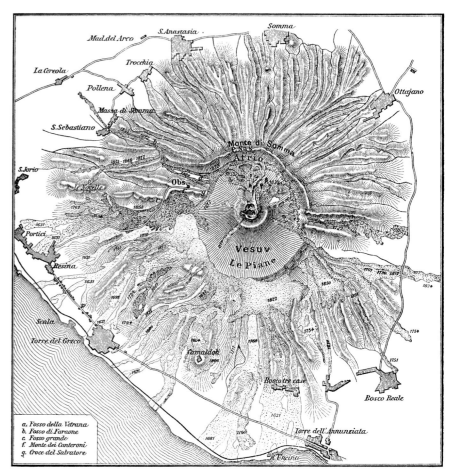

a. Fosso della Vetrana
b. Fosso di Faraone
c. Fosso grande
f. Monte dei Canteroni
g. Croce del Salvatore

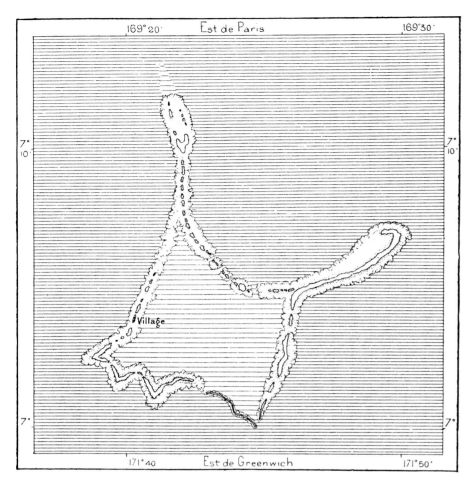

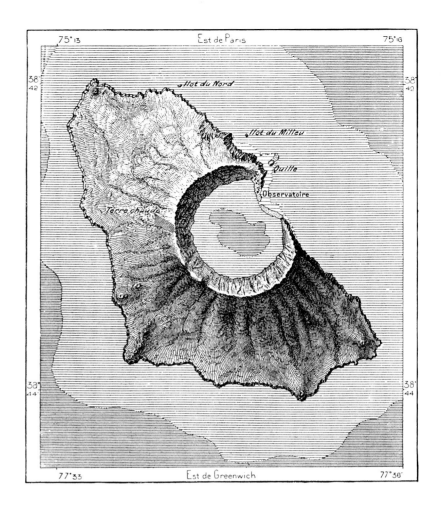

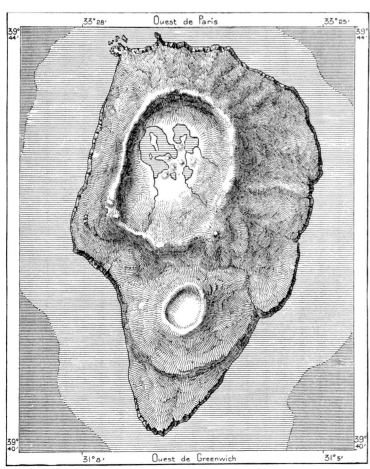

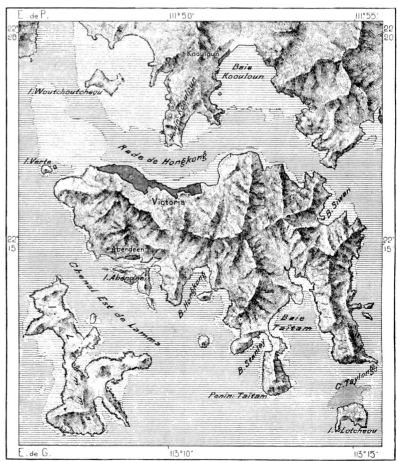

76 Africa
The Netherlands, ca. 1780

77 Africa
Germany, ca. 1800

78 South America
France, 1841

79 North America
France, 1841

80 America

81 America
The Netherlands, ca. 1700

82 Ancient Persia
France, 1842

83 Asia
Germany, 1878

84 Indian Ocean and surrounding countries
The Netherlands, 1680

85 India and parts of Southeast Asia
Great Britain, 1747

86 Map of India showing Buddhist and Jain locations
Great Britain, 1891

87 Asia
The Netherlands, 1880

88 Asia
The Netherlands, 1667

89 Asia
The Netherlands, 1667

90 Chinese maps
China, 1984

91 Chinese map
China, 1984

92 Japan
Japan, year unknown

93 Detail of p. 92

94 New York, U.S.A.
Germany, year unknown

95 Polder De Schermer
The Netherlands, ca. 1910

96 Ancient plan of Mexico City
France, 1855

97 The Great Chicago Fire, U.S.A. in 1871
France, 1872

98 TL Algiers  France, 1882
TR Copenhagen and surroundings  Germany, ca. 1900
BL Detail of St. Petersburg  France, ca. 1850
BR Paris  Germany, ca. 1900

99 City plan of Munich, Germany
Germany, ca. 1925

100 Cape Town and surroundings, South Africa
Germany, 1899

101 Singapore and surroundings
Germany, 1899

102 R The Middle East
Germany, ca. 1880
L Bombay and surroundings
Germany, 1901

103 R Course of the Pei-Ho River, China
Germany, ca. 1850
L Jakarta, Indonesia,
The Netherlands, year unknown

104 Ancient Jerusalem and surroundings
United Kingdom, 1901

105 Two maps of ancient Babylon (Iraq)
France, 1866

106 Ancient Rome, Italy
Germany, ca. 1900

107 Network of the Calixtus Catacombs, Rome, Italy
Germany, 1902

108 Detail of Japanese map
Japan, year unknown

109 Japanese map
Japan, year unknown

110 Plan of the Dutch settlement in Deshima, Japan
Japan, year unknown

111 Japanese map
Japan, year unknown

 112 Beijing, China
China, 1984

 113 Ancient Beijing, China
France, 1884

 114 L Suzhou, China
China, 1984
R Suzhou, China
France, 1882

 115 Chinese map
China, year unknown

 116 T Suez delta and canal
B Volga Riner delta, Russia
France, 1882

 117 T Ho Chi Minh City (Saigon), Vietnam
B Stockholm and surroundings, Sweden
France, 1882

 118 TL Important sites where fossils of early humans are
found Germany, 1955
TR The gold district, Black Hawk, U.S.A. U.S.A., ca. 1880
BL The Maya area, Central America U.S.A., year unknown
BR Lakes and rivers of the Rio Japurá, Brazil France, 1867

 119 TL Colonial annexation in Southern Africa France, 1888
TR Gulf stream, Atlantic Ocean Spain, 1886
BL South America France, 1903
BR Africa, based on a map from 1711 France, 1888

 120 TL Diamond district, South Africa France, 1888
TR Togo Germany, 1891
BL Northern Africa, after Ptolemy Germany, ca. 1900
BR Africa based on a map from 1321 Germany, ca. 1900

 121 TL Cameroon Germany, 1891
TR Boufarik, Algeria France, 1882
BL Southern Africa Germany, 1891
BR Mali France, 1882

122 T Cross-section and plan of tunnel between France
and Italy France, year unknown
BL Volcano Plateau, Italy France, 1882
BR Vesuvius, Italy Germany, ca. 1900

123 TL One of the Marshall Islands, Oceania France, 1882
TR St Paul Island, Indian Ocean France, 1882
TL The Azores, Portugal France, 1882
BR Hong Kong and surroundings France, 1882

 128 TL Ancient map of Cuba
France, 1855
BL Egypt
United Kingdom, 1882
R Maldives
France, 1855

Cb B Compass rose
United Kingdom, 1897

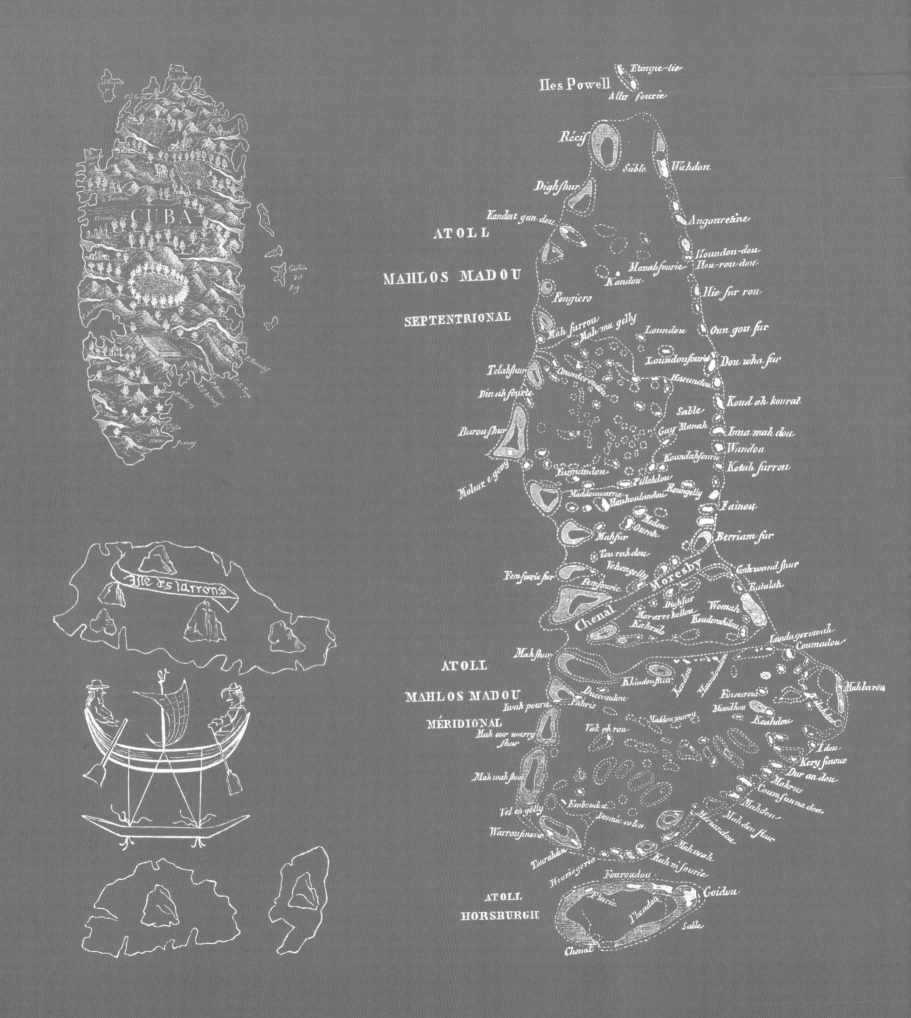